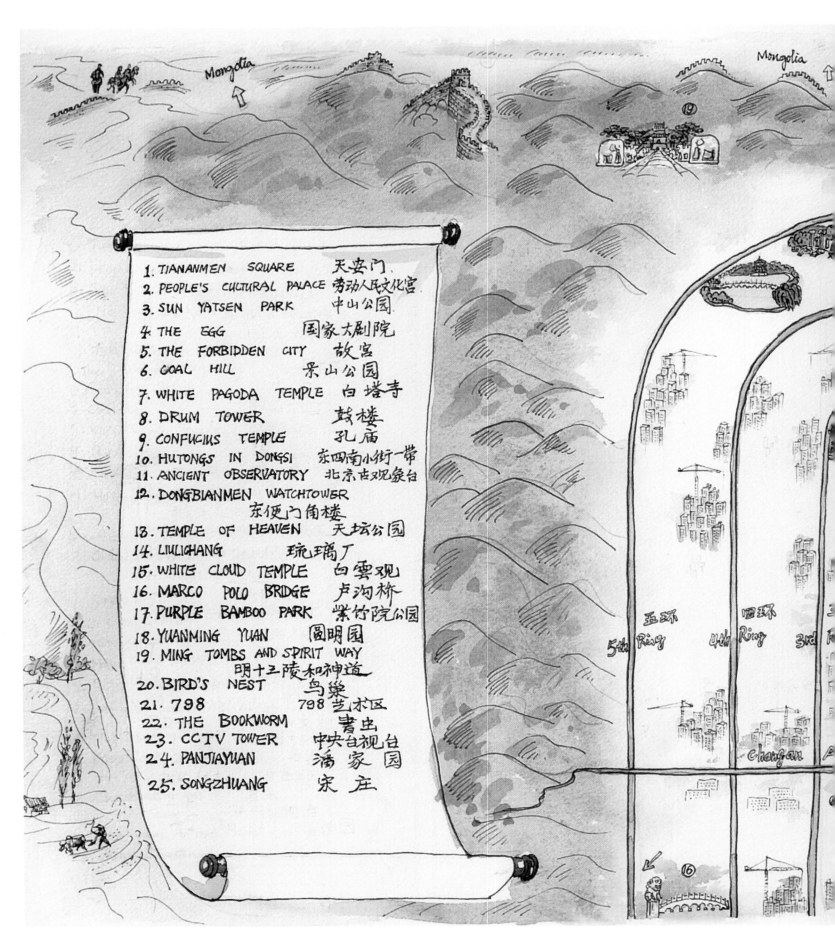

1. TIANANMEN SQUARE 天安门
2. PEOPLE'S CULTURAL PALACE 劳动人民文化宫
3. SUN YATSEN PARK 中山公园
4. THE EGG 国家大剧院
5. THE FORBIDDEN CITY 故宫
6. COAL HILL 景山公园
7. WHITE PAGODA TEMPLE 白塔寺
8. DRUM TOWER 鼓楼
9. CONFUCIUS TEMPLE 孔庙
10. HUTONGS IN DONGSI 东四南小街一带
11. ANCIENT OBSERVATORY 北京古观象台
12. DONGBIANMEN WATCHTOWER
 东便门角楼
13. TEMPLE OF HEAVEN 天坛公园
14. LIULICHANG 琉璃厂
15. WHITE CLOUD TEMPLE 白云观
16. MARCO POLO BRIDGE 卢沟桥
17. PURPLE BAMBOO PARK 紫竹院公园
18. YUANMING YUAN 圆明园
19. MING TOMBS AND SPIRIT WAY
 明十三陵和神道
20. BIRD'S NEST 鸟巢
21. 798 798艺术区
22. THE BOOKWORM 书虫
23. CCTV TOWER 中央台视台
24. PANJIAYUAN 潘家园
25. SONGZHUANG 宋庄

Mongolia

Mongolia

五环 5th Ring

四环 4th Ring

三环 3rd

Changan

⑲

⑯

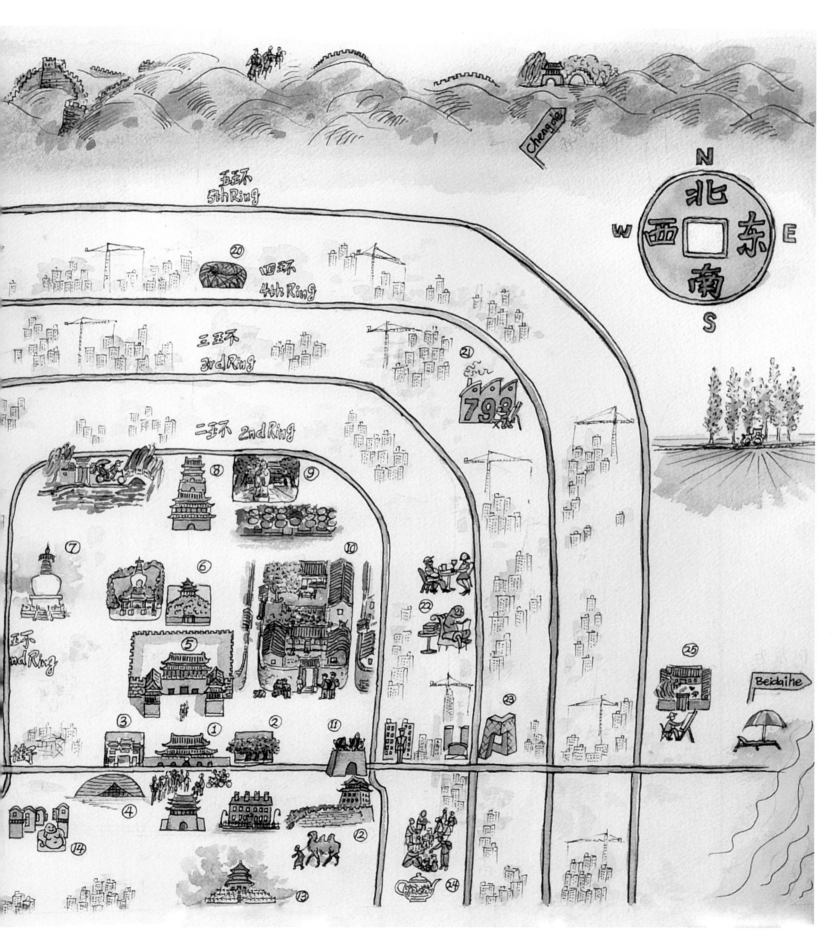

Edited by Peter Goff
– Journalist and co-owner of The Bookworm

Author biographies by Jenny Niven
– Books Editor of *Time Out Beijing,* and Events
and Marketing Manager of The Bookworm

Translation by Eric Abrahamsen
– Translator and host of *www.paperrepublic.org*

Poetry translation by James Kynge
– Author of *China Shakes the World*

Map by Pan Gang

Photographs by Lucy Cavender

北京

Beijing
Portrait of a City

Compiled by
Alexandra Pearson *and* Lucy Cavender

Beijing Portrait of a City © 2008
The Middle Kingdom Bookworm Limited
The full rights to all contributions are held by the individual authors
Photographs © 2008 Lucy Cavender
Map © 2008 The Middle Kingdom Bookworm Limited

The Middle Kingdom Bookworm Limited
7/F., 80 Gloucester Road, Wanchai, Hong Kong
Email: books@beijingbookworm.com

Library of Congress Catalog Card Number has been requested.

ISBN: 978-962-217-803-8

Grateful acknowledgment is made to the following:
McSweeney's, *The New Yorker* and Faber & Faber.
Design and layout by Beijing Jade Vision Design Studio

Production by Twin Age Ltd, Hong Kong.
Email: twinage@netvigator.com
Printed in Hong Kong

We shall not cease from exploration
And the end of all our exploring
Will be to arrive where we started
And know the place for the first time.

T.S. Eliot
Four Quartets

CONTENTS

Foreword

Zhu Wen – *Poems* *12*

Adam Williams – *Camels of Khanbalik* *22*

Roy Kesey – *Loess* *34*

Ma Jian – *Memories of No. 53 Nanxiao Lane* *44*

Alfreda Murck – *Panjiayuan* *54*

Tim Clissold – *Coal Hill* *66*

Catherine Sampson – *Hit and Run* *76*

Peter Hessler – *Autumn Drive* *90*

Karen Smith – *Heart of the Art* *106*

Paul French – *A 1930s Peking Murder* *122*

M.A. Aldrich – *Batjargal's Secret History of the Mongols* *134*

Hong Ying – *Gay Capital* *148*

Rob Gifford – *Return to Centre* *162*

Acknowledgements *169*

Foreword

James Kynge

There are many ways to apprehend a city. You can look across it from the window of a high building, or render it in paint less than a millimetre thick. You can photograph its skyline and its buildings, capturing a moment in time. You can follow a linear account of its history, but miss the byways where its simpler nature resides. You can mount it in model form and display it in a museum, or gaze down upon it through Google Earth, skimming the parts obscured by puffs of white cloud. You can do all of these things and more, and yet be left with a nominal portrait, a slim sense of the dialogue that animates its character.

Some cities, such as New York, Paris and Barcelona, wear their charm on their sleeves. After only a few days, the visitor is conscious of a distinct personality, a fusion of people and place that makes the identity of each dependent on the other. The persona of others, such as London, perhaps, and Berlin, appear caught in a divergence of past glories, current realities and future aspirations. Still others – Nineveh, Troy and Xanadu, for example – beguile the mind more as ruins than they ever did in their heyday. But ultimately, the popular reputations that cities acquire amount to little more than a collection of surface impressions, the sophistry of branding. To really know a place, you need time. And time should spool freely from the reel, released from the fiduciary grip that treats it as a valued commodity. That is what this book offers: a generous, unstinting

sense of Beijing as it is experienced by people who have lived in it for many years and understood, each in their own terms, aspects of the conversation that it conducts within its limits. The stories, memoirs and depictions collected here do not so much represent a search for the city's identity as a resignation that such a search would be fruitless if conducted in a single dimension. Beijing is better approached as a mysterious aggregation, a mélange of cultures, hopes, fears, beliefs, histories and languages; a place defined less by answers than by questions, an entity illuminated more in flow than in static installments.

In spite of its transient nature, one thing is constant. Beijing is a city of the imagination. Whether in the past, the present or the future, the force that the city exerts over the realm of possibility is all-pervading. There are rules and regulations to cover every eventuality, but uneven enforcement has made the capital of the world's largest authoritarian country into a surprisingly permissive place. The abiding questions here have more to do with what could be and what could have been rather than what is. Economic planners talk about what the future will bring, next year, in 2010 or at some more distant point when China overtakes America as the world's largest economy. Others peer intently into the past; at the city's Mongolian origins, at remnants of exquisite dynastic excess, at the patina on an old stone lion or the graceful arch of an historic bridge.

With perspectives telescoping thus from imagined futures to assumed pasts, it can be difficult to keep a purchase on the here and now. Even for those whose feet are planted on the ground, the urge to be transported is strong. When Ma Jian recalls the way that the contemporary era of Chinese literature sprang from a run-down hutong home in "Memories of No. 53 Nanxiao Lane", it is enthralling to read of a crowd of wayward Beijing youth in the late 1970s thrown together "as if by a gust of wind", debating new ideas, testing new freedoms and "engaging in depravity" – the official language of the time for unsanctioned love affairs. Who would have guessed then that this tousled group had amongst it a future winner of the Nobel Prize for Literature, and other authors (including Ma Jian himself) who were to gain worldwide recognition for their work. In "Heart of the Art", Karen Smith conjures memories of similarly historic scenes at the dawn of the Yuanmingyuan Artists' Village.

Though invisible and apparently frail, the imagination can sometimes do extraordinary things, such as transforming concrete blocks and intersections clogged with vehicles into bucolic vistas from another time. Adam Williams' Great-Aunt Ben returned to Beijing sixty-six years after her first visit in the winter of 1938-39, and found it somewhat altered. But then, one afternoon as she stood with Adam looking at a crowded crossroads, she asked for the name of the old city gate that had once stood there. "Hatamen," replied Adam, and instantly Ben was back in 1938 with a line of shaggy, swaying camels padding over the sand – with not a car or a concrete block in sight.

"And I began to wonder: do we ever see a place as it truly is? Can we ever look through the curtains that our memories and our imaginations hang over the original stone?" asks Adam in "The Camels of Khanbalik".

This book is full of such moments: poignant personal observations that illuminate not only an aspect of Beijing but also something more universal. Sometimes the experience is truly timeless. Tim Clissold was walking one day in the park around Coal Hill when he came across a man drawing characters in water with a long brush on the park's paving stones. Once drawn, each character was visible momentarily, but disappeared as the water evaporated. After a while, Tim realised that the man was writing out sections of the *Tao*, a text written thirty centuries ago as Chinese civilisation was stirring on the banks of the Yellow River. But, as Tim noticed, the words he wrote seemed more relevant to mankind today than ever before.

Other sections of the book resonate for different reasons. Catherine Sampson and Paul French give us crime thrillers, Hong Ying unveils a Beijing scene that few outsiders might guess existed, Peter Hessler relates the moving true story of a boy's illness, Zhu Wen's poetry distills impressions from his early days in the capital, Roy Kesey is mesmeric in his witty rendering of a recent epic, Alfreda Murck leads us through the captivating world of a local antiques market, Rob Gifford captures the spirit of a city girding for the Olympic Games, and Michael Aldrich delivers us into a spellbinding Mongol dreamtime. Interleaved with each of these steps on a literary journey are telling and wry scenes from everyday life photographed by Lucy Cavender with her Hasselblad.

The overall effect is far from conventional. The linkages here are not chronological, or pedagogical or possibly even logical. They are the product of a shared passion. The portrait that emerges is layered and textured, nuanced and commanding – a work that reverberates in the mind long after the book has been put aside. The only certain commonality among the authors here is that they have all – as if blown by a gust of wind – congregated at The Bookworm, a library-cum-restaurant near the Sanlitun bar area that has become a cultural lodestar for many who live in Beijing. The feelings of warmth, gentle enquiry, good conversation and a love of books that this meeting place is synonymous with are consistent not only with the content of this book but also with The Beijing Bookworm's charming and talented owner, Alexandra Pearson. Each piece contained in this book was commissioned by her and Lucy Cavender. That none of the authors were paid for the work they submitted (unless you count a bottle of whiskey each as payment) is typical of the spirit that The Bookworm invests in those that are devoted to it.

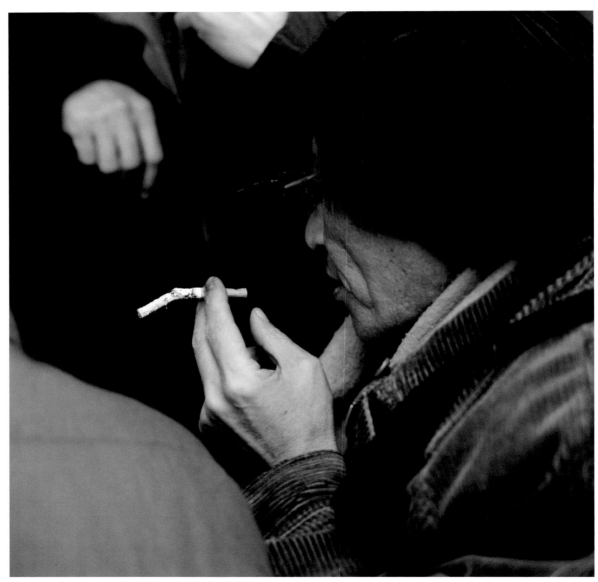

A lengthening cigarette ash measures the concentration of a card game spectator

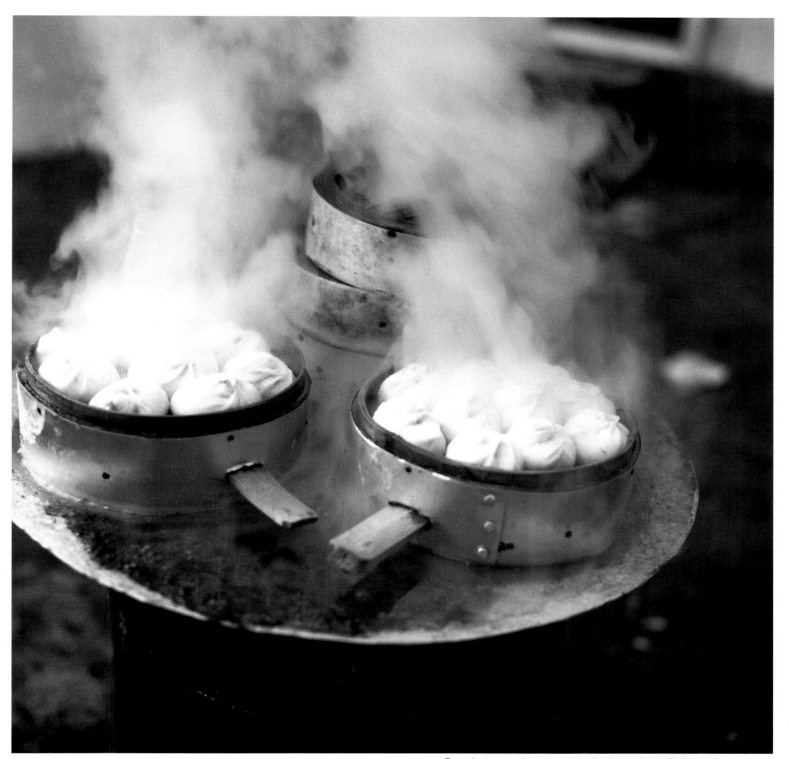

Baozi, steamed buns, a staple throughout Beijing's long winter

Zhu Wen was born in 1967 in Quanzhou in Fujian. He later moved to Nanjing to study electrical engineering, and it was there that he joined ranks with a diverse range of poets and writers. Under the collective name *Tamen*, or 'them', Zhu Wen and his contemporaries – including the poets Yu Xiaowei and Han Dong – self-published and distributed their writing, at their own expense, for more than a decade. During this time, Zhu Wen published his first formal collection of poems and began to write short stories.

In 1994, he left his job in a thermal power plant to pursue a writing career. Since then he has published six collections of novellas and short stories, two collections of poetry and one novel. He first gained prominence on a wider stage with his 1995 novella, *Wo ai Meiyuan*, a riotous critique of a society abandoning all moral and familial values in pursuit of material wealth. This was published in English as *I Love Dollars* in 2007.

In recent years, Zhu Wen's focus has been primarily as a filmmaker. His first film, *Seafood*, won the prestigious Grand Jury Prize at the Venice Film Festival in 2001, with *South of the Clouds* taking the NETPAC prize in Berlin in 2004. He now lives in Beijing.

诗
Poems

朱文 Zhu Wen

我是一种声音叫寂静

蓟门桥北，太月园边
是我落脚北京的第二站：
罗庄南里

傍晚的鸽哨每每让我想起
一件古旧的往事
未曾经历，却记忆犹新

夜深人静，读书，抽烟
突然逼近的火车声
忘我于思念远方的喜悦

我是一种声音叫寂静
像巴西木的根部，无端抽出
一条绿油油的新枝

我是一种声音叫寂静
在窗外沙沙响的树声中躺着
在正午的光线下立着

和鸽哨一起盘旋
和火车一起奔驰
听不见的声音，看不见的快乐

I am a Sound Called Silence

North of Jimen Bridge, beside the Taiyue Garden,
That's the second place that I stayed after moving to Beijing:
Luozhuang's South Lane.

The cooing of a dove at dusk recalls
A time in my past.
My experience is slim, so the memory is fresh.

In the deep recess of night, I read, and smoke.
Then, suddenly, a train's urgent clarion;
But I am lost in the ease of distant thoughts.

I am a sound called silence,
Like that of a Brazilwood's buttress root when,
Inexplicably, it throws forth a new green sprig.

I am a sound called silence,
Such as that which lies among the rustling leaves outside the window,
And that which stands upright in the midday sun.

It turns with the coo of the dove
And flees with the thundering train;
An imperceptible sound, an invisible joy.

早春二月

换一条路去菜场，
没有更近，
反而多走了一段冤枉路

买了西红柿和柴鸡蛋
还有一条乌鱼

回来的路上
想到两个人的生活
如果像西红柿炒鸡蛋

那就是绝配
如果其中一个是乌鱼

那该怎么办好
这么想的时候，我们侧身
从两条铁栅栏中钻出来

有人扶着自行车站着
等我们出来，他好进去

哎，这多出来的一段冤枉路
正好对着风口
把我们刮得一点想法都没有

February in Early Spring

We chose a new way to the vegetable market
But it wasn't a shortcut,
It took us longer to get there.

We bought tomatoes, free-range eggs
And a mullet.

On the way back
I think about the life of two people together
If it's like tomato stir-fried with eggs

That would be perfect
If one of the couple was a mullet.

But what should *we* do?
As I am thinking about that
We slide out sideways between two iron railings

And see someone standing there with a bicycle
Waiting for us to slide out, so that he can slide in.

Oh, so unnecessary, the long way home
Right into a wind
That blows our thoughts into blankness.

北方

这是北方常见的树木，
挺拔，高蹈
我不知道它叫什么，
但是已若干次的碰见.
它的名字一经说出，一定广为人知
单棵看起来象树，
两棵在一起就成林.
身上有很多结巴，
象惊愕的眼，也象青涩的乳头
没有结巴的地方又十分光滑
看了就想伸手上去摸一下
谁也不要告诉我它叫什么
让我们就这样相处个三、五年看看

The North

There is a tree commonly seen in the North,

Monumental, towering.

I don't know what it is called

But I have encountered it on many occasions.

If its name was to be mentioned, many would know what I mean.

One of them alone looks like a tree.

Two of them together make a forest.

Their trunks are covered with whorls

Like astonished eyes, or innocent nipples.

The expanses between the whorls are so smooth

They make you want to feel them.

Don't anyone tell me the tree's name

Just let us co-habit for three to five years and see how things work out.

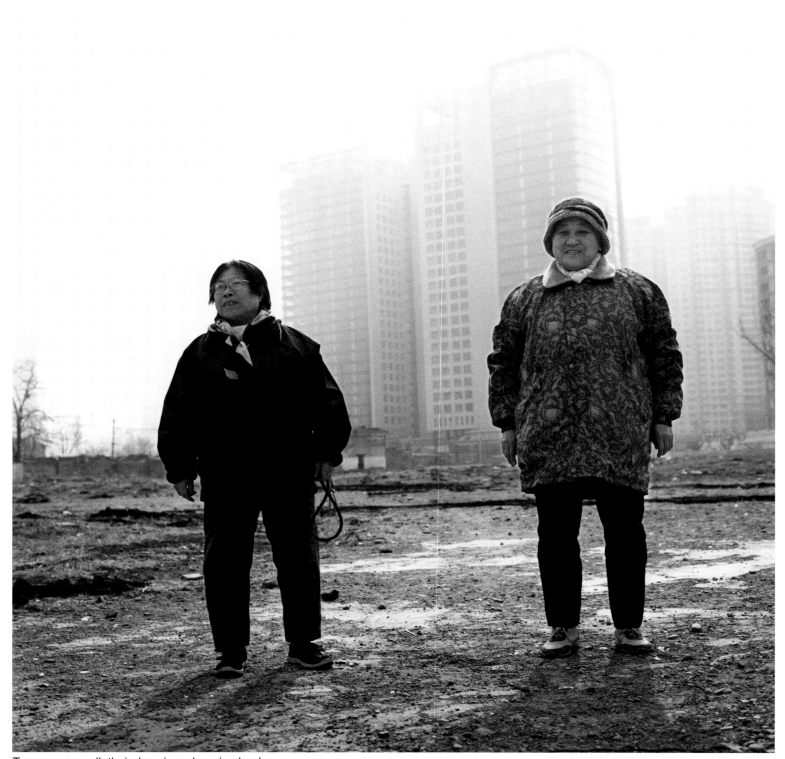

Two women walk their dogs in a changing landscape

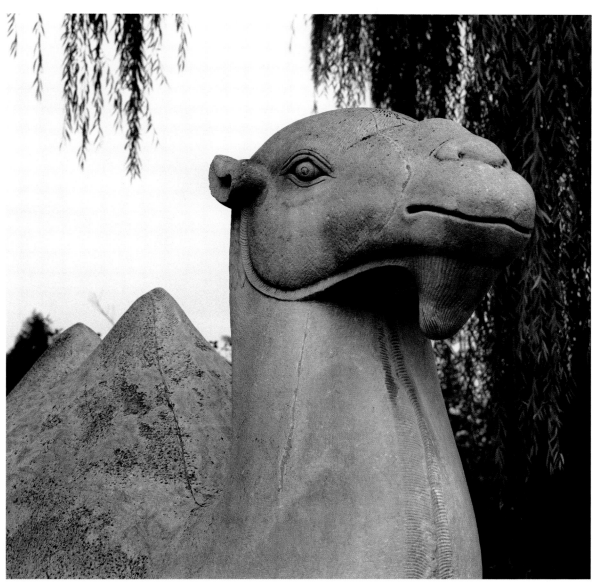

A stone camel forms part of the Spirit Way to the tomb of the Ming Emperors

Adam Williams is a businessman and novelist based in Beijing. His historical fiction trilogy, comprising *The Palace of Heavenly Pleasure*, *The Emperor's Bones* and *The Dragon's Tail* follows the fortunes of three generations of an English family, spanning China's tumultuous last century from the Boxer Rebellion until the summer of 1989.

The fourth generation of his own family to be connected to China since his great-great-grandfather first stepped off the boat as a medical missionary in 1895, Adam's richly colourful family saga is informed by his own fascinating familial ties to the country. Inspired by the tales of his grandmother and his Great-Aunt Ben, Adam's novelistic sensibilities have been fuelled since childhood by the imaginative potential of China, using it as a stage on which to explore dramas of moral choice, political intrigue and societal upheaval.

Having completed his China trilogy, and by way of contrast, Adam is currently working on a novel set in eleventh century Andaluz.

The Camels of Khanbalik

by Adam Williams

He woke on the last morning of his journey, red dawn light creeping through the cracks in the curtain. Listlessly, he opened them, and saw that the landscape had changed. The endless paddy fields were gone, replaced by the maize of the north. Yellowing leaves covered ears of corn that glistened ruddy ochre in the early sunshine. Lines of tall poplar trees marked a road, their shadows striping the sandy path. Suddenly he saw a cart being pulled by a Bactrian camel. Two little boys, in ragged clothes but with shining eyes and wide, happy grins, were jumping up and down, waving at the train. An old farmer, leading the camel, had a hand to his brow and was smiling. It was only a brief glimpse – but Harry was filled with joy, and something of his old sense of purpose.

That is the moment in my novel, *The Dragon's Tail*, when my hero spy realises that he really is about to return to his beloved Beijing after an exile of twenty years.

I didn't invent the scene. I'd seen that camel cart myself when I looked out of a train window during my own first visit to the mainland in August 1979. It thrilled me as much as it did Harry. Beijing was beckoning me. It was so close up the track that in only two or three hours I'd be walking its streets.

Beijing! Suddenly my mind was flooded with memories and associations: it was the school holidays and I was staying with my grandmother in Sussex; the dining table was set for tea, and she was telling me stories about China and the magical city that she had known as a girl...

She smiled fondly from behind the Chinese silk tea cosy, while I gazed up from my iced buns. "Did you know, darling, that your granny once walked the whole length of the Forbidden City, and the only living things I saw in there were goats grazing on the roofs?"

As a ten-year-old, I had been indignant. What right had a warlord general to throw out an Emperor from his palace, and leave it abandoned to goats?

But she went on: "I crossed the ornamental bridges in the big squares. I climbed the great terrace in the centre and looked inside the throne rooms and temples, and all this time I saw no one. On a red pillar, a mare's tail waved in the wind. The carving of a dragon rippled down steps that led me to a maze of alleys and courtyards. Do you know what they were?" (I did, and told her. I'd heard this story before.) "That's right, you clever boy. They were the private quarters of the Emperors." (Here she always smiled) "Can you imagine? Your granny, in Cixi's palace... Still I saw no one. Not even a gardener. But the Emperors' treasures were there. Oh yes, I could see them through the locked windows — beautiful windows with wooden lattice frames. I could make out precious stones, carvings made of lapis lazuli, jade and gold. And statues, strange statues..." (I held my breath and she leaned forward. We were coming to the climax of her tale) "And that was when I felt a shiver down my spine. Nothing had moved." (She was speaking ever so softly now) "Only the wind blowing through the grass tufts in the courtyard, and the light shifting through the leaves... but I sensed the presence of eunuchs watching from behind the hangings" (Her voice rose in pitch) "and executioners with scimitars hovering on the other side of the walls." (She always paused here, so I could whisper, "And what did you do, granny?") "I ran and I ran and I ran," she cried "and I heard the sound of great gates slamming behind me..."

There were even spookier tales.

She and her friends rode with pack mules to the Great Wall, passing under the desolate arch of Zhuyongguan and sleeping on *kangs* in one of the old caravanserais.

They travelled back to the city by way of the Ming Tombs. There were no crops planted there then because it was land that was reserved for the royal dead. Along the Spirit Way, statues of lions, elephants and mythical beasts called chilins watched silently over an empty plain. The party rode on, and came to a mossy wall, a crumbling tower, and behind it an emperor's tomb. Here they camped, and in the dead of night they were suddenly woken by... Well, of course I now know she was embroidering her memories with the sort of supernatural Orientalism that was the vogue in her youth, a pastiche of Daniele Varé and *Strange Stories from a Chinese Studio*. Even then I probably suspected that my grandmother never really saw ghostly green lights above the grave mounds, or heard strange singing in the trees — but I wanted to believe she did. Anyway, I asked her to repeat the story over and over again. As well as others — less evocative than her Peking tales, but all adding to my China of the imagination: I heard about her confrontations with warlords, about the miraculous escape of my great-grandfather, a medical missionary, from the Boxers and his later heroism during the Russo-Japanese War, about the great Manchurian plague of 1911 ("When silent trains from Peking arrived in Mukden station with everybody dead on board") or tales of beach holidays at Beidaihe and how my mother and godmother once climbed a sand dune and stumbled over the bodies of beheaded pirates on the sand...

I thought I'd locked away all these romantic memories of what I then, in my priggishness, considered to be my family's inappropriate colonial past. I was twenty six years old, a journalist, with my mind fixed on the

present; I knew all about post-Maoist China and what to expect. I'd interviewed victims of the Cultural Revolution when I was a general reporter on the *South China Morning Post*... but that fleeting cameo of a camel cart outside the window had undone me, and – I couldn't help it – I found myself dreaming again, as I had as a little boy.

It was the camel, of course, that was to blame.

The fact was that I had unconsciously always associated Beijing (or Peking as I still thought of it) with camels – the shaggy, two-humped Bactrian version, preferably loaded down with sacks of silk, or boxes of tea, and led by a turbaned merchant. Quite where this fancy came from, I'm not sure. It could have been an illustration from my Ladybird history of Marco Polo. Or maybe I was inspired by my father's collections of pre-War photography that he found in second-hand bookshops near the British Museum: the hauntingly beautiful portraits of city gates, crenellated walls and lines of camels plodding silently across the snow.

For that was the Peking of my reawakened imagina-tion: Kublai Khan's capital, Khanbalik. It was the city that lay on northern plains under huge Central Asian skies. Palace of the emperors, it was also the entrepôt at the end of the Silk Road, where the civilisation of China had perfectly absorbed the mysteries of its desert interior and synthesised them in great Buddhist temples, and market places, where grizzled Uighur traders sold Confucian scholars gum guggul and benzoin, frankincense and myrrh, peepuls, aloeswood, realgar, rhinocerous horn and anything else that could

be carried on the back of an animal from the furthest boundaries of the Middle Kingdom and beyond. The camel – to me – symbolised it all.

Naturally, I didn't find any of this when I eventually reached Beijing. My fairytale city had vanished along with its walls – pulled down during the Great Leap Forward.

Oh, there were traces left, here and there, in the hutongs, and the set-piece tourist sites were open. I could wander as much as I liked through the Forbidden City and marvel at the deep blue of the Temple of Heaven. Indeed, if I were only going by the pages of my *Nagel's Guide*, I might have been forgiven for believing that the ghost of the Empress Dowager Cixi was still haunting the old palaces – but she wasn't. The sardonic face of Mao on the Tiananmen Gate had replaced her.

I found I was not alone in my romantic yearnings. The few businessmen, diplomats and sinologists who constituted the foreign community in the early eighties often tried to escape into a mythical past. In summer we played rounders on the grave mounds during our Ming Tomb picnics, and on New Year's Day staff and families of the Australian and British Embassies gathered on the frozen lake of the Summer Palace for a cricket match, roasting chestnuts between the overs to keep warm. It was all nostalgia and homage to what we imagined were the good old days, when Boxer-era diplomats like Sir Claude MacDonald commandeered temples in the Western Hills for weekend bungalows. But we couldn't avoid the reality for long. Foreigners lived in ghettoes; any communication with a local

might be reported by a neighbourhood committee. The city we saw around us had become an ugly, uniform cluster of brick-built workers' blocks interspersed with dusty, treeless avenues. Clothing was drab – uniform blues or browns. Everybody appeared to be malnourished. There were ophthalmic eyes and belts wrapped twice round the body, and in the corner co-ops there were long queues for meagre cabbages. The Democracy Wall movement, which had briefly risen up and shaken the Communist establishment, was on its last legs, with its leaders arrested and tried. There had not yet been any official verdict on the Gang of Four, let alone the Cultural Revolution, and its victims were still living cheek by jowl in factories and apartment buildings with their former persecutors. There was a tired, joyless atmosphere about the city; the inhabitants reminded me of survivors trying to pick up the pieces after a devastating natural catastrophe (in their case one which had been political and man-made).

And there were certainly no camels (if you discounted the sad, mocking specimen that waited at Badaling for tourists to mount as part of their Great Wall experience). There were only bicycles, hundreds of them, thousands of them, a constant motion under a cloud of dust, faces wrapped in gauze and sunglasses over the eyes, cloth caps pulled low over the forehead, soft slippers pushing the pedals, blank expressions, each cyclist isolated from his neighbour, concrete and brick buildings looming hazily behind.

And gradually I realised that my private emblem for Beijing was antiquated. Bicycles ruled now, not camels. Sometimes it was comic (the bicycle crash in the hutongs, followed by the ritual exchange of curses in teapot posture, one arm curled, the other pointing like a spout, ending only when one of the combatants anxiously gestured the crowd to restrain him, shouting "Don't hold me back. Don't hold me back."). More often it was melancholy: those creaking silhouettes, wheeling through the rush hour haze, a reflection of the Workers' Paradise that had failed to deliver.

Changes occurred, the winter of ideological Communism thawed: slowly at first, then in torrents. Imperceptibly, the drab city metamorphosed into something modern and flamboyant. A few years ago it began to tone up for the Olympic Games, like a wrestler oiling himself before an expected triumph.

By then I'd been resident for twenty years. I never did find my beautiful city – concrete and smog are not aesthetic, despite any amount of expensive new buildings – but it had become home for me. I'd raised a family here, my work for an old China trading house was still challenging and, not being a golfer, I had begun to write novels on weekends.

One thing I had completely forgotten – or thought I had – were my camels.

Until spring 2005, when I received a visit from my ninety-three-year-old great-aunt, Ben.

•••

It was her second trip to Beijing. The last time she had been here was sixty-six years before, during the winter

of 1938-39. That had been a holiday too, but to a very different sort of China, in a world that was on the brink of war. Her adventure started when a banker friend of her father's invited her to spend Christmas with his family in Tientsin (or Tianjin, as we spell it today). She left her quiet existence in the beautiful Vale of Clywd, booked a passage on a liner, and eventually found herself in a smoky, mercantile metropolis, intersected by the dark, sluggish waters of the Pei Ho.

The banker and his limousine picked her up and took her to a mansion concealed in a leafy drive off Race Course Road. There she found seven cooks and house servants, nine gardeners and two chauffeurs. Close by was the Country Club, where, the banker told her proudly, she could meet "all the best people." Every morning she strolled there, along the bank of the canal, walking the banker's dogs, and it was not long before she realised that membership of this unremarkable-looking institution – it was as if a suburban golf club had been transplanted from Camberley or Esher – opened the doors into an undreamed of world of luxury, privilege and excitement.

And the tweed-clad people she met there welcomed her as "the right sort", "a good sport". She was able to teach the hungry exiles the latest dances from London. On New Year's Eve she led them in the Lambeth Walk. In return, the doors of the city were opened to her. In the evenings she attended dinners or balls, followed by wild car drives in the early hours and parties until dawn in the White Russian nightclubs. There were days at the Races, and gymkhanas on the weekends. There were exciting excursions into the flatlands and

marshes, duck shooting and paper chases, and trips up the railway line to the ancient capital, Peking. Her two months in China sped by magically. She met few Chinese, but the friendships she made with fellow foreigners were enduring ones.

One of these friends was my grandmother, who introduced her in turn to her brothers, the second youngest of whom, after the War, she married. And that was how Ben became part of our family, and my favourite great-aunt. Today she is the last of that elder generation, surviving my grandmother and her brothers, and even my father and mother, preserving in her cottage in Wales the memories of our China heritage.

•••

In 2005, she was sitting in my house in Beijing, her humorous eyes fixed on the television screen. The evening of her arrival, Wales was playing Ireland in rugby so she insisted, despite her years and the fifteen-hour plane journey, that we stay up and watch the match. At three in the morning, she was applauding Wales' victory, while the rest of us had fallen asleep.

Next morning she was up early. Her energy and enthusiasm had no bounds. She wanted to see everything, and nodded merrily, her slight shoulders hunched under her shawl, as we took her round the famous Beijing sites, but I knew where she really wanted to revisit, so one day I drove her east down the Beijing-Tianjin-Tanggu Expressway. As the road signs whipped by, I wondered what she, and I, would discover

down this memory lane. Her first recollections were startling. Just after we passed Tianjin station, we came in sight of the old iron drawbridge across the river built by British engineers at the start of the twentieth century (predictably the communists had renamed it Liberation Bridge). Suddenly Ben leaned back in her seat and began to laugh. "That sends me back," she said.

"You remember this bridge?" I asked her.

"I'll say I do," she replied. "The last time I crossed it must have been three o'clock on a winter morning in 1939. I'll never forget the expressions on the faces of those Japanese guards."

"Japanese guards?"

"Oh, yes," she said. "Don't you remember? The city was occupied then. You had to be very polite to the conquerors. Get out of the car and bow. At least that's what the foreigners had to do. It was much worse for the Chinese. Baseball bats and buckets over their heads for them." She shuddered. "Horrible." Then she smiled again. "Well, we weren't so polite that night. We'd been at the Forum. You know it? That fabulous nightclub in the Russian Quarter, the one that had the Can-Can girls? I was being driven back by a couple of Frenchmen. Don't know who they were. Only just met them. I do recall we were all a bit tipsy. Anyway, the driver, an attractive young man, when he saw the Japanese soldier come up with his bayonet, he wasn't having it. Not him. 'En avant!' he shouted, and put his foot down on the accelerator. We scattered them, simply scattered them, all those puttees and helmets,

rifles and samurai swords – and we drove off into the night, in a hail of bullets and laughter!"

We had lunch in the Astor House Hotel in the same dining room that she remembered from before the Second World War and she showed me the coffee room where she used to meet my grandmother. We drove up to the old racecourse, and tried to identify the banker's house where she had stayed. In that we failed, but we did find the country club. Now it is the centre-piece of a whole villa complex for retired cadres. We weren't allowed in but we wandered over the lawn, and, standing outside those mullioned windows of the hall where after one New Year's Dinner she had taught the members the Lambeth Walk, Ben was content. I was sure that, for her at that moment, the past lived more strongly than the present.

And I began to wonder: do we ever see a place as it truly is? Can we ever look through the curtains that our memories or our imaginations hang over the original stone?

Nowadays I often notice that visitors from the West, coming here for the first time, are a little surprised by what they see, or rather, what they don't see. "I had expected more cyclists on the road," they murmur, or "So they don't wear Mao suits any more?" Considering the fact that there is no country on the planet more covered by the media than China, with a new documentary on American or European television about some aspect related to China every week, it is odd that the preconceptions of what is to be found here are not more up to date – but no, it seems that whatever penetrated

the new arrivals' consciousness in their earliest youth prevails. For a whole generation of Westerners slightly younger than me, the first images they saw on their TV screens were of the drab, post-Mao China, when China was beginning to modernise. So, much as I sought camels, they are still today subconsciously seeking bicycles. How ironic, I thought. The reality that had done away with my nostalgic fantasies had over time become theirs. But that seems to be the way it works. I don't know what emblem the next generation of newcomers will choose – Bar Street in Sanlitun? One shudders.

I began to wonder, looking at my nonagenarian great aunt, what image of Beijing had she in her mind when she first came here so long ago?

On the day after our Tianjin trip I took her to Beijing's newly restored Tatar Wall. It is only a kilometre long and it is all that remains of the battlements that once encircled the city. It is more Disney-fication than preservation of cultural heritage, because actually the destruction of the city wall in the revolutionary 1950s was absolute. Still, this ersatz copy of the old Hatamen Gate serves the municipal government's purpose to give Olympic tourists a whiff of the old imperial city. And I was curious to see if it would stir any memories in Aunt Ben. As we sat on a bench on the lawn by the new/old gate, I asked her, had she ever envisioned that she would come across great walls like these when she first came to this city sixty-six years ago?

"I suppose I imagined something like it. Our impressions of the mystic Orient were very much guided by

Hollywood in those days." She chuckled. "Great gates and clanging gongs, Aladdin, Douglas Fairbanks, Anna May Wong and the Arabian Nights…"

"Surely you had some idea of what China would be like?"

"Not really. I'd seen illustrations in children's books: sampans, pigtails, kites, that sort of thing. Oh, and prints and drawings of the tea trade in old leather books, but it was all very much China of the nineteenth century, and it was totally different when I got here. Well, they still flew kites. I saw plenty of those."

"They fly them today in Tiananmen," I said. "What impression of Peking did you come away with once you had seen it?"

She frowned. "Dirt, smells – it was all a bit shabbier than I anticipated." Her face suddenly brightened. "There were the camels, though. They were marvellous."

I felt a trickle down my spine. "Camels?"

She laughed. "What did you say the name of this gate was? The original one that was here?"

"Hatamen," I said. "It was the one that led into the Legation Quarter. There was a market here too, I think. It was the place Varé called *The Gate of Happy Sparrows.*"

"Then I think it's the very one," she said firmly. I waited for her to explain, but her pale eyes were searching the

procession of cars on the big tree-lined avenue and the tall, white skyscrapers beyond.

"It was just sand outside the gate in those days," she said. "Sand and muddy clay, and a big dry moat. The camel trains used to plod by on the edge of it. Great swaying creatures, with long, tousled hair. There." She pointed towards the traffic lights. "That's where the camels were. And we commandeered them. For a laugh."

I stared at her.

"We'd come up for the gymkhana, you see, and were dressed in our riding clothes, and suddenly, there were all these camels. So, naturally, we decided to race them, right there and then, alongside the city walls. Madcap fools that we were."

"You rode camels here sixty-six years ago?"

But she was not listening to me. Those staring eyes no longer saw concrete buildings and traffic jams. She appeared to me to be in a parallel world where she had travelled back in time, and was looking at sand and camels.

And I gave up the battle, defeated. Reality, I decided, is only what you want it to be. Imagination can transform a city.

Everything that was once beautiful may be obliterated – but the mind has the power to recreate it: the child's mind, that prefers to live in stories, or the minds of the very old, whose memories you can share, and by so doing bring back the past to co-exist with the present – if only you want it badly enough.

And I realised I did.

So sitting under the reconstructed city walls with my Great-Aunt Ben, I spent a happy half hour in Khanbalik, looking at camels.

Tomorrow's Beijing takes shape

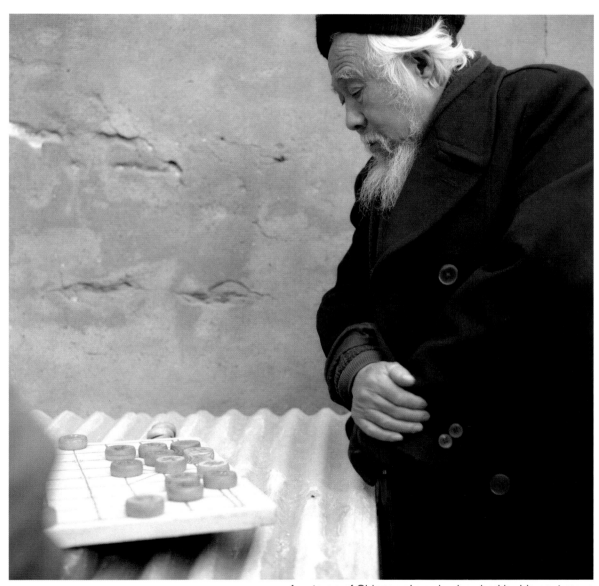

A veteran of Chinese chess is absorbed by his next move

Roy Kesey grew up in northern California, but moved to Beijing with his family when his wife, a diplomat in the Peruvian embassy, was posted to China in 2003. A writer interested in more unusual forms, his short fiction and 'dispatches' have appeared in more than sixty magazines, anthologies, and literary journals both in print and online, including the celebrated *McSweeney's*, *The Georgia Review* and *The Future Dictionary of America*.

Roy's rich and challenging novella, *Nothing in the World*, set during the Serbo-Croatian conflict in the 1990s, was selected for publication after winning the Bullfight Prize for previously unpublished shorter fiction.

A busy year for Roy, 2007 saw both the publication of his first solo collection of short stories, *All Over*, as well as his inclusion in the much-feted anthology *Best American Short Stories*.

Loess

by Roy Kesey

A few questions first, if I may?
– And of course.
– Fine, then. The goal?
– There are two: the overthrow of this world, and the construction of the next.
– Right. And what, may I ask, are your qualifications?
– I have read the classics, farmed rice, kept accounting records. I was a soldier for six months. I applied and was accepted to police school, law school and soap-making school but did not attend. I went to business school for a month. There were other schools as well. Then I became a library assistant. During winter holidays I walked through the countryside, and took rain-baths when it rained. Also I have edited newspapers and organised certain organisations.

– Outstanding.
– Are you with me, then?
– Entirely. Will we work together or in parallel?
– For now you shall go and I shall stay, and in our respective places we shall organise still more organisations. Then you will return, and we will ally with our domestic enemy against the foreign invaders; I will help to plan uprisings for you and others to lead, and they will be wildly successful and then fail horribly as the alliance dissolves. You will be captured by our domestic enemy, and your execution order will be signed, and a former student of yours will help you to escape; I will also be captured, and my execution order will also be signed, and I too will escape, and hide in tall grass until nightfall, and slip away. Nearly all of the members of our organisations shall subsequently and quickly be slaughtered. Is that alright with you?
– Perfectly. To work.

It was not simple, but it was managed, that which has been mentioned, and other things: a flag was raised, and an army. Thought was remolded, forcibly when necessary, and of course the domestic enemy began extermination campaigns. The foreign invaders took the northeast, and in the northwest there was famine, men and boys standing beside roads, their stomachs swollen with dirt and bark and sawdust, men and boys only as the women and girls had already died or been sold; men and boys standing naked having exchanged all possessions even clothing for food and they stood and the sun weighted their skin and they stood and their eyes closed and still they stood and then died: several million.

Extermination Campaigns One through Four were turned back, the defenders successfully melding elasticity and mobility, secrecy and ambush. During the Fifth Campaign, however, these requisites were mislaid; the domestic enemy routed and chased them, and executed their families, and likewise killed or else relocated all others who lived in areas under dispute, the short-haired and/or large-footed women all killed, and the long-haired, small-footed women made concubines, and the children called war orphans and sent as slaves or prostitutes to cities, and when a million more were dead it was time for another plan.

– We cannot stay here any longer.
– And where will we go?
– Northwest, to the cradle.
– But our domestic enemy lies wholly between it and us.
– So we shall travel circuitously: six thousand miles of

walking and fighting, walking and fighting.

– But most of us are shoeless!

– Unfortunately, yes.

– Through twelve provinces...

– And over eighteen mountain ranges, and across twenty-four rivers.

– Walking and fighting and climbing and crossing without rest?

– Of three hundred and sixty-eight days we shall spend two hundred and fifty marching; we shall skirmish daily, and fight fifteen major battles, but otherwise, yes, rest, though even that rest will be not rest but sharing, speaking with those through whose lands we walk and fight, and we shall need a way to convince them not only to join us but to lose their very them-ness and subsist in all five senses of the word in us-ness, not one-of-us-ness but us-ness itself...

– Perhaps... Perhaps theatre!

– Theatre! With messages!

– Anti-foreign-invaders-and-domestic-enemies, for example.

– And pro-us.

– Superb, but we precede ourselves. The four lines of domestic enemy defensive works, their nine regiments, how will we—

– Walking and fighting, walking and fighting. We shall march at night when possible; the wounded will be left behind with those few who can be spared to fight rearguard, two years or three, as long as they last, and any leaders caught then paraded naked in bamboo cages and beheaded. Once through, a feint south, then a push west to the first of the rivers, a doubling-back, a ploy, a quick battle, and we'll all be across in nine days.

– What then of the Lolos?

– We shall ally with them, and follow them on and through to the Tatu. The river will rise and swell and rage as we ferry much of our army across on three boats left stupidly unburned. There will be constant aerial strafing as of the third morning, and the domestic enemy will push hard towards us, and no choice then for those not yet across but west to the Bridge Fixed by Liu.

– Liu!

– Liu. Those already crossed shall fight and we shall race but the domestic enemy will arrive first, will remove all planking from our half of the bridge, will emplace machine guns.

– And then?

– The chains. Volunteers, hand over hand, and they shall mainly be annihilated, but one shall make it halfway across, shall then hang beneath and be protected by unremoved planking, shall throw grenades and shout terms of encouragement, the bridge will be ordered burned but too late, those already crossed will arrive and the enemy will run.

– That is fortunate.

– Very.

– Then the highlands and mountains.

– Yes, and here many more shall be lost to the cold, the fatigue, the precipices. But there will also be things worth taking from those with too much: ham and duck and salt.

– Duck!

– Precisely.

– But what of the Hsifan, and the tribal Mantzu?

– They shall roll boulders upon us, and we in turn shall steal and eat their wheat, their beets, their massive turnips. Many too will be lost to the swamps, and there

will be no shelter from the rain, and there will be no fire to cook our food or warm our bodies, but the cradle will at last not be so distant.

– And having once arrived—

– After several more battles here undescribed—

– Where exactly will we live?

– In the caves.

– Cave-caves?

– Loess caves!

– Loess, of course, loess. But will there be enough of them?

– We shall not need so many by then.

– Heavy losses?

– Eighty percent.

– Disastrous.

– Disastrous indeed, but survivable.

It was not simple, but it was managed, that which has been mentioned, and other things. The caves were temperate and dry, and soon were fitted with floors of stone, rice-paper windows and lacquered doors. The lower loess slopes fluted down towards fields of wheat, corn, millet; the hills themselves were twisted and scored by water and wind, and with the changing of the light became brigantines, ballrooms, battlements.

New preparations, then, and new organisations: the Young Vanguards, the Children's Brigades, the Elder Brother Society. Large-footed women cleared and planted; small-footed women pulled weeds and collected dung. And of course all that was owned by those who owned much was taken: goods, crops, land. Old poisons were drained, and all doors replaced when soldiers left homes they had been lent. Mass justice

took the form of executions. Factories were looted for necessary machinery. Handbills, dropped by the enemy giving bounty amounts for each leader, were flipped and bound for schoolbooks.

The question, now, was time and how to fill it. Responses: classes on reading and writing, and political lectures, each student bringing his or her brick to answer the lack of chairs. There were public health and factory efficiency competitions. Clay models served as instructional aids for history and geography, strategy and tactics, anatomy and surgery. There were broadsheets giving praise, criticism and something a little like news. There was ping-pong. When military circumstances permitted there were group walks into the hills, gazelles and buzzards to watch, and hot water was drunk, and it was called white tea. There were card games, war songs sung to the music of old hymns, and of course always theatre, needed greatly now as policies occasionally changed: in the first act of each play the old policies were followed and errors were thus committed and hundreds died theatrically; in the second act the new policies were followed and the result was triumphant marching.

Throughout all this there were small attacks on their base. Then the domestic enemy leader was seized by his own generals while organising Extermination Campaign Number Six. He was not released until he'd agreed to desist, to ally, to attack the foreign invaders instead. The invaders however did not wait for the allies to arrive; they schemed at the Marco Polo Bridge, came in full and took half the country. Soon on other continents too there were millions on ships and in

tanks and on foot dying, and the war here against the foreign invaders became part of that greater war, a war that took all the world. This greater war ended well, the invaders driven now wholly out, new bombs dropped by greater allies, the no-longer-invaders disappearing in smoke, their shadows burned into their concrete.

– And now?

– Another war.

– The domestic enemy again, yes. Will they be definitively defeated?

– It will take three years, but in the end the remnants will be driven to an island, and the remnants will pretend to be us, but they will not be us, and the world will be made to know.

– Peace, then.

– Yes.

– Stability at last.

– Also.

– The world overthrown, you and I together as before, all else below us and time for a construction of the new.

– Though for a project of that nature and size, perhaps we would do well to invite the participation of others.

– Others, yes, to make manifest that which we design. A Minister of Commerce! Of Education! Of Industry!

– These yes of course, but more importantly, no fewer than four hagiographers. And someone to rewrite all literature. And a former emperor to garden. Also...

– Yes?

– Also...

– Is something wrong?

– Also... Yes. Beyond the peace... It is as if I cannot see.

– I can.

– Can what?

– See beyond.

– But how?

– The gift, simply, has been given.

– And? How will it go?

– You shall begin well, abolishing the sales tax, the camel tax, the salt carrying tax, the salt consumption tax, and also the taxes on pigeons, middlemen, land, food, special food, additional land, coal, pelts, tobacco, wine, stamps, boats, irrigation, millstones, houses, wood, marriage and vegetables.

– Magnificent!

– But you will also have certain other ideas.

– Will they too provoke happiness?

– Those with differing ideas will be accused of mistakes of subjectivism, of economism, of reactionary and feudalistic atavisms; you will order them killed or imprisoned.

– Yes, but my ideas, will they provoke happiness?

– You shall stage your own foreign invasion of a nearby land filled with glaciers and temples and yaks so as to secure hydrological resources in perpetuity, infuriating actors and actresses everywhere.

– Their opinion is of no consequence.

– You will have the entire country making steel in their backyards.

– Steel is important!

– All other work will be abandoned; factories, schools and hospitals will close, and the crops shall rot in the fields.

– Oh.

– In the following years, unfortunate droughts shall occur.

– Ah.

– Perhaps forty million will die.

– That is a large number.

– Immense, yes.

– We have many to spare, however.

– Spare?

– And we can always tell everyone that it was nonetheless a success.

– That is an option, yes.

– And then?

– Your power shall be reduced, and things shall be returned to how they were before your steel idea insofar as that is possible.

– Unthinkable!

– Yes, but true. However, you will subsequently recover much of the power you had lost.

– Excellent.

– Well...

– What?

– You shall apply all your remaining energy to designing and implementing a new system of primary education; soon enough the children will be very young adults who will praise you, and act vastly in your name.

– They will perform great feats?

– Feats, at any rate. They shall worship you, shall announce that all you say is true. You will disappear, then return, and employ them to destroy all who oppose you.

– That sounds alright.

– In a manner of speaking. Unfortunately you shall have additional ideas.

It was not simple, but it was managed, that which has been mentioned. Also, other things. A play satirising their leadership gave the necessary opening; gambits were played, counterattacks organised, tentacles extended. The result: eleven million teenagers now held all practical power. Playing hooky pleased them, as did the establishment of tribunals and the meting out of punishment. Intellectuals were of course pilloried first. When there were no more intellectuals the teenagers went simply from house to house, even into their own houses, and brought their families forth. The chewing of broken glass was obligatory in certain circumstances, and of course millions died.

All who might at some point provide opposition were re-educated in labour camps. Classical musicians were made to play outdoors in the rain to keep sparrows from landing on branches; economists were made to catch cockroaches, and to count them; and all were made to make bricks, and paint asphalt streets, and dig large holes.

The teenagers smiled at the police and the army and bade them crawl. They set fire to libraries and museums, temples and mosques and churches. Any who did not now participate or cheerlead were likewise pilloried, or sent to the provinces to shovel manure, or obliged to write about the wrong things they liked, such as Mozart, that they might better be criticised for liking wrongly.

– That was unfortunate.

– Yes, and it is not yet quite finished.

– Is there to be a future upside?

– You shall continue to be praised as a god for a time.

– Alright then.

– Though in fact by this point you shall be only a figurehead.

– And who will hold true control? You?

– No. Others. I shall try to slow the worst of them. A coup will be attempted, but you will escape, will still have certain allies, and the coup leaders will be caught and disappeared. Later, other rivals will emerge; by then you will be mainly insensate in all three senses of the word, and I shall just barely defeat them, and the worst of it shall be over.

– And we rise again?

– No, we die. Me first, then you.

– But afterwards our works live on?

– For a time. Then they are repudiated. Then they are ignored. Then they are forgotten.

– Will we at least be remembered?

– Your body shall be preserved, though not much later everyone will wonder … Why? Our names, of course, our names will be remembered. Hundreds of millions of copies of your sayings will have been sold but will now be seldom read.

– And who will then lead?

– The man who shall establish the Two Whatevers.

– These Whatevers, they will be successful?

– No. And he who established them shall not last long; curiously, the next man to lead will be one whom we regularly demoted and often discussed eradicating but never quite did.

– Will he lead well?

– In some respects, considering. He shall rehabilitate many in need, though nearly all those who thought will be gone irrevocably. After him there will be others, and the same shall be said of them. By then your sayings will be tourist curiosities. Those who destroyed in your name will be tried and imprisoned and executed where practicable. Your mistakes will continue to be condemned. Martial law will be applied at times, and new protestors suppressed – in this at least things shall be consistent.

– I had hoped for better.

– I know.

– Ah, well.

– Indeed. There is always the further future, of course, though it cannot yet be seen.

– Onward, then.

– Onward, yes, onward.

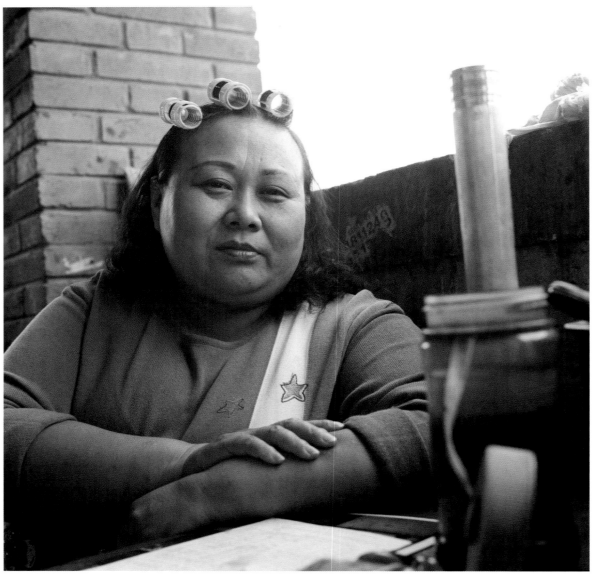

This Beijing resident fought to stay in her downtown home, but it was eventually bulldozed by developers

Cabbages are stored on courtyard walls in winter

Ma Jian was born in Qingdao in 1953. He moved to Beijing to work as a photojournalist for a state-run magazine in the late seventies, where he was soon to find himself at the centre of a vibrant – if underground – literary and creative community. The political climate of the time was unsympathetic to those living such lifestyles, however, as Ma Jian and his fellow artists and writers would discover. In 1983, he embarked on a three-year journey around China, the basis of which became his seminal travelogue, *Red Dust,* which won the Thomas Cook Travel Award. Immediately banned in his homeland, the memoir saw Ma Jian accused of spreading "spiritual pollution", doing little to endear him to his neighbours in Nanxiao Lane.

Failing to resettle in Beijing, Ma Jian moved to Hong Kong, returning on a wave of optimism for political change in the spring of 1989. He left again for Hong Kong in 1991, eventually moving to Europe in 1997. He continues to live in London with his partner and translator, Flora Drew, in reluctant, yet self-imposed exile.

Ma Jian has written nine books – including novels and collections of short stories and essays – largely documenting the struggle of China's poor and disenfranchised. Best known in English for *Red Dust*, *The Noodlemaker* and *Stick Out Your Tongue*, his writing – powerful, unremitting and often shot through with humour of the blackest kind – has led Nobel Laureate Gao Xingjian to describe him as "one of the most important and courageous voices in Chinese literature today."

中国现代文学艺术的启蒙地
记北京东直门南小街五十三号

The Cradle of Modern Chinese Literature
Memories of No. 53 Nanxiao Lane

马 健 Ma Jian

北京的胡同在国内挺有名，许多人物和故事都是从这些又窄又长的胡同子里冒出来去书写历史的。南小街在东四十二条和十三条之间的巷子，两辆汽车刚好可以擦身而过。到了下班时间，由于人车混杂，常常交通阻塞。

坐在南小街五十三号的屋子里，可以真切地听到公共汽车停下，售票员拍着车门呼三喝四的声音。这间房子夹在两座楼的中间，不时会有从"天"而降的蛋壳、白菜叶以及鸽子粪。有一次竟然掉下来一盘爆炒腰花，估计是变了味，倒给我处理。除此之外，小院子和屋顶还算安静。我在这间大屋子里画画、写作、睡觉和"搞腐化"。

站在院子里可以看见一棵大槐树，秋天来临，它的叶子和断枝落满屋顶和院子。冬天是这里最安静的时候，四周的邻居把门窗封起。在有雪的日子里，小院甚至有些怀旧情调。

虽然这是一间又破又旧的房子。但一帮又一帮的画家、作家、诗人，以及各种各样"离经叛道"的哥们经常来到五十三号聚会。好多梦想在这儿诞生，理想从这儿策划，幻想也在这儿不着边际地讨论。

在七十年代末期，我们这些北京青年，神使鬼差地聚在一起，像是被一阵什么风吹着走。那时候，艺术家本身也不能确定这些语言的开放、大胆，自由地想像可以带来改革开放。第一个跟外国人走在街上的进了监狱，很快就有第二个更大胆的出现。一批与外国人恋爱的青年判了刑，又有一批涌出来，两个人走在一起被抓，马上就有无数人干脆去外国的大使馆，去外国人的家，每天都有新突破。多少爱情和残酷都交叉出现。有的多年后成了现实，有的被忘却。留给南小街的只有一些零碎记忆。

这也是一个文学艺术家的大本营，在这里呆过的人有：高行健、谭甫成、石涛、贝岭、李陀、徐虹、付惟慈、刘湛秋、王志平、周舵、岛子、赵文量、杨雨树、雪迪、姚霏……多的写不下。

在北京还是一片僵化的时期，这里有信任，有理解，有共同的心理暗示。谭甫成在这里住得最久，完成了他最著名的中篇小说《高原》。很多艺术家的手稿在这里诞生和交流。我的主要作品都在这里完成。刘索拉的《你别无选择》也在这里传阅，后来由李陀帮忙发表。他也就成了一位没有理论的"理论家"了。高行健在这里谈现代文学的创作手法，谈他的《绝对信号》，马原在这里谈他的小说收尾，翻译家付惟慈则把他的新作《月亮六便士》介绍给大家。周舵经常从美学谈到政治经济学。他还启发我听歌剧，我也教他画素描。我的画挂满了屋子，连"地毯"也是一大张油画。因此，来宾往往要对画评论一番，好多作品往往不知被谁摘走，有时我干脆在屋里办画展。直到现在我也搞不清楚有多少人有这房间的钥匙。在改革开放以前的四人帮时代，我们的聚会是非法的。那时，半夜走在街道上本身就很危险，特别是二、三个人一起，经常会被抓走。关在派出所，第二天下午左右才能放出来。在南小街五十三号，同仁们可以谈论思想、交流作品，把手稿集中出油印诗集；策划展览、诗会，互相通报最新的开放程度，以及某某人被抓走的消息。

本来五十三号就处在众目睽睽之下，再加上经常人来人往，又放音乐又唱歌，更成了"小脚侦辑队"的"重点保护对象"。记得有一次我和石涛、贝岭几个朋友喝多了酒，在院子里摔起了跤，没过五分钟，公安局的警车呼啸着停在门口，跳下来的警察把我们全部堵在屋里里，一个个地查对证件。当时石涛和他的女朋友正在布帘后面拥抱，警察拉开布帘时，他正进

入水深火热之中，腾出手又拉上，警察不急不慢地又拉开。直到他睁开眼看到帽子上的国徽为止。有证件的留下了，仅抓走几个没证件的，我这才明白，群众的眼睛是雪亮的。后来去了几趟派出所了解内情，那里的朋友告诉我，不要在院子里胡闹，他们接到告密电话说我们在院子里打架，而且是男男女女鬼混在一起。

那个年代，人们要想表达内心的情绪，聚会诉说交流观点是唯一的途径，改革开放也是在这种控制下一点点破茧而出。虽然有些人做出了牺牲，对中国社会而言还是起到了推动进步的作用。

终于，第一个民间画会—"无名画会"，在官方允许下成立，紧接着又一个民间画会—"星星画会"也公开展出。自发组织的"四月影会"打破了近四十年的禁锢，展出了社会的真实写照，第一部现代主义的小说谭甫成的"吉尔特走向世界"在高行健的策划下发表了。人们开始明白了创作可以用"自由"这个字眼，而"爱情"这个词也光明正大地登在了官方的文学刊物上。

封闭了近四十年的中国社会，渐渐开始松动。当邓小平和国家主席华国锋为形势所迫，不得不批准了李爽和法国人结婚，改革开放的速度一下子晋级到了政治和群众的阶层了。当人们可以从嘴里讲出外语，而不被斥骂崇洋媚外的时候，自由引来的民主效果就不可避免的发生了。中国的大门开始打开了。

当初在南小街五十三号偷偷聚会的人如今都卷进了开放的海潮中，扮演着各种各样的角色。有可能因为观点和派别使他们互相不再来往，但是，南小街五十三号会使他们有缘聚在了一起，使个人的观念有可能成为文化思潮，并渐渐地由地下走入光明正大的街道，

在社会上传开。由此你可以明白，很多思想和文化都是这样从一间房，一些聚会逐渐萌发和形成的。南小街５３号经历了几次运动，特别是"反资产阶级自由化"和"反精神污染"，还是完好地立在那条街道上，离清末启蒙运动的重要人物梁启超的故居仅百多米之隔。反资产阶级自由化一开始，我就被抓走，然后抄了家。那用纸糊的顶棚，因怀疑有什么资产阶级内容的东西藏在里面而被撕下来。露出些混和着稻草的旧墙灰。上面的老鼠也只好搬入更阴暗的地方去了。历史就这样一步步地往前走，街道依旧静立无语，它默默记载着人世沧桑的变迁。

Beijing's hutongs are well known in China – many famous personalities and stories have emerged from those long, narrow alleyways and entered into history. Nanxiao Lane lies between Dongsi Twelfth Street and Dongsi Thirteenth in Beijing's Dongcheng District, and is just wide enough for two cars to squeeze past one another. In the early evenings, the confusion of people and cars often blocks the lane entirely.

The tiny courtyard house I used to live in was at No. 53. When I sat inside it, I could hear buses stop outside, and conductors shouting and banging on the bus doors. The house was tucked between two taller buildings, and occasionally egg shells, cabbage leaves or pigeon droppings would fall into my yard. Once, a plate of fried kidneys dropped down. I presumed they'd gone off and the owners wanted me to deal with them. But usually my little house was quiet. It was a one-room shack with a tiny yard. I used the room for painting, writing, sleeping and what was referred to at the time as "engaging in depravity".

There was a large scholar tree outside the courtyard's walls. In early autumn it would litter my yard and roof with leaves and broken twigs. Winter was the quietest time as my neighbours would seal up their doors and windows. When it snowed, the house recaptured some of the flavour of old Beijing.

Although the house was old and decrepit, crowds of young painters, writers, poets and hangers-on would regularly gather there in the late seventies and early eighties. It seemed as though we'd been thrown together by fate, caught up in the same gust of wind. Many dreams, ideals and fantasies were hatched and discussed within its four walls. At the time, we weren't certain whether our avant garde experiments in literature and art would prompt China to open up. After one of our gang was jailed for daring to walk down the street with a foreigner, another fearlessly repeated the crime. Soon, members of our gang progressed from walking down the street with a foreigner to actually moving into their apartments or ambassadorial residences. They became more and more audacious by the day. The love stories usually ended badly, though. Some of the relationships survived, but most of them were forgotten, leaving Nanxiao Lane only a few scattered memories.

Many writers came to the house, including Gao Xingjian, Tan Fucheng, Shi Tao, Bei Ling, Li Tuo, Xu Hong, Fu Weici, Liu Zhanqiu, Wang Zhiping, Zhou Duo, Dao Zi, Zhao Wenliang, Yang Yushu, Xue Di, Yao Fei... too many to list.

In those repressive days, No. 53 was a small haven where writers could go to read and discuss each others works. Tan Fucheng camped in the house for several months while writing his famous novella, *The High Plateau*. Several of my early books were completed there. Early copies of Liu Suola's *You Have No Other Choice* were passed around there, and later Li Tuo, the 'theorist' with no theories, helped get it published. Gao Xingjian came to the house to discuss modernist literature, and his play, *Absolute Signal*. Ma Yuan read out the last pages of his first novel there, and Fu Weici came to discuss his translation of *The Moon*

and Sixpence. Zhou Duo would hold forth for hours, talking about everything from aesthetics to political economy. He introduced me to opera while I taught him to sketch. My paintings covered every wall of my room. I even used one as a rug. My visitors would pass judgment on them, some would even take a few home with them. I often held private exhibitions.

Even now, I'm not sure how many people owned keys to my front gate. During the Gang of Four era, our meetings were illegal. At the time, it was illegal to even walk down the streets at night. If there were two or three of you out together, you were bound to get arrested and locked in a police station until the following afternoon.

My neighbours in the surrounding buildings were able to keep a close watch on me. But the loud music and streams of visitors soon also aroused the attention of the local "old biddy patrol" as well. I remember one night, after we'd had a lot to drink, we collapsed in a heap in the yard. Less than five minutes later a police car came wailing up to the front gate. The policemen jumped out, pushed us inside the house and began checking our identity cards. Shi Tao and his girlfriend were canoodling behind my bed curtain by that time. One of the policemen raised the curtain. Too absorbed in what he was doing to look up, Shi Tao simply pulled the curtain down. The officer then calmly pulled the curtain up again. This carried on until Shi Tao at last looked up and saw the national emblem on the officer's cap. Those of us with ID were allowed to stay, those without were taken away. Later, I found out that my neighbours had been watching us, and that they'd told

the police that a fight had broken out in the yard, and that men and women inside the house were behaving in a debauched manner.

At that time, our small gatherings gave us our only opportunities to express our inner feelings. But following Deng Xiaoping's reforms, the political climate slowly relaxed a little. So although we suffered persecution and arrest, our efforts helped advance Chinese society.

In 1979, The Nameless Group, China's first independent art association, was formed. Shortly afterwards The Stars group was established, and it held public exhibitions. Then there was the "April Film Festival" which screened films that for the first time in forty years dared show China as it really was. Then came the first modernist novel, Tan Fucheng's *Geert Sees the World*, published under Gao Xingjian's direction. People began to understand the relevance of the word "freedom" to the creation of art, and the word "love" began to appear bold and unabashed on the pages of official literary journals.

Chinese society, closed for nearly four decades, was gradually beginning to open up. When Deng Xiaoping and President Hua Guofeng found themselves forced to approve the marriage of artist Li Shuang to her boyfriend, a French diplomat, reform accelerated into the realm of the masses.

Once people were able to speak foreign languages without being accused of being toadies of foreign powers, the democratising effects of freedom became irresistible. The gates began to swing open.

Those who once secretly gathered at No. 53 Nanxiao Lane were swept out on the waves of reform, and they now play all manner of roles. They no longer have much contact with each other, perhaps because of differences of opinion or allegiance. But No. 53 Nanxiao Lane once brought them together, once made it possible for personal points of view to become cultural trends and slowly emerge from underground into broad daylight, to circulate in society. Many ideas and cultural movements emerged from houses like mine and gatherings like ours.

No. 53 Nanxiao Lane has weathered several political campaigns, in particular the Anti-Bourgeois Liberalisation and Anti-Spiritual Pollution campaigns, yet today it still stands intact, barely a hundred metres from the former residence of Liang Qichao, a leading figure of the late-Qing renaissance.

During the Anti-Bourgeois Liberalisation campaign, I was arrested and all my belongings were confiscated. In their hunt for bourgeois material, the police ripped down the paper ceiling in my room, exposing the dirt and the straw and the dust behind. The rats had no choice but to move to a quieter place.

So history moves forward step by step, while Nanxiao Lane stands as still as ever, silently recording the great, slow changes of the city.

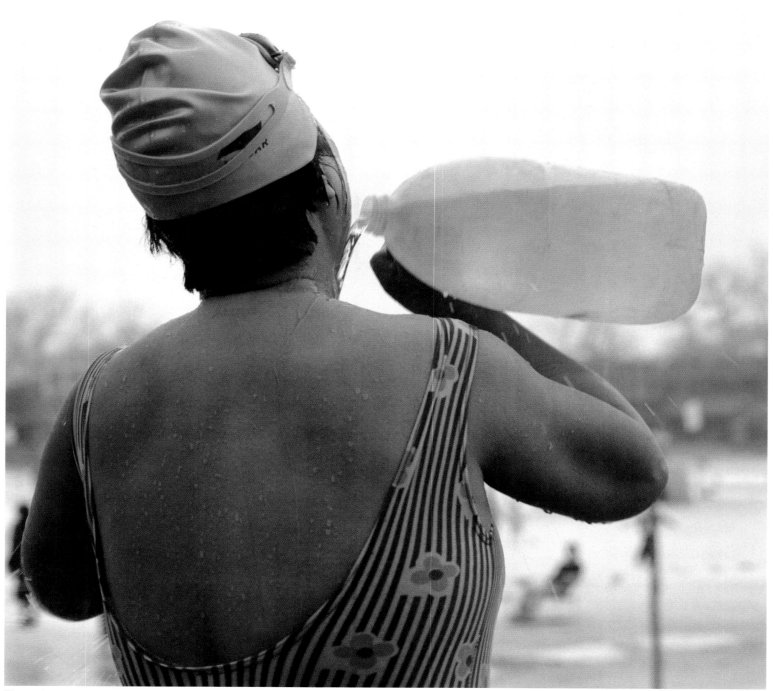

Throughout winter, members of an ice swimming club swim in the frozen lake of Shichahai. A woman thaws out with warm water after her dip

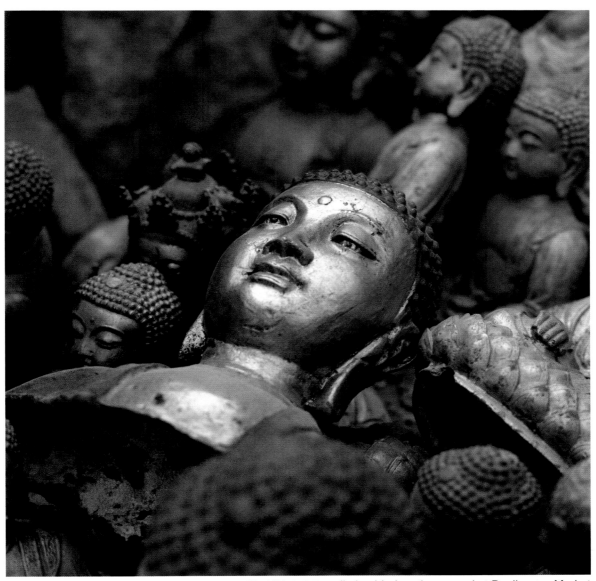

Buddhist statues lie jumbled on the ground at Panjiayuan Market

Alfreda Murck is an art historian, specialising in the history of Song Dynasty painting and the use of symbols in Chinese art.

She worked for twelve years in the Asia department of the Metropolitan Museum of Art in New York, and did a PhD in Chinese art and archaeology at Princeton University, under the tutelage of world renowned expert Wen Fong. She has lived and travelled extensively in Asia, and has studied Chinese art from a multitude of perspectives, including its relationship with art from Japan and its role as an agent of social change and commentary in China from the Song Dynasty (960–1279) to the Cultural Revolution.

Since 1997, Alfreda has lived in Beijing with her husband, and has taught at Peking University and the Central Academy of Fine Arts. She is currently a consultant to the Palace Museum, where she is engaged in editing English language signage ahead of the Olympic Games in 2008.

Her publications include articles on Chinese gardens and art, as well as the book, *Poetry and Painting in Song China: The Subtle Art of Dissent.*

Alfreda is also perhaps the only person in the world with a collection of painstakingly gathered and researched textiles featuring illustrations of China's various political movements since 1950.

Panjiayuan

by Alfreda Murck

For recreational shoppers, Panjiayuan is a browsing paradise. From the exotic to the mundane, Chinese collectibles of almost every type vie for your attention. It is an "antique market" only in the liberal sense, given that many of the goods on offer have recently rolled off factory production lines. Those browsing are greeted by baskets, boxes, gem stones, jades, fossils, bronze vessels purporting to be more than two millennia old and incense burners claiming to be six hundred years old. There is calligraphy and traditional-style paintings mounted into hanging scrolls, and new ceramics from every kiln of China. Luoyang, alone, is said to have ten factories making Tang Dynasty-style three-colour tomb figurines, including fat ladies with rosy cheeks. Remnants of the Cultural Revolution mix with reproductions of posters and timepieces, musical instruments, old books and magazines, photographs, and an acre of stone sculptures. In 2005, carved lucky stones from Tibet appeared; from the summer of 2006, copies of oil paintings that had set auction records were on offer. If you can't find what you are looking for, chances are you can order it.

From humble origins, Panjiayuan has morphed into a true Beijing institution. Deng Xiaoping's economic reforms in the late seventies emboldened ordinary folks with the slogan, "To get rich is glorious". On either side of the Panjiayuan East Road people would spread mats to sell personal effects. Bicycle parts, electric fans, radios, battered furniture, and the detritus of the Cultural Revolution competed with Singer sewing machines, and the occasional treasure. This was a free-market complement to the long-established antique shops at Liulichang that were state-owned. Collectors fondly recall those years in the late seventies when really distinguished objects that had been hidden during the Cultural Revolution found their way into the marketplace. Palace Museum experts roved the street mats searching for objects that only months beforehand had been condemned as bourgeois.

Because a vaguely-defined law in the eighties forbade citizens from selling antiques, free markets like Panjiayuan were called ghost markets. It was an appropriate moniker: not only did they open before daybreak, but whenever the police showed their faces the vendors vanished. By the end of the eighties, when the proliferating number of mats spilled into the street from Panjiayuan Road all the way north to Jinsong South Road, the Neighbourhood Committee urged people to use a construction site by the Third Ring Road. While the market was still illegal, officialdom at least tolerated it.

In 1992, unable to restrain the burgeoning entrepreneurial population, the committee designated a site and cleared a lot where Panjiayuan stands today. It was dubbed the Dirt Market, another fitting title as even the hardiest weed could not survive. During the rainy season it was a quagmire. Shoppers hopped from brick to brick as a strange assemblage of furniture, doors and camphor chests teetered in mud. At that time the market entrance was on the west side where stone sculptures are now sold. Some said that you had to arrive before dawn to get the good things because provincial sellers took the Friday night train to Beijing and made their way in darkness directly to the market

so they could sell their objects before rents were collected at 8am. Others said that arriving before dawn with flashlights was pointless as the best things were taken to nearby hotels where out-of-town vendors had prearranged appointments with clients. Because most vendors were from Beijing, the market came to an end about noon so they could get home for lunch.

In the summer of 1997 the Panjiayuan market was deemed a good-if-still-temporary thing. The Panjiayuan Neighbourhood Management Office spiffed up the facilities with the help of the local government, and a multi-coloured awning was installed on vaulted steel frames. On a brick wall on the east perimeter, the slogan "Regularised Management, Civilised Commerce" was inscribed in handsome clerical script. And at the north, an entrance was created with the name of the market written in gold on an imposing free-standing screen. Emblematic of government approval, the calligraphy was by An Shunsheng, Director of the Standing Committee of the People's Congress of Chaoyang District.

During the week, Panjiayuan was a wholesale market for vegetables and household goods. The flea market took up occupancy on weekends. Under the colourful awning that cast a mellow sepia glow, the market was hot in summer and drippy on rainy days, but at least there was a cement slab under foot. Spaces under the awning went for ten yuan. A Panjiayuan monitor moved along the aisles collecting the rent. Those who did not mind facing the elements could opt for uncovered space on dusty, uneven ground for half that price. Or they could situate themselves around the old

houses that stood beside the new concrete slab. That was where the Hunan traders showed up every couple of weeks with bowls decorated with themes from the Great Leap Forward and the Cultural Revolution. Because in the sixties and seventies people pooled their bowls for communal use at celebrations, the names of the owners were often engraved with nail pricks to facilitate retrieval after the event.

Occasionally someone strolled amongst the crowd attempting to sell antiques out of a bag or crumpled newspaper – an unfair practice, according to those who rented space, and an illegal one in the eyes of the management. More than once the routine hum of the market was temporarily disrupted by arguments, and even scuffles, between the interlopers and the regulars. Nowadays most rogue vendors are said to be Tibetans from Sichuan, but it is also said that some of these are actually Han Chinese masquerading as Tibetans. The costumes, the theory goes, protect them from officialdom: they can feign inability to communicate in Chinese, and despite their rule-breaking habits, the authorities would not dare to beat them, fearing scenes of ethnic discord.

In 1999, in a further attempt to regulate the market, a loudspeaker system was installed. At 9am a recorded message admonished vendors to be on good behaviour because important foreigners might be circulating among them. And indeed, foreign ambassadors and visiting dignitaries were often seen at the market. The loudspeaker's recorded message continued with brief English lessons on numerals and key adjectives phonetically expressed in characters (such that "old" came out

as a two syllable word absent its "L": ou de), then a mellifluous Kenny G tape was played. The retailer of opera things created a welcome contrast with sharp rhythmic clacks of opera clappers that rang out over the noise of the crowd, generating smiles and adding to the unique Panjiayuan ambiance.

Panjiayuan offers shoppers multifarious opportunities. American and European academics have often found items to take home to enlighten their students: trays of movable type, ink cakes and scholar studio paraphernalia, kitchen gods, old coins with a hole in the centre tied on a string (nowadays minted by the thousand).

Scanning thousands of items on the mats at Panjiayuan for certain categories of objects takes patience and concentration, and often renders other categories of treasures invisible. In 2000, the South African artist William Kentridge wanted to buy certain used tools which I told him I had never seen. But touring the market, there they were: tools for obscure tasks in strange shapes and in heavily corroded iron.

As a collector, my own preferences and penchants have changed over the years. Beginning in the late nineties, twentieth-century inscribed porcelain teapots took my fancy – I bought hundreds of them. Sellers would see me coming and raise a teapot high in the air. One morning I bought so many I could barely squeeze into a taxi, and broke an inscribed jar on the way home. Scrubbing a teapot, my housekeeper recalled that growing up in rural Baoding, her family never had a piece of porcelain in the house, only baked enamel. Shelves of shoes were eliminated from my closet to ac-

commodate the enamel cups, bowls, wash basins and trays necessary to illustrate this aspect of the socialist economy. Hot water thermoses followed. For a time I frequented the postage stamp sellers and flipped through thousands of envelopes to find that curious commemorative stamp for the Barcelona Olympics that was said to be a commentary on the Tiananmen crackdown. The numbers on the Marathon runners' jerseys read 64-9-17 – homophones for "June 4 will soon come up [for re-evaluation]," a common expectation in 1992.

Later I became something of a mango maven. In the summer of 1968 Chairman Mao gave some workers a gift of mangoes, a gesture that transformed the mango into something of a sacred relic. Party propagandists used the mango image to symbolise the change in leadership of the Cultural Revolution from the Red Guards to factory workers; whereas it was the People's Liberation Army who actually held the real power. From Panjiayuan I acquired wax mangoes, plastic mangoes, mango vitrines, mango reliquaries, mango posters, mango-decorated enamel cups and trays, mango cigarette packs, Mao buttons with tiny mangoes, and most improbably, mango duvet covers.

From the fifties, visual interpretations of government policies were worked into the designs of printed and woven textiles. Although to many people old duvet covers are no more than rags, they can also be thought of as historical documents. In Liulichang West, in the low-end warehouse market, Hao Yu thought of them as cold cash. In her bizarrely over-crowded shop, Ms Hao specialised in Cultural Revolution artifacts including

some attractive textiles. She once challenged a friend and I with hefty prices: two hundred, five hundred, and then seven hundred yuan. We made the mistake of showing enthusiasm. She saw how much we needed them, and we were helpless to bargain her down. How could one resist a duvet cover with an atomic mushroom cloud in gold against a purple background?

Tang Jun became my main duvet supplier. Like all Panjiayuan vendors, Mr. Tang's prices are flexible. With good bargaining skills some shoppers can work him down to twenty or thirty yuan for a piece. But more typical is up to seventy yuan for a duvet cover. In 2007, the price sometimes went up to a hundred yuan, depending on quality, condition and size.

When he senses a promising prospective customer, Tang Jun defends his turf by deflecting curious passers-by with off-putting prices: three hundred yuan for the foreigner who might buy; up to four hundred yuan for the elderly Chinese matron who may still be using such printed cottons at home. The inquiring matron may conclude that foreigners are getting taken. Well, in a way we are. Tang Jun gets most of his textiles from recycling centres around Beijing, Tianjin, and Liaoning for a mere five or ten yuan. However, his service of travelling around the region, of assembling and cleaning textiles is invaluable, and the convenience of one-stop shopping makes Tang Jun's duvet covers a great bargain.

Born in 1959 in Yantai, on the northern tip of the Shandong peninsula, Tang Jun is the third of four brothers. His grandmother carried on the family tradition of tailoring and embroidery, which she taught her grandson. One day, when he was nine years old, Tang Jun was having lunch in her courtyard. Suddenly they heard drums and chanting outside in the lane, then pounding on the door and, more ominously, the splintering of wood. Red Guards were destroying the decorative gate to the house. Wearing red armbands, they charged into the courtyard and hurled abuse at his grandmother, criticising her bourgeois taste. She furiously upbraided them as lawless truants. The teenagers replied with epithets such as "Old Thing" (an insult implying something non-human). Gathering garments from every room of the house, they piled them in the courtyard and set them ablaze. In 1997, he came to Beijing and began dealing in textiles. He runs the business with family members, but it's Tang Jun who has the sparkle in his eye, the ready smile, the gift of gab, and the talent for buying and selling.

When Tang Jun learned of my enthusiasm for mangoes, he promised to keep an eye out for related duvet covers. He remembers as a child he saw a mango displayed with reverence and thinks it was the real thing, which is possible since some of Mao's thirty-plus mangoes were sent on tour. However, it is more likely that what Tang Jun saw was a facsimile. When Chairman Mao's mangoes began rotting, wax and plastic reproductions were made to keep the symbol fresh, the synthetic materials in no way compromising the mangoes' numinosity. Tang Jun sourced some excellent duvet covers. One depicts a basket of mangoes on bright red ground; it is flanked by a blue cog representing workers and pink sunflowers. Symbolising loyalty to Chairman Mao for always turning toward the sun, the sunflower

is depicted with huge petals creating a hybrid that combines the sunflower's loyalty with the peony's associations of wealth and prosperity.

Since it's easy to get fleeced at Panjiayuan, global flea-market rules apply: 1) Never snap up the first exotic thing you see: it may be the New Thing in the market and appear on ten other mats; 2) Everything is negotiable so rather than pay the asking price, express dismay. Would you be delighted to get the item at half the asking price? Gently try for ten percent. Do not immediately make a counter offer; rather ask the vendor to come down; 3) Feigned indifference works better than displays of enthusiasm. Point out defects, look longingly at the object, put it down, ask them to reconsider, walk away. Chances are the vendor will follow with "OK! OK!" and tell you with a smile how much money she is losing; 4) Do not offer a price you are not willing to pay. Once you have spoken, if the vendor accepts, you are obligated, by the unwritten code of the market, to pay; 5) Contradicting the first rule, if you really love an item, it's better to buy on spec – part with your money rather than wake up the next morning longing for the treasure that got away.

The advent of mobile telephones has added a new twist to the bargaining process: "I want to sell it to you, but it's not mine. Let me check with the owner." Instantly contacted by cell phone, the owner always starts off insisting on a higher price. It's a dance that requires patience and good cheer. For smooth negotiations, modest dress is also well-advised. In late 2000, I introduced sinologist and European diplomat Endymion Wilkinson to the market. It was a frigid December day and, to guard against the wind that was sweeping the city, he chose to wear a full-length drop-dead raccoon coat. Endymion's repeated claims in Chinese that the coat was made in Inner Mongolia did nothing to quench the glint in sellers' eyes, and their certain anticipation that they could score big with this swell newcomer. That day, ordinary goods were offered for not just hundreds, but thousands of yuan. Lengthy and persistent negotiations for a homely and damaged teapot, dated 1905, resulted in a price four times the going rate. No bargains were to be had and Endymion was puzzled as to why the market was considered good sport.

But then again, paying "tuition" from time to time – that is, buying the occasional fake, over-paying for a mundane item – goes with the territory. Both dealers and collectors concede that for "antiques" there are no set prices. Fair prices are those that leave both buyer and seller glowing with satisfaction.

The wholesale ceramic section at Panjiayuan offers small tea bowls, each with an autumn leaf pressed into the glaze. Study of traditional Chinese painting piqued my interest in the possibility that twelfth and thirteenth century tea bowls with an autumn leaf might be an image of grief, or a reflection on the ephemeral quality of life. Based on an ancient metaphor, the leaf bowls were first made in the twelfth century following the loss of the north of China to non-Chinese dynasties when thousands of Song imperial clan members were captured and killed. Could the Panjiayuan leaf bowls possibly make a similar connection? The vendor told me that they were made by the Han family in Henan

in Yuzhou – one of those counties you have likely never heard of with a population of two million. In 2001, I travelled to Henan and sought out the Han family in Shenhouzhen. Their house was perched on a steep hill, and inside Han Jianyuan turned out the leaf bowls at a clip of three hundred a day. His wife helped him press the leaves into the glaze. They rested only two days a year, for the Chinese Spring Festival.

Because his own life was harsh, Han forbade his son to become a potter. I watched for hours as he threw the bowls, dipped them in glaze, pressed leaves in, dried them, pulled the leaves out, then glazed a second time. He had learned how to make the leaf bowls more than ten years earlier from a book, and they sold particularly well in Taiwan, Korea and Japan. When I went again three years later, Mrs Han confided in me that in 2001 they were in mourning for a son who had drowned. We went up the hill to the Buddhist temple and prayed.

The tragedy may have contributed to Mr. Han's continuing to make leaf bowls but did not explain why he began. Later I learned that in the early nineties he had lost both of his parents in a car accident. His father had apparently been a fine potter. Are his leaf bowls a reflection on life's vicissitudes? I would like to know, but I found it impossible to ask.

Behind every stall, behind every artifact lies a story – intriguing comings and goings, mysteries to be unraveled. Every year Panjiayuan has brought me new tales and sub-plots. Meanwhile, beyond the market's four walls, Beijing has modernised and developed at a frenetic pace. Initially considered something of a backwater, the real estate boom meant Panjiayuan suddenly found itself in the developer's eye – a dangerous place for a market to be. By 2001, rumours abounded that, like so many other parts of Beijing, the market was going to meet the wrecking ball. Petitions were signed and protests were lodged. The Chaoyang District government pondered its next move, and finally, thankfully, came down on the side of the market. Panjiayuan would stay, it was decided, and not only that, but it would get the makeover of its young life.

At the centre, the vaults of tricolor awning yielded to more permanent structures many times grander: four airy pavilions with quasi-Chinese roofs and six spacious aisles. The entire compound was paved in concrete tiles. Red silk lanterns were hung. ATMs and a flashy electronic board were installed, and the security guards were given smart grey uniforms. A lecture hall, a food court, a business centre and auction rooms were built. Plans are underway for a Panjiayuan Hotel.

No one would have described the 1997 Panjiayuan market as intimate, but that is how it seems in retrospect. The Panjiayuan of 2008 is easily ten-times larger than the earlier version. Under the four pavilions alone there are close to 1,500 spaces for mats; and with rents of up to 3,300 yuan per half year the pavilions generate monthly revenue of over US$100,000.

The Panjiayuan management estimates that in 2006 there were a quarter of a million visitors per month, served by over four thousand "shops" and close to ten thousand vendors. The sixteen managers and security

personnel are more than justifying their existence. The fees and taxes have made Panjiayuan a significant profit centre for the district government. Vendors complain that it has become too big with too much competition, too many fees and taxes, and too little income. They, however, keep coming back, and so do the crowds.

China's collectibles industry has developed to such an extent that now not only is it possible to find identical baubles on adjoining mats in Panjiayuan, but also on the streets of Shanghai, Lijiang, Ulaan Baatar, Venice and Chicago. This is not to say that there are not treasures to be found – they are all around. It depends largely on how you enjoy the trawling process. And it depends, of course, on how you define "treasure".

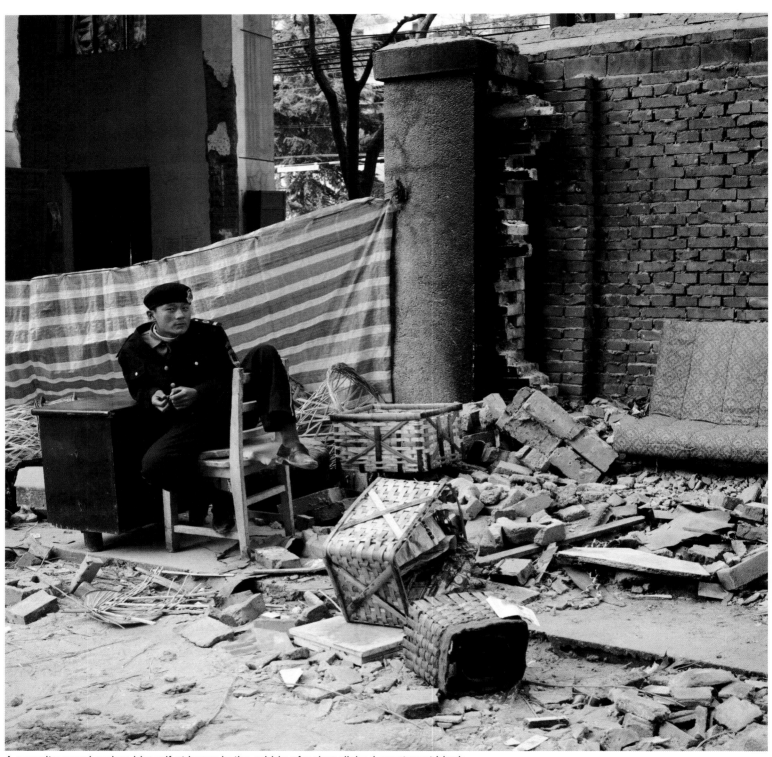

A security guard makes himself at home in the rubble of a demolished apartment block

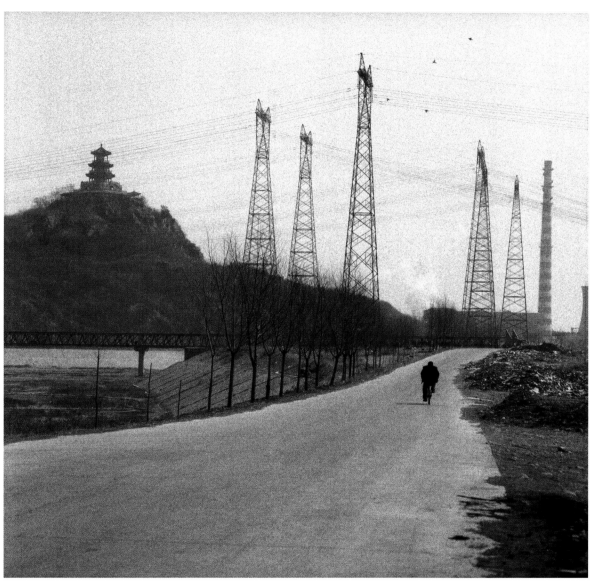

Cycling to the steel works

Tim Clissold studied physics and theoretical physics at Cambridge before moving to Hong Kong in 1987. He later moved to Beijing and was immediately struck by the dynamism and ferocious energy of a country he found to "bear no relationship to anything" he'd previously experienced. He spent two years studying Mandarin before joining the financial services sector, eventually co-founding a private equity firm. An entrepreneur in the truest sense, he has worked on numerous projects in China over the past twenty years, largely facilitating business negotiations between Chinese and Western companies. His current focus is on developing greenhouse gas emission reduction projects in China, in which he is investing money on behalf of the Bill and Melinda Gates Foundation Trust.

Tim's first book, *Mr China*, an arrestingly honest account of his first forays into the labyrinthine world of doing business in the Middle Kingdom, was published in 2004. It immediately appeared on bestseller lists worldwide, opening the floodgates for a deluge of titles on how-to – and how-not-to – manage commerce and relationships between China and the West.

Currently working on a second book, Tim now divides his time between China and England. He is married and has four children.

Coal Hill

by Tim Clissold

Behind the Forbidden City stands a hill which, legend has it, hides a vast reserve of coal for use in times of siege. Early in the morning, as the sun's rays first strike the pavilions at the top, people gather in the park below for early morning exercises. A young man climbs through the trees and bushes, up the three hundred and four stone steps, panting in the damp hot air. Nearby, a group of women practice swordplay, their arms outstretched, bodies straight, tilting backwards and balanced perfectly on one heel. An older man shambles past, half running, half walking, while hidden amongst the bushes the early morning exercisers stretch and bend and shout to greet the dawn.

Outside the park gates, a woman sprinkles chives over a pancake on a hot stone on the back of her tricycle. An old man peers through the wooden hatch at the ticket office beside the gate. He buys his ticket, five fen in those days, picks his way through the neat rows of pot-plants and begins the laborious climb to the altar at the top of the hill. As he shuffles across the stone paving in his battered cloth shoes, one leg drags behind him. His left hand is clenched and hangs slightly inwards. The stroke that came in the middle of the night has slowed him down, but it hasn't killed his will to live. Up the stone steps he goes, slowly winding his way along the pathways between the trees, pausing sometimes to rest his leg and wipe his mouth with a piece of old towel. Through the trees, he drags himself towards the summit, hauling his battered frame over the uneven stone flags. Gathering his strength for the last few steps, he mounts the raised platform around the pavilion and leans against the great carved stone

altar, lungs bursting. After a few minutes, using his good hand, he grasps his leaden leg and, with a heave, pulls up his foot, resting it momentarily on the top of the altar. "One," he cries and down goes the leg. Up again and "Two," shouts the man. Every day, he struggles up to the altar to try to revive his leg, lifting it up and down one hundred times, hoping it'll breathe some life back into the wasted muscle. The light grows stronger and the sweat starts to drip from his face. With a twist of pain, he finally reaches his goal and throws back his head. "Yi bai!!" "One hundred!!" comes a final defiant shout up into the morning air. From all about among the bushes, a faint sound of clapping rises up the hill. Hidden from view but silently listening, the early morning exercisers are looking out for him, watching to make sure he's alright.

I often watched the sunrise from that hill and saw the first light strike the corner watch towers on the Forbidden City below. In the eighties it was easy to imagine that Beijing had hardly changed since Imperial times. Beyond the vast palace complex with its maze of courtyards and passageways, the top of the front gateway of the ancient city was visible in the distance. Towards the west, an ornamental lake was covered with lotus leaves and surrounded by willows and little stone bridges. Around the hill, as far as the eye could see, the sloping roofs of a thousand courtyard dwellings stretched out towards the horizon. It seemed as though only the odd hoot of a passing Liberation truck or the sight of the Great Hall of the People on Tiananmen Square marked the passing of the centuries. But when I looked more closely and carefully out towards the west I could pick out the vague and distant outline

of factories standing out against the mountainsides. Huge chemical plants and iron foundries rose up at the foot of the hills. Columns of twisted metal pipework reflected the sun from inside a reactor tower; there were smoke stacks and gantries with great hoops of rusted tubing that poked out at odd angles. Clouds of steam, pink and rosy in the early sun, billowed from cooling towers next to the giant black hulk of a blast furnace. In the other direction, towards the south-east, a row of chimneys marked the site of the city's main power station; great ceramic insulators with coils of wire led to a line of pylons that marched off in straight lines towards the south. All of these were the early signs of industrialisation and, in those days, I never gave it a thought. But now, if you were to go back to that hill and look out over the great city, you would find a very different sight.

•••

I lived for a while with my family in the maze of twisting alleyways that surrounded the hill. We had part of an old courtyard in a hutong on the eastern side of Beijing just inside where the old city walls once stood. It was built in the Qing Dynasty on a street named after the huge granaries that were used to store tithes collected in from the provinces. There was a pattern to life in the old hutongs, a rhythm to the day and a closeness to nature that felt unusual in the midst of such a vast city. Time was marked by the particular shout of a street vendor or the preparation of different types of food for each part of the day. At seven forty-five, commuters with bicycles queued for deep fried bread sticks; at ten-thirty, the cooks at the

nearby restaurant started to flatten out dough into little circles and wrap them into dumplings. Just before eleven, steam appeared at the top of the pile of bamboo steamers. At three-fifteen, a delivery of fruit arrived for the local shop; just after six, a group of men gathered at the end of our alleyway, pulled out a table and some low folding stools and started the evening's game of *weiqi.*

The passing of the seasons was equally apparent in the old alleyways. The hutongs seemed connected to what was happening in the fields outside the city; there was a close interdependence between the farmers outside and the city dwellers within. The local vegetable markets showed the time of year; in winter, pots of pickled vegetable or white cabbages lined the stalls; in late summer, it was lotus root and fresh ginger. Springtime brought blossom to the fruit trees in the Temple of Knowledge and to the old wisteria that climbed around the kitchen windows; huge silk gourds, carefully tended throughout the summer, hung over doorways as the weather turned cold. Even inside the courtyard, life was much closer to the elements; there were no connecting corridors between the rooms so we had to venture outside as we moved about the house. In winter, it was often below freezing inside and the children wore coats in bed. But in the summer it was sweltering and when flash rainstorms flooded the courtyard we'd retreat up the steps into the main south-facing room and listen to the water splashing onto the tiles above our heads.

Then the city started to change, gradually at first. I'd notice that an old restaurant had gone and a mobile phone outlet had appeared in its place, or that a corner shop had been demolished to make way for a

wider road. In the early days I hardly noticed, but the changes gathered pace. Suddenly I'd realise a long line of shops had gone; then the whole side of a road would disappear. I heard rumours about an old woman in Xicheng District on the west side of Beijing who had chained herself to a tree inside her old courtyard as the court official read out the eviction order. She'd lived there for sixty years and had nowhere else to go. Grabbing my bicycle, I rode over to see what was going on and was horrified by what I found; there were huge areas of rubble with solitary trees standing where the old courtyard gardens had been. Window frames and roof beams lay scattered all about; broken saucepans and smashed pots lay in amongst the heaps of shattered tiles. Quite alone amidst the devastation one house remained in the sea of broken bricks. Although it was chained and padlocked, the sledgehammers had spared the old courtyard of Qi Baishi, one of China's most famous artists. The local government has since converted the courtyard into a museum and it cowers in the shadows of colossal glass towers that have been built along "Financial Street".

Once Beijing won the Olympics there was an inevitability about the fate of the old city. Gradually, I sank into a kind of siege mentality and shut my mind to what was happening. All around me the air shook with the roar of bulldozers and I felt the distant pounding of pile drivers through the ground beneath my feet. I heard that more areas of old hutongs in the north had disappeared, but I couldn't bear to go and look. An ancient city was being dismantled brick by brick and the living link with history had been cut. Each day as I walked back from work I chose the same route through the alleyways and stopped to chat for a while on the street corners. I'd ask anyone who would talk to me what they thought about the disappearing hutongs, hoping for some tirade against the government, but it rarely came. Although I felt angry and confused, I knew that I couldn't pass judgment on what was happening. Our courtyard had hot water and plumbing, while most of the locals had to walk down the street to the public latrines on the corner. The emotions I felt raised uncomfortable questions for me as a foreigner, living amongst a society that could never really be mine.

Then one day, the inevitable happened: I came back to find the character I most dreaded painted within a big white circle on the wall of our courtyard. 拆 – or "chai" – means "demolish," "strike down," "strip" or "tear apart." At first I put up a fight; the courtyard had been owned by a famous author in the 1930s. But of course my argument that the old building should be preserved because of its historical value fell on deaf ears; I told them I'd just refuse to move out. "Well, we'll be turning off the water on Wednesday," said the woman at the Street Committee office before adjusting her glasses and going back to her newspaper. So I sat in the courtyard, writing at a table whilst the workers climbed onto the roof with their hammers and picks, and bits of old tile and plaster fell onto the sheets of paper in front of me.

•••

And so an ancient way of city life has almost vanished in the space of a few years; a connection between everyday life and nature has been lost. Over the

past two decades China has experienced the largest sustained burst of economic growth in human history. In the country villages more than a hundred and fifty million people have been lifted out of absolute poverty; in the cities, living standards have improved beyond recognition. But the comfort and convenience has been bought at a terrible price. The iron and steel works that I first saw two decades ago has grown into one of the largest in China and produces more steel per month than it did in the whole of the first thirty years of its existence. Its appetite is staggering: it consumes millions of gallons of water, in a region that scarcely has enough for drinking; it devours vast quantities of coal and electricity; huge railways cross the mountains from the west bringing millions of tonnes of coal and iron ore from the inner provinces. The colossal complex employs one hundred and thirty thousand people and disgorges vast clouds of smoke and particulates into the air. A sulphurous smell hangs over the factory, heat blasts out from the furnaces; clouds of carbon dioxide spew from the coke ovens. On the south-east of the city, the power stations have been upgraded and the four enormous chimneys relentlessly pump gases up into the sky.

Now when I stare out from my window on the twenty-third floor of a high rise apartment block, the hills towards the west are often hidden from view. The air of the Beijing summer this year has been almost opaque. Down below, the traffic snarls up and tempers fray. Cyclists clutch at their mouths and turn their faces away from the exhaust fumes. In my mind's eye, I move westward across the mountains and out over Shanxi, visualising the pitted ravines and valleys on the great

Loess Plateau of central China. Beijing is merely a vantage point to survey all the desperate activity across China; further inland, millions toil in search of a better life. Miners descend black shafts in cages, workers hammer in factories and hack at rockfaces to make way for the next inter-city superhighway. Engines roar and sirens scream; the rivers inland have run completely dry, their beds a mass of smashed rocks and thorn bushes, and there are no trees. Dead fish float about in dirty foam; the water table is falling and vast areas are being lost to the deserts. More than three hundred million country people have no access to clean drinking water, and acid rain falls across the land. Bizarre events are routinely reported in the press, like the strange green algae that covered the lakes in southern China and deprived whole cities of drinking water, or the sudden appearance of two billion water-rats that devastated crops in an area the size of Holland.

These changes in Beijing hold up a mirror to ourselves in the West, but do we dare to look? We read about Chinese container ships arriving at Harwich packed with Christmas decorations and plastic toys that break on Boxing Day. We know that much of it will end up back in landfill sites in China. Factories from all over Europe and North America have been packed up and shipped lock stock and barrel to China where they sit pumping out gases and effluents into the rivers. All countries go through a period of growth when developing the economy seems more important than preserving the environment; a hundred years ago Europe and America were just the same. But the problems in China are deeper because the population is so vast and a whole phase of development that might

have taken a century in Europe has been compressed in China into the space of just a few short years. In this interconnected world, the rise of China has sent shock waves coursing across the planet. The poison seeping into China's land may never reach beyond its borders, but the rise of China is feeding climate change and that is affecting the whole planet.

Outside a small group of experts, recognition of climate change as a global emergency is less than a few years old, and yet the effects will last for centuries. Climate change is inextricably linked to development; there is no precedent for any society to develop without massively increasing consumption of energy and other resources that release carbon into the atmosphere. But if climate change is caused by human activity, then we have to confront the notion that the entire cascading mess of collapsing glaciers, dried-up river beds and extreme weather events has been sparked off by a tiny proportion of the world's population. Imagine if China reaches the same stage of development. Already, China is building new power stations at such a rate that the equivalent of Britain's entire installed generating capacity is added to China's existing output every thirteen months. China is still a country at an early stage of development and it is dependent on coal, the most polluting of energy sources, so its carbon emissions are sky-rocketing. But Europe and America have by far the highest per capita consumption of energy and oil in the world, so how can anyone there argue that China should restrict its development? Is it morally acceptable (or practical) to think that countries like China should not develop? Can the rich nations work with China to help find a more sustainable de-

velopment path? No one has the answers, but perhaps there is room for hope; the onset of climate change may prove to be the first time in history where coordinated efforts between rich and poor nations are essential for the survival of the rich.

•••

I still go to the park behind the Forbidden City and climb to the top of the hill. The same woman is still selling the tickets at the gateway, but these days it's five kuai to get in; one hundred times more than the old man had to pay. Last time, I stopped and told her I had been coming to the park for many years. "Is the old man still here, you know, the one who had a stroke?" I asked. She shook her head briefly and waved me on in. "So many changes in the city," I said. "Yes," she said, pointing her thumb behind her towards the hill, "Danshi libian haishi neiyang'r!" "But it's still the same inside."

I wandered in and climbed the path to the top through the twisted pines and the aromatic smell of sap that filled the early evening air. At the summit, the altar has been carved with images of fantastic sea-monsters and strange kissing fish. A shining gold Buddha sits upon the top. Tourists from the provinces yell and jostle and snap their digital cameras; for ten kuai you can hire yellow robes and pose as an Emperor on a crudely erected throne with the Forbidden City as a backdrop far below. I wandered off towards the Eastern Gate, where four centuries earlier the last Ming Emperor had hanged himself on a tree. A peasant army had laid siege to the Forbidden City and, when his ministers failed to

answer his summons, the Emperor despaired and took his own life; thus the Qing Dynasty was born. The sight reminded me that Chinese history has been marked by great upheavals over the ages; the dynasties rise and fall but the culture still survives.

Just next to the site of the tree, where a rock garden now stands, a man was practicing calligraphy with a long brush that he dipped into a small bucket of water. Absorbed in the task, he meticulously drew long flowing brushstrokes in the dust on the paving stones at his feet. I gazed at the characters lying there on the ground; clearly visible for a few moments, they soon faded and disappeared forever as the water evaporated. The man was writing out sections of the *Tao*, one of the oldest texts written in the days when the Chinese civilisation first stirred on the banks of the Yellow River. The words resonate across more than thirty centuries and seem more relevant today than ever before:

知止不辱，知足不殆，可以长久

To know when to stop is to be immune from disgrace,
To know what is enough is to be preserved from all perils,
Only thus can we endure long.

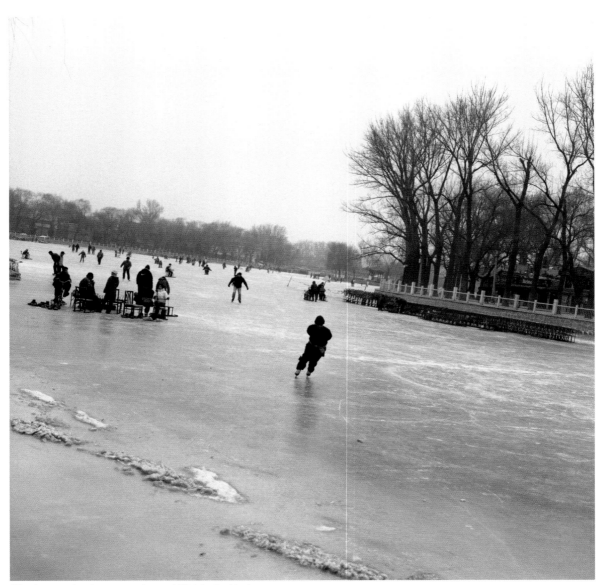

Skating on the frozen waters of Shichahai Lake

Beijing is home to millions of migrant workers

Catherine Sampson studied Chinese at Leeds University, first visiting China as a student at Fudan University, Shanghai in 1981. After receiving a Kennedy scholarship to study Chinese politics at Harvard, and following a stint in London with the BBC's World Service, Catherine returned to China as a journalist, working for five years for *The Times*. She lives in Beijing with her husband and three children, "who think China is ordinary and Britain is exotic."

She has published three crime novels, *Falling Off Air*, *Out of Mind* and *The Pool of Unease*. The genre, with its demand for strong stories, and its obligation to probe the murkier aspects of society, has provided Catherine with a lens through which to investigate many pressing issues within contemporary China, particularly corruption and criminality, still largely unexplored in fiction within the country itself.

Song Ren, a Beijing-based private detective, appeared for the first time in *The Pool of Unease* and takes the lead in her forthcoming novel, *The Slaughter Pavilion*. The short story which appears here, *Hit and Run*, describes a time in Song's life before he became a private detective, and serves as an introduction to his character and motivations.

Hit and Run

by Catherine Sampson

Song Ren followed Xiao Huang along the shore of the artificial stream that burbled through the restaurant. The waitress led them to an area screened off behind white linen drapes and a grove of potted bamboo in which hung a caged mynah bird.

"Not bad, eh?" Xiao Huang gestured around him as he lowered himself onto a chair, "Uncle brought me here last week, I thought you'd like it."

"Very sophisticated," Song agreed. He was thinking that his old friend's muscle had turned to fat. Xiao Huang's expensive shirt was straining at its shoulder seams.

"Ha! You think it's too bourgeois, you old leftist!" Xiao Huang bellowed with laughter. Song shook his head and protested, but he smiled too.

Xiao Huang raised his arm to summon the waitress, then leaned forward so that his face was inches from Song's.

"So my friend, have you found a job yet?"
Song tried not to flinch. Xiao Huang had always been charming and irritating and direct to the point of brutality.

"I have several offers," Song lied, "I'm in talks with potential employers."

On the table in front of him a goldfish swam in tiny circles in a small glass bowl. No need to tell Xiao Huang that the only job he'd been offered recently was as a 'living advert', and that the woman had approached him on the street only because he was unusually tall and well-built. She had told him that the position involved marching up and down outside a supermarket wearing a suit of armour and grasping a plastic spear. He had turned it down at once, of course, with alarm that things had come to this. Later he thought that at least no one would have seen his face, hidden behind a visor.

"I might have something for you," Xiao Huang said. Song nodded, thinking it had been a mistake to come.

A decade ago, at training camp for the national swimming squad, Song and Xiao Huang had shared a dorm room. Song had walked out on the squad and then, several years later, walked out on the police force, leaving himself, as Xiao Huang had so helpfully observed, jobless.

By contrast, Xiao Huang had been kicked off the squad and had walked into a job with his uncle, the owner of the Hawaii Lifestyle KTV Club. Xiao Huang was in charge of security – a substantial responsibility in a venue where vast sums of cash changed hands every night.

Periodically, Xiao Huang tried to persuade Song to join him at the club. Until now, Song had always turned him down, believing that something better – something less criminal – would turn up.

A waitress brought a starter of chopped vegetables and sauce to be wrapped in beancurd sheets. Another waitress poured beer, a third poured *Pu'er* tea, and yet a

fourth placed a napkin in his lap. Song shifted uncomfortably – he disliked the way these girls hovered around him. They were like flies. When the waitresses retreated, one of them flashed him a coy smile.

"Why is it they can't take their eyes off you?" Xiao Huang grumbled. "You dress like a peasant."

He grinned to let Song know that he was just teasing, then changed the subject abruptly.

"One of our customers, Gao Lanqing, is looking for a bodyguard," he said, "and I've recommended you."

Song grimaced.

"I'm no bodyguard," he said.

"There's nothing to it," Xiao Huang urged. "You're so big you just have to look at a kidnapper and he'll run a mile."

Song shook his head.

"Come on, put on a dark suit, a tie, you're a natural. If you take off your glasses and shave your head you'll look like a born thug."

Song chuckled to cover his discomfiture.

"Come on," Xiao Huang said again, "the money's good, the man's a multi-millionaire…"

"A man like that has a dozen bodyguards."

"No," Xiao Huang said quickly, "he's had problems with staff. He needs the right man, and you're the right man for him."

"The right man for *him*, am I?" Song spoke dryly. He sat back and watched his friend's face. "Or is it that I'm the right man for *you*?"

Xiao Huang smiled and shook his head.

"You're too smart for your own good," he said. He leaned across the table, speaking softly.

"Uncle wants a man in Gao's household. We want you to go in undercover. It's what you were trained for. It's just for a few days. You get paid by him, and you get paid by us. It's beautiful…"

Xiao Huang broke off, looking expectantly at his friend, but Song signalled that he wanted more information.

"Uncle is due to help Gao with a certain financial transaction at the end of the week, but we have heard that Gao is under investigation by the authorities. Uncle wants to make sure Gao is not being tailed or otherwise compromised when he comes to the Club."

"Under investigation for what?"

Xiao Huang glanced around nervously. The mynah bird peered down at him, muttering.

"It's nothing…"

"It's never nothing."

"He's been given a substantial bank loan… for construction work… there is some question about whether the loan was obtained fraudulently."

"And the financial transaction that your uncle is facilitating?"

"The usual," Xiao Huang murmured.

"Money laundering you mean," Song said, and was rewarded with a pained expression on Xiao Huang's face. Song knew how it usually went. Gao would hand over cash to Uncle, who would declare the amount in his books as income. Uncle would take his cut and then redirect the money to Gao's chosen destination, probably an account outside of China.

"You can't lose," Xiao Huang said quietly, "nobody loses."

•••

Gao ignored Song, his head bent over a desk which was the size of a table tennis table and which shone like glass. He perched on an armchair of soft dark leather. The wall opposite him was largely taken up by a gigantic screen, with ticker tapes of financial information flickering across it. Hanging on the wall behind Gao's desk was the *Mona Lisa*. She seemed amused by Song's discomfiture.

Gao spoke to Song at the same time as gathering up the papers on his desk.

"Xiao Huang said you're ex-police." His voice was impatient.

"Serious crime squad," Song replied. Gao looked up at him, frowning as he ran his eyes over Song's face and his physique.

"You're big. Xiao Huang said you used to be an athlete…"

"A swimmer."

"Can you handle yourself in a fight?" He asked it in a matter of fact way.

"If necessary."

"Why did you leave the force?"

"Personal reasons."

"Personal reasons?" Gao's lip curled, but he had already lost interest.

"My secretary's told you the terms of your employment?"

Song nodded.

"Then I want you to come with me," Gao said, rising from his chair.

Outside, a brisk wind was whipping up the dust and rain clouds had darkened the sky. There was a black stretch Mercedes waiting with its engine running. A chauffeur held the rear door open for Gao and indicated to Song that he should sit in the front passenger seat. When the driver pulled away from the curb he did so at great speed, and the car swept through the compound, hardly hesitating at the gate, then swinging out into the traffic on the street. Inside the car no one spoke. The driver repeatedly glanced in the rearview mirror, and Song observed that he was checking on the mood of his boss.

Soon they reached a construction site. The building already reached into the gloomy sky, but it was just a skeleton, the bare bones of a structure with no cladding on the exterior and no glass in the windows. A pair of life-sized gold-painted horses guarded the gate, and there was a plaque advertising a sales office, but no one could live or work here in the near future. Song had only to glance at the place to know that whoever the developer was – and he suspected it was Gao – had run out of money. If he was relying on the sale of apartments to finance the completion of the building work then he'd miscalculated badly. The site was next to a dirty river and a gridlocked intersection.

The driver revved the car over the pavement and up onto the forecourt where he braked sharply in front of a crowd of labourers who had gathered up ahead. They had set up a makeshift brazier on top of which a kettle was steaming. Several of the men were smoking. Song, letting himself out of the car, thought they looked a sorry lot. Their short stature suggested a lifetime of

poor nourishment, and they were braced against the wind, heads sunk on shoulders, eyes half closed against the grit in the air. Nevertheless, their stance was one of confrontation, and seeing this, Song had a presentiment of disaster. Gao should have come here with an army of thugs or – and this would have been vastly preferable – not at all.

The chauffeur jumped out of the car and pulled open the rear door for his boss. Gao stepped out, his polished shoes landing in the dirt. He stood for a moment, straightening his tie and eyeing the men. When he started to walk towards them, Song followed. He felt the first few drops of rain fall, and heard thunder in the distance.

"What's this about?" Gao snapped, stopping well short of the labourers. Song came to a halt behind his boss, so that he could scan the crowd. "Who told you to down tools?"

No one answered him. Song felt the contempt that radiated from the workers. Some of them gazed silently at Gao, and some at the stretch Mercedes.

"You said we'd have our money this week," one said at last from the angry silence.
"You'll have your cash if you work," Gao said, "and not a penny if you don't."

The labourer who had addressed Gao now spat into the dirt just inches from his polished leather shoes. Song fancied he could see his boss's toes flinch. "We've believed your promises too many times. We're

returning to our families empty-handed..." The labourer-turned-spokesman challenged Gao, and voices rose in support behind him. "For a year we've sweated blood for you..."

"Your peasant blood is worthless!" Gao retorted, anger carrying his voice easily over the crowd. For a moment there was silence, and then they advanced. Gao took a quick step backwards onto Song's toe.
"Let's get out of here," Gao muttered, fumbling for the car door.

They retreated into the car and the driver locked the doors and started the engine, but before they could move off, the labourers surrounded the car and started to rock it back and forth. Inside the car, Song grasped the door handle to brace himself against the turbulence, but Gao – who had not anchored himself – was being thrown from side to side of the long passenger seat.

"Make them stop!" Gao yelped, "Make them stop!"
"You haven't paid them for a year, you think they'll stop?" Song shouted over his shoulder.
But Gao ignored him. He was shouting at the driver.
"Drive on!" he said, "Drive on!"
The driver gestured helplessly at the windscreen, which was a mass of faces and the palms of hands pressed up against glass which was slick with rain.
"Drive on!" Gao was screaming now, clutching at the back of the driver's seat. "Drive on, or I fire you today."
The driver gave a moan of fear and revved the engine. The construction workers stepped away from the car. The driver revved again, and lifted his foot from the

clutch so that the nose of the car rose. The car moved and gathered speed, but one worker – a skinny young man with shoulder-length hair and a wisp of hair on his chin – had broken away from the crowd and was standing in front of the car, shoulders braced, mouth open, screaming unintelligibly at Gao.

"Stop!" Song yelled at the driver.

"Accelerate!" Gao shouted from the back of the car.

The car lurched forwards. Song closed his eyes, but he felt the impact. He felt the car accelerate away. Swearing, he twisted in his seat to look what they had left in their wake. He saw a figure lying immobile on the forecourt, and then men crowding around.

•••

Back at the villa, Gao paced up and down behind his desk. His voice was high and urgent and he had developed a twitch in his left eye.

"Go back to the construction site – get the CCTV film and destroy it."

"Destroy it?"

"Destroy it. Do your job. Tell them if they want a penny from me they'll keep their mouths shut…"

"You want to buy their silence?" Song had followed Gao back into the house only in order to find out what his boss was intending to do about the man he had run over.

"I don't give a fuck how you do it," Gao yelped, "beat the shit out of them if you have to…"

"He has to be taken to hospital," Song cried out, "you…" Song's voice was drowned out by the noise of a vehicle outside, and angry voices. Gao strode to look out of the window. From where he stood Song could see an open-topped truck pulling up outside the house. Construction workers stood pressed up against each other in its open trailer, the blustery wind whipping their ragged clothes around them.

Men clambered down and waited expectantly, while those still inside bent to lift an object from the floor of the truck. It was long and unwieldy, and they struggled to hoist it up and pass it to the men on the ground.

Gao stepped backwards, with a small exclamation as the object came into full view and he saw that it was a man's body, bloodied and crushed, and wrapped in a sheet that was a makeshift shroud. Grey with shock, Gao turned and hurried over to a panel on the wall, where he flicked a switch, and outside Song saw the heavy iron gates begin to close across the driveway. The labourers saw the gates move too, and they hurried to lay the man's body on the wet ground in the path of the gates. Repeatedly the gates hummed partway closed, then came up against flesh, nudging at the corpse.

Confused by the obstruction, the gates twitched open, then advanced again. Most of the workers were standing staring at the grotesque progress of the gates, one or two of the boldest stepped over the body in their path and approached the front of the house. Now Song could see that the men had come armed with construction tools, with iron bars and mallets.

"Fight! Fight! Fight!" the chant started with one voice and then grew louder. Song watched them. It was possible that they would lynch Gao, he thought. Gao

seized a fat metal briefcase. He hurried to the wall and swung the *Mona Lisa* aside, to reveal a safe. He punched at the keypad, but he was so flustered that he could not remember the combination. He tried again and again, his frustration mounting, glancing over his shoulder at the threatening crowd outside. Song watched his fingers return to the same numbers, time and again, but in his distraction Gao had lost the pattern, and the safe refused to open for him.

There was a crash as a stone was hurled against the window, shattering the pane of glass.
"Shit!" Song muttered.

He went to Gao and took hold of the man's shoulders, pushing him away from the safe and towards the door.

Gao protested, but his fear had sapped any fight he had in him. Song bundled him out of the room and towards the back of the house.

He didn't know the place, didn't know what he'd find, but he knew that a house of this size must have a rear exit. He found a door in the kitchen, and saw with relief that the villa was at the edge of the compound, and that its wall was a perimeter wall.

Outside the rain poured down. Song dragged Gao roughly to the wall and shoved him on top of it, where he clung precariously, rain trickling from his chin and his eyelashes, scrabbling to keep his balance.

Suddenly he plummeted to the other side. Song heard a thump and a shout of pain as he fell.

"I hope you've broken your miserable neck," Song said as he turned away.

•••

This time it was Song who chose the venue, a small noodle café near his home. The owner, Lao Meng, was an old friend, and today he'd given Song the sole use of his small back room. When Xiao Huang arrived, Lao Meng showed him into the room where Song was waiting. He poured two cups of black tea, then left the room, closing the door behind him. A bare light bulb illuminated the room against the premature darkness outside.

"Why did you call me out on a miserable day like this?" Xiao Huang complained, shaking himself like a dog.
"Your man's crazy," Song burst out, "the man's a killer."
Xiao Huang pulled up a stool and sat down.
"Tell me what happened."
"He had his driver mow a man down," Song said, "at the construction site, the workers were protesting because Gao hasn't paid them…"
"He hasn't paid them?" Xiao Huang was interested.
"For a year. They rocked the car, and then Gao had the chauffeur drive at them and he killed one of them, just ran over him!"
Xiao Huang frowned.
"Why didn't the man move out of the way?"
"What?"
Xiao Huang chuckled at Song's expression.
"Why didn't the idiot move?"
For a moment Song stared at Xiao Huang, and in that moment Song experienced a revelation: Xiao Huang's

charm evaporated in front of his eyes.

Song looked away from Xiao Huang and said nothing for a moment, recovering his composure. Then he spoke again.

"Gao has the cash, doesn't he? He could have paid the men if he'd wanted to."

"Oh yes," Xiao Huang said. "Gao has the cash. The bank loan, as far as we are aware, amounts to one million yuan."

Song thought he heard satisfaction in his friend's voice. Xiao Huang's mobile rang. He answered it, mouthing 'Gao' at Song.

"Mr Gao, are you alright?" Xiao Huang asked him, "I've just been hearing about your... problem."

Xiao Huang listened, running his tongue over his lips. Then he glanced towards Song and smiled.

"Yes, he's right here. He did? He saved your life? I told you he was a good man in a crisis... I'll tell him... Tonight? That's much sooner... of course. It's a matter of urgency."

When he hung up, Xiao Huang looked at Song and smiled.

"You're his hero," he said.

"I'll have no more to do with the murdering bastard."

"He's leaving the country in a hurry. You're to drive him to the club tonight. He'll come in alone with the cash, that's the deal. You stand lookout at the door."

Song shook his head and got to his feet.

"I trust you," Xiao Huang stood and gripped Song's arm. "He trusts you."

Song tried to pull away, still shaking his head.

"You'll get a cut," Xiao Huang wouldn't let him go. "You

can take my percentage. There. It's yours. Besides, what else are you going to do? Do you want to parade up and down in a suit of armour all day long?"

Song wheeled around.

"Hey, it was a joke," Xiao Huang laughed, "I had to pay that girl a fortune, she was scared to approach you directly. But it was worth it, you know I love to tease you."

•••

The workers had gone, and with them the corpse. The heavy gates were closed across the driveway. The sky was dark now that evening had truly drawn in, but the front of the house was illuminated by street lights. Song could see no blood. At any rate, he thought, the great raindrops which were splashing on the driveway would have washed it away. The stretch Mercedes was still parked outside, gleaming wetly.

He was surprised to see the construction workers had left its windows and tyres intact. Song tried its doors and found, as he had expected, that in the chaos after the visit to the construction site the driver had forgotten to lock it. As quietly as he could, Song opened the boot. He had brought a heavy bag with him, and this he placed inside the boot. He would not need it until later. Then he pressed the buzzer.

Gao came out to greet him in person at the gate, struggling with an umbrella that threatened to fly off in the wind. He clasped a raincoat around himself awkwardly, and Song was pleased to see that his arm was in a sling, and he had a plaster on his nose.

"You came, you came, that's good," Gao said, ushering him inside and closing the door quickly behind him against the weather. Inside, there were shards of glass and smashed porcelain lying on the floor, and no staff in evidence.

Song followed him into the office. The fat metal briefcase was lying on the desk again. This time it was open.

"I'm going away for a little while," Gao said, his eyes moving restlessly to Song's face, then to the broken window and back. "I want you to drive me to the Hawaii. I have to take care of some business there."
"Where's your driver?"
Gao shook his head and threw up his arms.
"Gone, he's gone."

Song nodded his acquiescence, and Gao turned towards the wall and once more shifted the *Mona Lisa* in order to gain access to the safe. This time his fingers moved easily over the keypad, there was a contented hum from the safe, and the door swung open. Inside, banknotes were stacked high and deep, and Gao piled them into the metal security case until it was full. He snapped the case closed, and then handed it to Song.
"Usually I carry this myself," he said, "but I know I can trust you."

••••

Later, Song stood in the shadows outside the construction workers' dormitory. Song could see the men, illuminated by a bare bulb, gathered on the bunks that crowded one small room. He could hear the men's voices through the half-open window, a roiling wave of outrage and resentment. Sometimes he caught their fantasies of revenge as they were carried in the wind. From where he stood, Song could identify the man who had acted as spokesperson earlier that day. When this man spoke, the others fell silent, and Song could hear what he was saying. He spoke of the need to return the corpse of the man who'd died to his family, he told the men that they must write down what had happened so that there was witness testimony, and said that they would appeal to the authorities for justice. His words seemed to soothe them.

Song shifted his weight. Gao's cash weighed a tonne. He glanced at his watch. It was past midnight. None of them would be asleep, he thought, not Xiao Huang, who would be furious that his friend had double-crossed him and made him look stupid. Not Gao, who would be volcanic at the loss of one million yuan. Song tried to summon up the scene in his head. Gao would have placed the fat metal suitcase on the table. He would have opened it... Gao's jaw must have dropped, Xiao Huang would have gasped, staring at the bags of flour inside. And Uncle – what on earth had he thought? Song wished he had been there. Instead, of course, he had been driving away in Gao's car, abandoning it in the suburbs, lifting from the boot an identical metal case. Then he had hailed a taxi and come here, to the construction site.

Gao would have to leave Beijing, Song thought, he couldn't risk staying to recover his missing money, not after killing a man. Neither Xiao Huang nor his Uncle

had actually lost out, since the money had never been in their hands. Xiao Huang would be sore at his humiliation, of course, and Song thought that perhaps he should lie low until Xiao Huang had got over it. Perhaps eventually Song could persuade him that it had been a prank.

Inside the workers' dormitory, the early morning brought exhaustion, and one by one men processed close to Song to visit the toilet. He let them pass, standing unnoticed in the shadows, until he saw the spokesman.

He allowed the man to visit the toilet and then, as he emerged, still doing up his fly, Song stepped onto the path and seized him, fastening his hand over the man's mouth as he struggled.

He whispered in his ear. "I have something for you."

Still covering the man's mouth, Song wrestled him down so that they were both squatting down. He restrained him, shrugged his bag onto the ground at their feet, unzipped it, and showed him the money inside. The man, moaning with surprise, ceased struggling. His eyes went from the money to Song's face, and there was recognition.

"You know where this came from, and you know what it's for," Song hissed in his ear. "Every one of you must be gone from Beijing first thing."

He nodded, eyes wide, shaking with excitement. Song pushed the bag into his arms and then released him, and the man ran in the direction of the dormitory hugging the money to his body. For a moment, Song watched him go. Then he walked towards the road, and a taxi that would carry him away from the site.

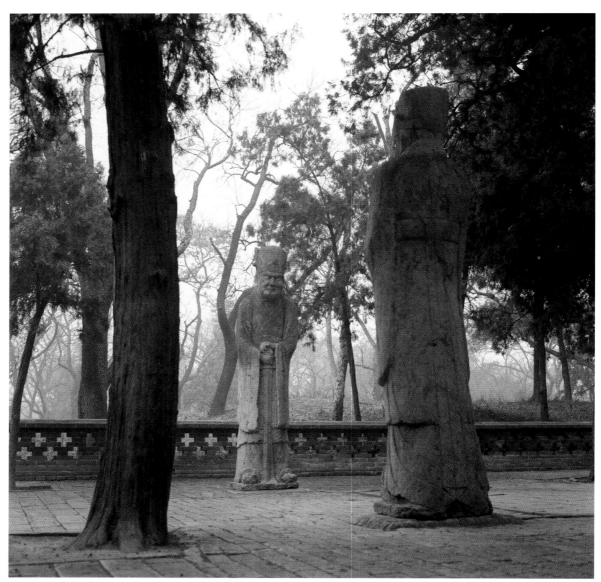

A scene at the tomb of Confucius in Qufu, Shandong

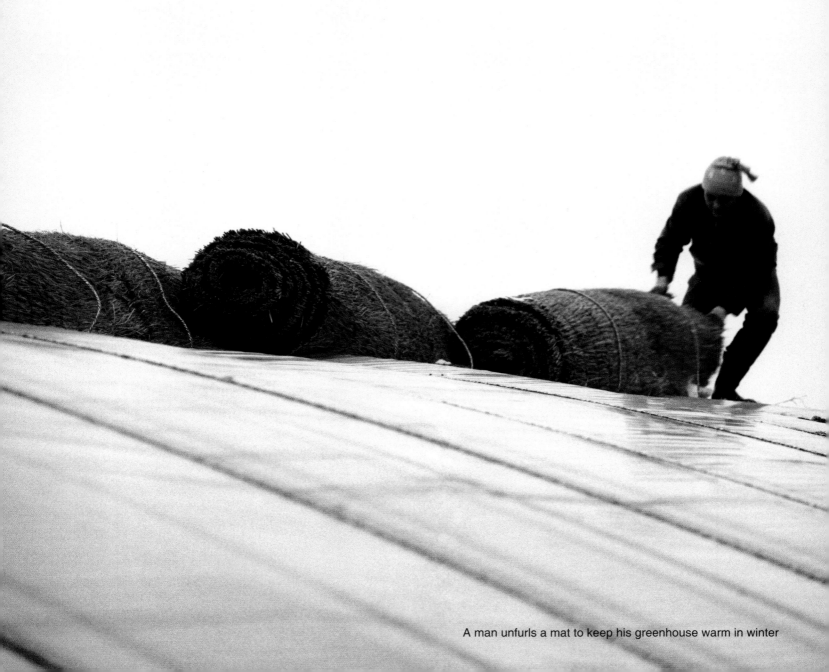

A man unfurls a mat to keep his greenhouse warm in winter

Peter Hessler was born in Pittsburgh in 1969, and spent his childhood in Columbia, Missouri. He studied English and creative writing at Princeton University, and then English Language and Literature at Oxford, before embarking on a six-month period of travel across Europe and Asia in 1994 and 1995. A journey on the trans-Siberian train gave Peter his first taste of China, and also inspired his first published piece of travel writing. The piece ran in *The New York Times*, and was followed shortly after with articles in publications such as *The Washington Post* and *The Philadelphia Inquirer*.

In 1996, Peter returned to China as a volunteer with the Peace Corps, teaching English in the city of Fuling, in Sichuan. With six months to go in his two-year tenure, and the stack of diaries and observations from his experiences growing rapidly, he began work formally on what would become *River Town: Two Years on the Yangtze*. Recipient of the Kiriyama Award (2001) for nonfiction, *River Town*, with its combination of memoir and travelogue, swiftly earned its place as mandatory reading on China. *Oracle Bones: A Journey Through Time in China* followed in 2006. Short-listed for a National Book Award, *Oracle Bones* cemented Peter's reputation as one of modern China's most interesting and panoramic commentators.

In 2001, Peter became *The New Yorker*'s accredited China correspondent, and a regular contributor to *National Geographic Magazine*. He now lives in Ridgway, a small town in southwestern Colorado, where he is writing the final volume in his trilogy of books on China.

Autumn Drive

by Peter Hessler

The night before Wei Jia started kindergarten, he refused to talk about it. The boy was five years old, and he sat in silence at the dinner table. Finally I asked him about tomorrow's journey into the valley, where his school was located. "Are you excited?" I said.

Wei Jia was eating rice and he didn't look up. "Answer your Uncle Monster," Cao Chunmei, his mother, said sternly. That was what the boy called me – a Chinese child always addresses an adult male respectfully as "uncle," even if that adult has a tendency to act like a monster. Whenever I came to the village, I rough-housed with Wei Jia, and usually the boy was lively. But tonight he seemed listless, staring at his bowl. It occurred to me that I had never seen him leave the village before.

"That's OK," I said to his mother. "He doesn't have to answer." Earlier that day, I had driven to the village with Mimi Kuo, an American friend who also lived in Beijing. For more than a year, we had shared a weekend house in Sancha, a farming village that is located about two hours north of the capital. In the past, Sancha had never been a large place, and it had become even smaller since the country's economic reforms began. In the seventies, the population had been over three hundred; now there were fewer than one hundred and fifty residents, because so many people had left to find jobs in the cities. The local school had been shut down in the mid-nineties, and there was no bus service to the village, which was located at the top of a dead-end road. There were no restaurants, no shops – not a single place where a person could spend money. Locals earned their sparse incomes mostly from the walnut and chestnut trees that grew on terraced plots throughout the mountains.

For me, the village represented a retreat. Beijing was the first real city I had ever lived in, and it was hard to get accustomed to having seven million neighbours. But the bustle of the capital was easy to escape – thirty miles to the north, the Beijing Plain gave way to the Jundu Mountains, a line of blue-grey peaks that rose more than three thousand feet above the surrounding fields.

In 2001, when I first began renting in Sancha, it was still unusual for city people to drive to the country-side, and I rarely saw other visitors in the village. It was a good place to write – that was another reason I went there. I kept my desk beside the window, where I could see the Great Wall in the distance. The brick towers climbed up from the valley floor, snaked their way along the folded peaks, and disappeared over the western horizon – on toward the faraway regions of the Loess Plateau, the Ordos Desert, the Hexi Corridor. In the past, a glimpse of the Great Wall always made me think about travelling, but when I saw it from Sancha I thought: This is where I'll stay.

From my desk, the sounds of the village were few and distinct. Wind rustled the leaves of the big walnut tree outside, and occasionally a donkey brayed. Three times a day, the village propaganda speakers crackled to life. They broadcast local announcements, county news, and national events, all of it jumbled together, the Communist Party's words distorted by the echoes

of the valley. Two or three times a week, a peddler's truck rumbled to the end of the dirt road where it sold basic goods – rice, vegetables, cooking oil. Whenever the truck appeared, I heard villagers chattering as they gathered around the makeshift market, but otherwise there were few voices. And rarely did I hear the most basic human sound of all: the noise of children playing. The government's planned birth policy limited most couples to one child, and in any case nearly all young families in the village had moved out. I lived in the upper section of Sancha, a cluster of fifteen homes huddled high on the mountainside, where the Weis' were the only couple with a small child. That was Wei Jia's distinction – he was the last boy in the village.

•••

On the first day of school Wei Jia wore new khaki trousers and a red T-shirt. In the past I had never seen him in clean clothes; all summer he had played around the village wearing nothing but a dirty tanktop and a pair of underpants. For school, I gave him a Mickey Mouse backpack, and his mother put a new pencil box in one of the pockets. Inside the box was a single pencil, freshly-sharpened. The boy still wasn't saying much – he walked in silence to the road, where Mimi's car was waiting.

The school was twenty miles away, down in the valley, where Wei Jia would board with his grandparents. In rural China it's not unusual for small children to live at their schools and return home only on weekends. For Wei Jia's first trip, the entire family would accompany him, and all of us piled into Mimi's Volkswagen Santana. I sat in front with Wei Jia on my lap; the parents took the back seat. Between them sat the Idiot.

Once, I had asked Cao Chunmei what the Idiot's real name was, but she didn't know. He was the only adult that the boy never addressed as "uncle," despite the fact that the Idiot was in fact the older brother of Wei Ziqi, the boy's father. The Idiot had been born in 1948, the year before the Communists came to power, when civil war had raged across northern China. Those had been difficult times, and poverty had probably caused the Idiot's disability. Most likely it had been a lack of iodine: if a pregnant woman doesn't consume enough, she runs the risk of bearing a mentally disabled child. Nowadays, the government ensures that iodised salt is widely distributed in the countryside, and such birth defects have become rare. But there is still an older generation of disabled people, and usually they were addressed simply as *Shazi*: Idiot.

The Idiot lived with the Weis, who made sure that he was clothed and well-fed. In their household he performed simple chores: he swept the floor, shelled walnuts, and searched for kindling along mountain trails. But he couldn't participate in the harvest, and he couldn't cook for himself. He was deaf. Whenever he wanted to communicate, he contorted his face with such passion that it seemed as if the power of speech had fled precisely at that moment and he was just beginning to grapple with its loss. But in fact he had never spoken. The villagers ignored his contorted face, and they never understood why Mimi and I sometimes talked to him, trying to engage him with eye contact. "He doesn't understand anything you say," Wei Ziqi always told me.

I had never seen the Idiot leave the village, and on the first day of school I asked Wei Ziqi if anything was wrong. "It's nothing," the man said. "We just have a little problem to take care of at the government office."

We drove out of the village, and Wei Jia leaned forward with both hands on the dashboard. He rarely saw cars, and the experience of riding in one was a treat. He peered intently out the windows as we descended into the valley of the Huaisha River, where the walnut harvest was already in full swing.

Dozens of farmers carried thin poles, ten feet long and perfectly straight. Some of them rode bicycles to their orchards, the poles balanced across the handlebars like knights at the joust. They used the sticks to knock the walnuts off the trees, and the road was full of discarded husks; they crunched beneath our tyres as we headed south.

At Bohai Township, Wei Ziqi asked Mimi to stop at the government office. She was pulling into the driveway when he finally explained why the Idiot had come along. "The government is supposed to pay a monthly fee to help us take care of him," Wei Ziqi said. "That's the law. I've asked the Communist Party secretary in Sancha about it, but she hasn't helped. So the only thing to do is to come here ourselves. I'll ask them to pay the fee now, and if they don't, then I'll leave the Idiot until they're willing to pay. It's their responsibility."

"You're going to leave him at the office?" Mimi asked. "Yes," Wei Ziqi said. "It's the only way to get their attention." Mimi asked how much the monthly fee should be. "Fifty yuan at the very least," Wei Ziqi said. It was the equivalent of about six dollars. Before Mimi or I could respond, Wei Ziqi had already helped his brother out of the car. He led him through the front gate, past a massive sculpture of silver steel that was accompanied by the township slogan: The Star of the Century. The Idiot's face was blank – he'd been silent since entering the car. Wei Jia kept his hands on the dash while we waited. Five minutes later, the boy's father returned. He was alone. We kept driving.

•••

Wei Jia was the smallest five-year-old I had ever known. He weighed only thirty pounds – he was a finicky eater, and his mother fretted about his health. But his eyes glowed with intelligence, and he had a wiry strength that I rarely saw among city children in China. Since the age of four, Wei Jia had been allowed to roam unsupervised around the village, and sometimes he stopped by my house. If I was writing, I told him to play quietly and leave Uncle Monster alone. He was remarkably good at entertaining himself – there had never been any other children in Sancha, and like many kids in the countryside he didn't have toys. He improvised with whatever happened to be at hand: a rusty rake, a broken plate. Once he spent a full hour on my porch, using an old cart and an empty beer bottle to pretend that he was driving a peddler's truck.

The boy's face was a perfect oval. He had black hair cropped close, and long eyes that sparked when he laughed. His ears were wonderful – that was often the best feature of small Chinese boys, whose ears

stuck straight out, giving them a perpetually startled expression. Neither of Wei Jia's parents was particularly good-looking, but the boy was handsome. Sometimes, if I wanted to annoy Mimi, I'd praise him.

"Wei Jia is so good-looking," I'd say.
"He's ugly," the boy's mother would say immediately.
"He's so smart."
"He's stupid," his mother would say. "Not one bit smart."
"Cut it out," Mimi would say, in English, but I'd continue: "What a nice child."
"He's a bad boy."

Traditional countryside parents avoided flattery – they didn't want to spoil a child, and they were superstitious about attracting misfortune. The only praise that I ever heard the parents give Wei Jia was a single adjective: *laoshi*. The dictionary definition is "honest," but it also conveys a certain sense of propriety that is characteristic of rural people. "Wei Jia is *laoshi*," his parents would say, and that was the closest they came to pride.

<div align="center">•••</div>

We parked at the back gate of the Xingying Elementary School. A teacher greeted us and led us inside; Wei Jia's face was expressionless. He walked into the classroom, stopped dead, and said, loudly, "This place is no good!"

His parents tried to grab him, but the boy squirmed free and ran out the door. He was crying now, rushing back toward the car. "I'm going home!" he shouted. "I don't want to be here!"

His mother followed, while the rest of us lingered for a moment in the classroom. Most of the other children had arrived, and twenty boys and girls sat behind tiny desks, playing with Lego-like blocks. There was a gaping hole in the ceiling, and the classroom was filthy; metal bars covered the windows. I had to admit that Wei Jia had a point – these were by far the worst conditions I had ever seen in a school in the Beijing region.

Outside, the boy stood in the dust beside the car. He was crying harder now, and he struggled against anybody who tried to lead him back into the school. Usually Wei Ziqi was strict with the boy, but the father seemed to sympathise with this particular fear. "Everybody goes to school," the man said gently. "I went to school, and so did your mother. Aunt Mimi went to school, and so did Uncle Monster." The fact that Uncle Monster was educated didn't seem to soothe the boy in the least. The school's loudspeakers kicked on for the daily flag-raising, and dozens of children, dressed in the red kerchiefs of the Young Pioneers, marched in place while the national anthem played.

Wei Jia looked terrified; he had never seen so many children together in one place. By now he was mute – he simply lunged at the car whenever somebody tried to pull him away. It took nearly forty-five minutes to calm the boy down. His father carried him into the classroom; his mother seated him behind a desk. He made another move for the door, but this time they caught him. He cried again, a hard burst, and then he quieted. He seemed exhausted – lines of resignation had crept across his forehead, like the furrows of an old man's brow.

We left as quietly as we could. I asked Wei Ziqi where the bathroom was, and he told me to use the schoolyard fence on the way out. I could hear children's voices – talking, laughing, chanting lessons – while I pissed in the weeds. On the way home the car seemed empty without the boy and the Idiot.

•••

That day, the Idiot escaped twice from the government office. The first time, the cadres caught him just outside the gate. The second time, he made it into Bohai Township, and it took a while for them to track him down. The officials telephoned Wei Ziqi and told him to pick up his brother; Wei Ziqi demanded the subsidy. Neither side would budge, and finally, late in the day, the cadres put the Idiot in a car and drove into the mountains. They dropped him off two miles outside of Sancha. The Idiot had never been alone so far from home, but he found his way back – some instinct must have told him to walk uphill.

I learned all of this later, from Wei Ziqi. He said that his brother had been exhausted and frightened, but otherwise he was fine; nobody in the government office had mistreated the man. They had finally agreed to pass the matter on to the county government, a higher level, and Wei Ziqi believed that he would eventually receive the subsidy. In his opinion, he had handled the situation in the best way possible – he had shown the officials that he was serious.

A week after the incident, I drove back to Sancha, where the Idiot greeted me with a huge grin, pointing at the automobile. I had never seen the man so animated; he kept grunting and gesturing toward the vehicle. I realised that he was telling the story of our trip into the valley. "I know," I said. "I remember." I wanted to apologise; I wished he knew that I hadn't understood the situation until it was too late. But there was no way to communicate my regret, and the Idiot continued his wild gestures. He seemed thrilled to see me again.

•••

Wei Jia's first holiday was National Day, when all Chinese schools have a week off. In the village, the corn harvest had just come in, and the Weis had gathered six hundred pounds of the crop. They stacked it beside their house, and Wei Jia spent a morning climbing and sliding down the bright yellow pile. Afterwards his mother noticed a pattern of bruises across his back and legs – angry smudges of purple that covered every few inches of skin. The boy said he felt fine, but his face looked pale.

Mimi and I had driven to the village in her car, and now I offered to take the boy and his father to the hospital. The three of us drove to Huairou, the nearest city, which is halfway between Sancha and Beijing. A nurse performed a blood test and said that the boy's *xuexiaoban* count was low. I didn't understand the technical term, and I hadn't brought a dictionary with me; but I could see from the woman's face that it was serious.

"His count is only seventeen thousand," she said. "It should be more than a hundred and fifty." She recom-

mended that we go immediately to the Children's Hospital in Beijing, for further tests. But the Children's Hospital was mobbed because of the holiday, and the staff seemed most intent on getting rid of patients.

A harried doctor performed another blood test and told us that the boy simply needed rest; he prescribed Vitamin C and told us to go home. It wasn't until a day later, after I had dropped off the boy and his father and then returned to Beijing, that I was finally able to look up *xuexiaoban* in a dictionary. The term meant "platelet," so I went online and searched for childhood diseases with bruising and low platelet counts. Over and over, the same thing kept coming up: leukemia.

In a panic, I sent e-mails to three doctor friends in the United States, copying the printouts from Wei Jia's blood tests. All three doctors responded immediately, and all of them believed that leukemia was unlikely. Independently, each doctor guessed that it was a condition known as ITP – immune thrombocytopenic purpura. ITP is a disease with unknown causes which is rarely chronic in children; generally, if the patient rests and eats well, it resolves itself within two months. But Wei Jia's platelet count was so dangerously low that a cut might not clot, and there was a risk of sponta- neous bleeding in the brain. "I'd give him steroids or immune globulin," one doctor wrote. Another recom- mended a biopsy to check for leukemia, commenting, "The thing that bothers me the most is that they didn't put him in the hospital to figure all of this out."

I telephoned Sancha and told Cao Chunmei to keep the boy calm. There was no transport in the village, apart from motorcycles, which were too rough for the boy's condition. I called Mimi and we decided that I would borrow her car, and meanwhile she would search for a better hospital in Beijing. While we were talking, my cell phone rang – it was Cao Chunmei.

"His nose won't stop bleeding," she said. She put her husband on the phone. "It's OK as long as he's lying down," Wei Ziqi said. "But if he sits up it starts bleeding again."

"He should be in the hospital," I said. "The doctor made a mistake. Just keep him lying down and I'll be there as soon as I can." I ran to Mimi's apartment to get the car keys. I started the Santana and headed north, cursing the Beijing traffic. If I was lucky I'd make it there in less than two hours.

•••

Like so many villagers, Wei Ziqi had left Sancha as a young man. He was born in 1969, and poverty figured heavily in his childhood memories – as a boy he often ate noodles made from the bark of elm trees. He finished eight years of education at the local school, and then he went to Beijing. He found assembly-line jobs at factories that made various products: electrical capacitors at one plant, cardboard boxes at another. For a spell he worked as a security guard. But he never felt comfortable in the city; he told me that the work routines were monotonous, and he missed the freedom of the countryside. Probably his discomfort also had something to do with his physical appearance. He was quite short, less than five-and-a-half-feet tall, and he

had the dark complexion of a farmer. He was barrel-chested, with squat, powerful legs; his hands were scarred from fieldwork. He looked like somebody who belonged in Sancha, and in the end that was where he returned. After ten years outside, he came back to the village, where he acquired the rights to farm land that had been left behind by other migrants.

Nearly all of Wei Ziqi's peers were gone. Of his eleven classmates from the local school, only three still lived in the village, and all four of Wei Ziqi's able-bodied siblings had left. His path was unusual, but he refused to see it as a retreat. In his mind, the village wasn't dying, and he was convinced that someday there would be opportunities for tourism in Sancha. He kept notes about the village in an exercise book that he called his "Information".

The information featured key data about the village, like altitude and temperatures, and he sketched simple maps with potential sightseeing destinations. On one page, he wrote a draft of a business plan: "If each household uses a small amount of money and big developers invest, we can change our village into a paradise where tourists can appreciate the forest, climb the Great Wall, and enjoy peasant family meals." He listed possible names for a business:

1. Farmyard Leisure Garden
2. Mountain Peace and Happiness Village
3. Sancha Farmyard Paradise

Wei Ziqi often asked me about the outside world, and his questions had a depth that was rare in the village.

Once, we had a conversation about time zones, and I mentioned that if you flew from Beijing to Los Angeles you would arrive earlier than your departure, because of the international date line. For a minute the man was completely silent. He sketched some vertical lines on a piece of paper, and then drew another line intersecting them; he studied the thing until his face lit up. After that, I often heard him explaining the Beijing-LA flight to other villagers. I don't think anybody else ever understood – they simply nodded, a glazed look in their eyes.

•••

I parked the car at the top of the dead-end road. Inside the Weis' house, the boy was lying down. His face was pale and flecks of blood had dried dark around his nose. He didn't say anything when I touched his forehead. "It's a lot of trouble for you," Cao Chunmei said. Usually she had a quick smile, but today her face was drawn. On the phone she had told me that the boy was running a high fever. "Will you eat some lunch?" she said politely. "I already ate," I said. "I think we should go now."

They had decided that Cao Chunmei would stay behind until Wei Jia was settled in the hospital, and she had prepared a change of clothes and a roll of toilet paper in the Mickey Mouse backpack. Wei Ziqi carried him down the hill and into the back seat of the car. The boy lay with his head in his father's lap.

The road from the village is steeply switchbacked, and I drove slowly, so the car wouldn't bounce. After ten minutes, Wei Jia said that he felt sick, and I pulled

over. He made gagging noises and twin trails of blood trickled down from his nostrils. Wei Ziqi dabbed at them with the toilet paper, and soon we set off again.

Autumn is the best season in northern China, and it was a beautiful clear day. The peasants had come to the final crop of the year, the soybeans, and they threshed the hay-like stalks beside the road. We were heading for the closest highway, but an hour of mountain driving lay before us, and I tried to keep calm by focusing on details. We came to Nine-Crossings River – the brightly painted rails of the bridge, the white-barked waterside poplars.

At Black Mountain Stockade, where orchards of walnut trees rose above town, we had to stop again; this time the boy vomited. Finally we reached the valley where the Ming emperors are buried. We passed the faded yellow roof of the tomb of Xuande, the fifth Ming ruler, and then we came to the imperial grave of his grandfather, Yongle. Just beyond that tomb, Wei Ziqi asked me to stop again. The boy spat up something, and then he produced a sickly stream of diarrhoea. He was very pale now and there was no expression in his eyes. We were less than ten minutes from the highway.
"I think we should keep moving," I said.
"Give him a minute," Wei Ziqi said.

We stood in a ditch next to a harvested apple orchard; tour buses streamed past on their way to the Ming tombs. I wondered if any tourists caught a glimpse of the scene: the bare trees in the stark autumn light, the parked car with its lights flashing. The father in the ditch, cradling his son.

•••

For most of that week, Wei Jia ran a high fever. Mimi had arranged for him to be in the children's ward of the Peking University Health Centre Number Three, where the blood specialists were supposed to be good. On the fifth day, Wei Jia's temperature reached a hundred and four degrees. His platelet count dipped beneath fifteen thousand – if it went much lower, there was a serious risk of bleeding in the brain.

Mimi and I visited daily, in part because we knew that Chinese hospitals had a reputation for mistreating people from the countryside. I stayed in frequent contact with my doctor friends in the United States, and I advised the parents that a transfusion should be seen as a last resort. The blood supply in China isn't safe; donors are in short supply and the system relies primarily on people who are paid for giving blood. In China, an estimated one million people have been infected with HIV, and the epidemic has been particularly severe in Henan, just south of Beijing, because of unsanitary donor conditions. Testing practices vary widely from region to region, blood bank to blood bank. Even in cities like Beijing, hospitals usually rely on antibody tests, which are cheaper and less reliable than the molecular diagnostics used by blood banks in developed countries.

On the morning of the seventh day, the doctors gave Wei Jia a bone-marrow test for leukemia. Immediately after the procedure, Wei Ziqi telephoned me and asked to borrow nearly a thousand dollars. The

doctors had decided that the boy needed a transfusion, which had to be paid for in advance. The Weis had a private insurance policy, but it would only reimburse them after the fact, and the hospital demanded cash now. If they borrowed money from relatives, it might take days to organise. Mimi was preparing to leave for a trip to Europe, so I went to the hospital alone. Wei Jia slept fitfully; his mother told me that now he was bleeding from his gums. Accompanied by his father, I introduced myself to one of the doctors on duty. I asked her if the transfusion was critical.

"Who is this?" she said sharply to Wei Ziqi. "Why is he asking questions?"
"He's a writer," Wei Ziqi said proudly.
"I'm a friend, as I just explained," I said quickly. "I have some simple questions about what we should do."
"This isn't his affair!" the doctor said to Wei Ziqi. "You're the parent, and you have responsibility. He has nothing to do with it."
"I just want to make sure that we make the right decision," I said.
"The decision has already been made!" With that, the woman turned her back on me.
People usually granted Chinese-speaking foreigners a sort of exaggerated respect, and like any long-term resident I had learned to use this to my advantage; but I had no illusions about what it really meant. At the root of that respect was insecurity: deep down, many Chinese, especially the educated ones, were ashamed of the way their country might appear to an outsider. In certain situations the shame was more likely to emerge, and in the past I had learned that hospitals could be sensitive places.

The doctor was clearly bothered by Wei Ziqi's faith in my judgment. It occurred to me that together we had brought out the city woman's worst instincts: she treated the peasant with arrogance, and the foreigner with insecurity. There were three nurses and another doctor in the room, and I turned to them...

"Who can I talk to about this?" I said, but they ignored me. I repeated the question – silence. Finally, one of the nurses whispered something, and the others laughed. I felt my face turn red.

"It's very simple," I said. "I'm paying for this. I have to know why he needs the transfusion before I pay the money. If you don't talk to me, I won't pay it."

One of the doctors turned to me. "He needs immune globulin," she said tersely. "If he doesn't get it, there's a risk that he'll have brain damage. Already he's bleeding inside his mouth. We know what to do, and you don't understand anything about it."
"I'm trying to understand as much as I can," I said. "If you speak slowly, it helps. I'm only asking questions because I care about the boy."
"If you care, then let us give him the transfusion!"
I asked if there was a risk that the immune globulin might be infected with a disease.
"Of course there's a risk!" the doctor said. "It could be infected with HIV or hepatitis or something else!"
"Don't they test the blood?" I asked.
"You can't test blood completely," she said.
"I think you can, actually."
"Believe me, you can't!"
"Where does the blood come from?"

"How am I supposed to know?" The woman was practically shouting now.

I backed out of the room with Wei Ziqi. I told him that the blood supply was my main concern, and he nodded calmly. Using my cell phone, I contacted an American I knew who worked in medicine in Beijing. She was familiar with one local organisation that followed international testing standards for blood. We tried to arrange a transfer of blood to Wei Jia's hospital, but it was impossible; Chinese law forbade such a sale. "I know some Chinese doctors who used to work at your hospital," the American woman finally told me. "I'll ask them to check on the blood supply, and then I'll call you back."

I waited in the hospital room with Wei Jia and his parents. During everything that had happened over the past week they had remained completely calm: no tears, no raised voices. Life in Sancha had taught them that there were limits to what you could control, and they were completely pragmatic, even when it came to the health of their child. Wei Ziqi had deferred to me in all the key decisions, even during my argument with the doctor. He had a deep respect for my unseen American medical friends, and he seemed to distinguish between emotion and practicality. It was his son, but the ability to get information was mine, and he waited patiently beside me. At last my phone rang.

"It's pretty good news," the American woman said. She told me that our hospital used the same blood bank as the medical organisation that followed international testing standards. "They haven't ever come up with a

positive for HIV," she said. "That blood bank has been safe so far."

On impulse, I called a doctor friend in San Francisco, but his answering machine clicked on – later he told me that he had been on the graveyard shift in the ER. For a moment I stared at my cell phone, trying to think if there was anybody else who could give me advice. Finally I turned to Wei Ziqi. "I think it's OK," I said.

We went downstairs to the hospital's payment division. Clerks sat behind windows like tellers at a bank, and cash was everywhere: strewn across tables, spinning in counting machines. From my bag, I produced a thick wad of red notes. Without a word, the clerk tossed it into a counting machine and handed us a receipt. Upstairs, the doctors began to prepare for the transfusion. Wei Jia had woken up; the boy looked pale and there was still blood around his mouth. He smiled when I told him that we'd go to the zoo once he got better.

•••

After the transfusion, the boy's fever broke. Within two days his platelet count returned to normal, and it held steady for the rest of the week. The bone-marrow test showed no leukemia. The doctors decided that the condition was in fact ITP, and the worst threat had passed. At the end of that week a group of the boy's relatives came to visit.

There were four men: his maternal grandfather, a great-uncle, an uncle, and a distant cousin named Li Ziwen.

Li was a peasant who had joined the military and then moved to Beijing, where he was now a low-ranking cadre. The rest of the men had come in directly from the countryside. The great-uncle was seventy-one years old, and he told me that he hadn't been to Beijing for almost three decades. The men gathered around Wei Jia's hospital bed. Cao Jifu, the grandfather, put his hand on the boy's back and spoke softly to him. But the sudden attention made Wei Jia shy and he bowed his head, staring down at the bed. The sheets still had red-brown stains from all the blood tests.

After ten minutes, somebody mentioned lunch. Li Ziwen reached into his pocket and pulled out a wad of bills: all hundreds. He dropped the money onto the bed.

"Use this for the child," he said. Wei Ziqi tried to give the money back, but Li refused. They argued gently until Wei Ziqi nodded his head in thanks. The uncle was next, and then the grandfather. The great-uncle went last. He was poorer than the others and his stack included some tens and twenties. The money lay in four bright piles on the bloodstained sheets. The boy looked very small now and he leaned back, away from the bills. There was an awkward silence, and then Cao Chunmei pushed the money out of sight, beneath the boy's pillow. Finally somebody mentioned lunch again.

All of the men went to a restaurant across the street, while Cao Chunmei stayed with the boy. At the restaurant, Wei Ziqi studied the menu intently. When the waitress brought a bottle of grain alcohol, he examined the seal. "Can you guarantee that this bottle isn't counterfeit?" The waitress seemed surprised by the question. "I'm pretty sure," she said. "But I guess I can't say for certain." Wei Ziqi sent the bottle back, and the next one as well. Finally, the third bottle seemed to satisfy him.

When the food arrived, he commented that the fish-flavoured pork was quite good, but the iron-plate beef was disappointing. He complained that they hadn't put the head of the Peking Duck into the soup. He found another dish of dried beef unacceptable and sent it back.

For a moment, I had trouble believing that this was the same man who had stood in the background during the arguments about his son's transfusion. But I realised that for him it was simply logical: the hospital had been a foreign environment, but food was Wei Ziqi's trade, and here at the restaurant he was the expert. The men drank steadily, and the grandfather's face was the first to turn red with the alcohol. He stood up and gave me a formal toast: "We appreciate all of your help with Wei Jia."

Everybody downed a shot. Wei Ziqi told the story of our drive into Beijing, and the men began discussing the boy's health. Wei Ziqi turned to me. "You know," he said softly. "I was frightened during that drive." I told him that I'd been scared, too.

All of the men had turned red and now the toasts came faster. Li Ziwen, the city resident, exchanged shots with the grandfather. "This is the second time we've drunk together," the grandfather said.

"The first time was when Wei Jia was born," Li Ziwen said. "Back then I was in the military, and they gave me two days vacation."

"We drank a lot that day!" the grandfather said. He smiled and tilted the bottle, and together they raised their glasses to the memory of the boy's birth.

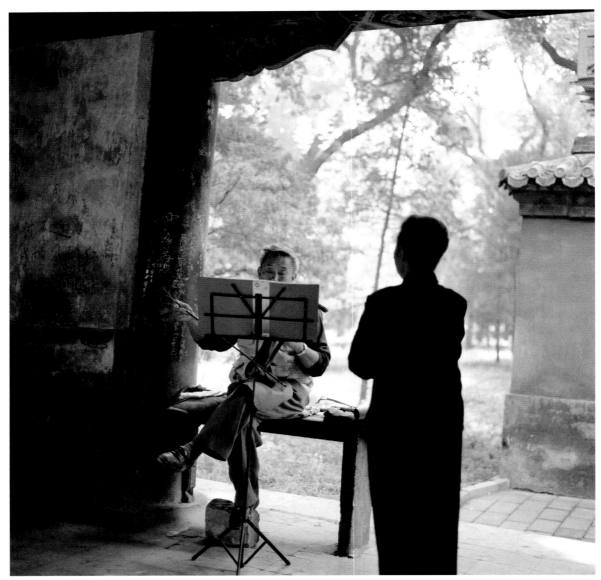
Imperial parks are venues for amateur musicians

Retail therapy for the newly rich

Karen Smith graduated from the Wimbledon School of Art with a degree in Fine Art in 1987, and moved from Britain to Japan a year later to study Japanese art. She moved to Hong Kong in 1989 and became managing editor of *Artention* magazine two years later. She has been at the heart of the contemporary Chinese art scene since her arrival in Beijing in 1992, and is now widely regarded as a leading authority on the subject.

A curator, and prolific writer and critic, Karen has been instrumental in raising the profile of contemporary Chinese art abroad, advising institutions and collectors worldwide, as well as running cultural tours to China on behalf of organisations such as the Tate International Council, the board of the New York Museum and the Museum of Modern Art, New York. She is continually inspired and fascinated by the freshness, diversity and quality of the artistic movement that is unfolding in China.

Her first book, *Nine Lives: The Birth of Avant Garde Art in Contemporary China*, documenting the first generation of avant garde artists who emerged between 1985 and 1989, was published by Scalo to critical acclaim in 2006. A second volume, *From Bang to Boom: Contemporary Chinese Art in the Nineties* is set to follow in 2008.

The Heart of the Art

by Karen Smith

Both in an artistic and geographic sense, contemporary Chinese artists have battled to establish themselves. Struggles on these two levels have been recurring themes in post-Mao China, and while the art has gone many diverse ways, the artists themselves have often tended to cluster together, seeking inspiration, like-minded companions and a sense of security in numbers – a sense, however, that has very often turned out to be misplaced.

Beijing has long been at the vanguard of China's art scene, a movement that has been driven by many different groups, its form as fluid as the socio-political trends that have dominated each period of time. Contemporary art emerged here as society embarked upon the process of normalisation that began in the late 1970s, following Mao's death in 1976, and the introduction of the Reform Policy by his successor Deng Xiaoping in 1978. The art scene was given a further boost by the restoration of university education at the end of the 1970s, and courtesy of the first wave of graduates to leave the art academies in the first half of the eighties.

But these graduates were not strictly the first advocates of new artistic expression and individual creative freedom in the capital: the progenitors were the worker-sons of workers – albeit per force, pseudo working-class families originally of more "bourgeois" heritage who necessarily concealed their intellectual roots under Mao's politically levelling rule. Towards the end of 1978, buoyed by a tentative tide of openness, this small force of would-be poets, painters, sculptors and writers joined forces under the collective name The Stars –

with all its implied aspiration for stardom. They were the first significant art group to form in the capital, and their unofficial, self-organised public exhibitions are now part of contemporary culture's historical legend. The assertion of Beijing as the nation's creative centre owes much to their endeavour.

As is the nature of evolution in China, The Stars established a model that was soon adopted by myriad groups of artists across the country, all with their independent creative ambitions. Their activities reached an unprecedented height in 1985, prompting the proclamation of a New Art Movement. The second half of the decade proved an extraordinary period of experimentation and advance, during which Beijing's new-found prowess as the centre of artistic innovation was ruptured as dynamic coalitions were formed nationwide. These were the days when self-determined relocation to another part of the country on a personal whim was inconceivable. However, by the early nineties, travel restrictions had become more lax, and the will to move of one's own volition demonstrably hardened. Within a few short years, Beijing once again became a draw for young, independent-minded artists, and home to a new wave of avant garde expression; this time, not only in terms of the artistic trends that would dominate the scene, but also due to a new mode of independent existence it offered. This took the form of an unofficial community that would be recorded as the nation's first avant garde "artists' village". The independently-styled communal lifestyle these artists embraced was not exactly welcomed in the capital, where departure from conventional occupations and means of support, official supervision and visibility raised a multitude of

concerns in government quarters. In spite of the fact that contemporary art now appears to have become a legitimate part of the cultural fabric, to some degree, these official concerns remain today. Many of the issues pertaining to the legitimacy of these communities have yet to be resolved.

The process of traversing Beijing's urban landscape in search of security, studio space, and the comfort of their own creative fraternity, reflects the momentous process of urban development and social change that was unfolding in tandem with their quest. Desiring both space and affordable market rates, artists habitually gravitated to the fringe of the city, where, in recent years, economic opportunism has encouraged the exploitation of grey areas within existing, and new, land laws. This has engendered its own brand of harassment; directed at the artists not for political or ideological reasons, but instead because their landlords would often flout zoning laws, then magically disappear at the first hint of trouble, leaving the artists out of pocket and out of studio quarters.

Change in China is both fast and protracted, profound and incremental, especially in the capital. The transient nature of artist communities in Beijing illustrates the uneasy coexistence of these contradictions.

In 1990, quietly, discreetly at first, a community of artists began to take root in an outlying area of the northwestern district of Beijing. It was within a stone's throw of the universities, whose students had precipitated a major political furor only a few months previously, but far enough away for the village

to feel secure. The sense of security was such that, within a year, the unofficial village community had become firmly established, and with it, the model for an idealised mode of artistic existence that drew an on-going procession of new residents from far and wide. To this day, the Yuanmingyuan Artists' Village remains arguably the most famous creative enclave in Chinese contemporary art history.

In hindsight, the location was as much coincidental as inevitable. Under a mood of restraint fostered by the tightening of political reins and individual freedoms in the wake of June 4, artists were compelled to maintain a low profile. Keeping to the fringe of society, on the outskirts of the city, was a natural impulse. Social change created the first vacant homes that could be privately rented, and Fuyuanmen Village was just such a district. The collective was dubbed the Yuan-mingyuan Artists' Village, being close to the Yuan-mingyuan, the ruins of the old Summer Palace.

The artist Qi Zhilong, who arrived there from Inner Mongolia in 1992, explained that "there [were] no peasants living in Fuyuanmen Village anymore, as most of the locals now worked in factories." The factories provided the workers with living quarters, for which the villagers gladly vacated the simple terraced houses typical to the northern suburbs, and the few courtyards dotted in between. It was the perfect environment for artists. "The houses were cheap," Fang Lijun, acclaimed leader of the Cynical Realist style, recalls, citing a figure of one hundred and fifty yuan per month, then less than twenty dollars. Cheap, but still beyond the reach of most artists, and many needed the help of supportive

parents. Fang's parents were not in a position to pay all of his rent but managed to give him 100 yuan a month. There were always ways and means of eking out a living in China, and for many this outweighed the inherent risk of being caught in Beijing without the proper resident's permit. This encouraged the initial trickle of artists to the village – most of them recent academy graduates fleeing the requisite work assignment, or taking a leave of absence from their job.

The proximity to the sylvan pastures of the old Summer Palace was perfectly in tune with the sensibilities of "outcast" artists seeking peace, privacy, and solitude in which to work. Razed by Franco-British allied forces in 1860, Yuanmingyuan had been abandoned for ninety years. The lonely, desolated site, the government decreed, is a silent accusation of the aggressive acts of foreign invaders, serving as an ideal place for "patriotic education". Under the order of Premier Zhou Enlai, Yuanmingyuan was designated a landmark and opened to the public to "remind the Chinese and the world of the destruction wrought by European colonial powers to a harmless and priceless cultural entity that rightly belongs to mankind."

The artists instinctively immersed in the safety of numbers. The desire to be amongst like-minded in-dividuals outweighed any vexation at the very basic existence in what were simple shell structures. Not that any of the new residents were used to higher standards of living, but the use of paper instead of glass to cover the window frames sent a shiver down many a spine as the harsh winter months approached. Most of the buildings lacked heating, or possessed only the most

rudimentary system. And those only functioned if they could afford coal for the stove. Then, there were the outside toilet facilities that in winter brought colour to even the most inured cheeks. Fang Lijun described his living space as looking like van Gogh's. "Not that I possessed an iron bed," he said. "Mine was a board balanced on a collection of bricks. Come to think of it, I didn't have any chairs either."

In addition to Fang Lijun, other early-comers included Ding Fang, painter of emotive metaphysical landscapes, Yang Maoyuan, and the older abstract painter Yi Ling. They were joined by now familiar figures like Zhang Dali, famous for his bald-head graffiti tag, master of kitsch Xu Yihui, painters Qi Zhilong, Xu Ruotao, and those now internationally acclaimed such as Yue Minjun and Yang Shaobin. At the village's height it was home to more than a hundred artists, writers, poets and musicians. Yuanmingyuan was a place in which independently-minded artists could let their creative juices flow. Day to day, their time, their thoughts, their activities, were their own. Yue Minjun jokes that there, he was at last free to grow his hair long.

The swelling population in the village could not escape attention for long. Initially, the attention came not from the authorities but from the media. Artists need an audience, and exposure, and were naturally delighted when journalists from a well-known national newspaper came to interview them. Following these interviews, in May 1992, *China Youth Daily* ran a long report under the headline "The Artists' Village in the Ruins of Yuanmingyuan". The piece carried a distinct undertone of reverence for the romantic lifestyle its

writers deemed the artists enjoyed, and the spirited sense of independence that led to this choice of lifestyle. Qi Zhilong describes 1992 as the year Yuanmingyuan Artists' Village, driven by its new-found fame, became fashionable. The impact of the article was such that "all the artists became carried away in the excitement generated by the public exposure... touched by the exhilaration that comes with leaping into the limelight overnight." This, then, was a delicious first fifteen minutes of fame, and no one had any reason to believe it would be their last. Indeed, other local publications and the foreign press followed suit.

In June 1992, cushioned by the confidence – and the false sense of security – that the media recognition encouraged, the community decided to organise a public display of their work. It was a sensitive time to test the political winds since the month of June marks the anniversary of the student demonstrations. Intrinsically aware of this, and obviously keen not to flaunt too much in the way of the freedoms they were enjoying, the organisers chose to make an open-air show in the depths of a grove of trees out beyond the back of the village. Paintings were literally hung from the trees. The sight of an early Yue Minjun painting, worth perhaps millions of dollars today, haphazardly propped against a tree, is an extraordinary one that few saw but that was captured on camera by Xu Zhiwei.

In such seclusion, the event went unchallenged. But also due to its covert location, it was not well-placed to draw much of an audience – a fact which left the artists deflated. Consequently, a general frustration at their invisibility, fuelled by more false confidence that the first exhibition did not spark an incident, encouraged a spurt of reckless behaviour in December, when students from Peking University invited a dozen or so artists to display their works in the main pedestrian area of the campus. The university authorities were quick to intervene, turning the artists away at the main gate.

The brief protest this incited seemed to have little impact at the time, but it was responsible for placing an ever-tightening net around the community. By straying on to such sensitive turf, the artists had registered themselves on the local security bureau's radar screen, and from that moment on, became a permanent fixture on it.

In 1993, as strategies for removing this "fixture" were explored, the community had regular visits from the authorities. Individuals would be goaded, engaged in "conversation", teased, and when their temper got the better of them, arrested. And sometimes, even if it didn't. Yuanmingyuan remained largely a local issue, a Haidian district problem, which explains why in 1993, Yanhuang Art Museum, in Chaoyang district, was proactive in inviting a number of artists to hold an exhibition. However, when the artists arrived to install their works they found that the exhibition had been postponed – indefinitely as it turned out – due to "previously scheduled activity"; activity which was never seen to transpire.

Undeterred, in September, residents sought permission to hold a large group exhibition at the Beijing Art Museum, but the initial agreement was quickly

withdrawn by higher authorities. As the year wore on, the community fell under ever-closer observation, and the encounters with officers of the law became increasingly less courteous.

Internationally though, 1993 was to be an extremely significant year for the avant garde: ten artists represented the debut of new Chinese art at the Venice Biennale, which included Fang Lijun. Prior to this, in the spring of 1993, two major Chinese exhibitions showed in Berlin and in Hong Kong. The modest spotlight the art enjoyed abroad was reflected back in China, magnifying concerns as to the potentially subversive messages being transmitted to the outside world in the apparent escalation of politically challenging images that characterised the art. Foreign gallerists and curators showed up often at the village.

While the artists welcomed the sales of paintings and the financial support it provided, as well as the affirmation of their art, for the authorities, foreign "interference" exacerbated the perceived need for official investigation and for effective constraints on the artists. This was still the age when a casual conversation could be construed as the extraction, or betrayal, of state secrets.

To outsiders, the new art, especially Cynical Realism, implied a tantalisingly defiant response to the socio-political climate. Its defining motifs – Fang Lijun's yawning, lumbering youths, Liu Wei's vision of post-Mao society indulging in every kind of fantasy, Yang Shaobin's loutish uniformed officers of the law, and Yue Minjun's gaping grins – carried a loaded

appeal. Few foreign visitors could tear their eyes away long enough to take in any other approach. As a result, as 1993 drew to a close, these leading artists had already established quite a name for themselves. They were already consciously seeking to detach themselves from the group, and step up their level of seclusion, more for reasons of privacy than concern for the future of the Artists' Village.

For the vast majority of residents, however, Yuanmingyuan was mostly about being part of a community, and being free of a state-governed work unit. They defined success in terms of happy independence, their dreams of stardom quietly relinquished without too much regret.

As painter Xu Ruotao explained: "We were poor but relaxed. You didn't have to be a great painter as long as you were doing your own thing. It was a lifestyle that was entirely new within China. We lived simply, having nothing but our art, but not in a lonely way for we were part of a community of liked-minded people." There was always a kettle on the stove, and warm beer in the summer, and anything would do as a table if friends dropped by for dinner.

"But the community was always vulnerable to intrusion," he continued, "and we lived in fear of incidents... Once, as I walked home, which happened to be the last house in the village, I knocked on five doors in succession without an answer. I immediately thought that all my friends had been arrested. But there they were at the sixth house having dinner together. I was so relieved. That sense of community helped us deal with

the uncomfortable position we were in vis-à-vis living outside of the political and social system."

Initially, the sense of being outside the system, referred to as being "underground", was exhilarating. The nature and content of the art was definitely problematic on an ideological level for the authorities, which made it a perfect weapon to wield against its creators, even where it was hard to point to anything specifically wrong in the work. Initially, the "problems" with the art deflected attention away from more pertinent social issues that had begun to cloud the urban skyline, and were perceived as a tangible threat to national social stability. The government had not entirely anticipated the emergence of certain social phenomena, such as the first waves of migrant workers to settle in the capital in the early nineties, just one of the many inevitable outcomes of economic reform. Although most artists did not come from peasant stock, and most had certified education, the government policy formulated to deal with "itinerate settlers" made no provision for such subtle distinctions: anyone caught in the capital without a Beijing permit was sent straight back to their native home. This, in turn, became another effective weapon in the fight against the spreading tide of "spiritual pollution" that was consistently perceived to be a threat to the social fabric. Again, as an unofficial community the village was an easy target.

The pressure was exacerbated by tensions between the invading artists and the original farming people. Artists tended to keep outlandish hours; they delighted in late night revelries, weird attire, and encouraged many foreigner visitors – including a steady stream of foreign girls who joined them to see more than a few etchings. The artists' sense of dress was rather provocative: a largely unvarying uniform of baggy trousers, big boots, sloppy jumpers and great coats in winter, an eclectic range of T-shirts and shorts in summer, and a parade of lank long tresses. Then there was the volume of noise pollution they created by indulging in a new-found obsession with western rock music: the heavier the better, the neighbours were forced to conclude.

And then there was the litter. When the first artists arrived, there was very little rubbish on the streets, but soon mounds of empty beer bottles and oily rags mushroomed along every lane. Villagers were also witness to a curious depletion in the supply of cabbage they had laid in store for the winter, as impoverished artists were forced to "acquire" cabbage – and coal – from their farmer-neighbours' stash stacked outside their homes. Each social *faux pas* would prove another nail in the Yuanmingyuan Artists' Village coffin.

The ultimate ending of Yuanmingyuan came in mid-1995, coinciding with the end of the "East Village". This second artist community appeared at the end of 1993, declared itself operational in early 1994, but was only a memory by early 1995, leaving only a legend behind. Did this signal a more determined government campaign targeted against contemporary artists? Not exactly, although the form of artistic expression that the East Village artists preferred clearly attracted the attention of those intent on containing the spread of spiritual pollution. East Village artists' performance works made the so-called cynical thrust of the

Yuanmingyuan painters seem almost academic by comparison. The East Village artists were proudly "performance orientated", every one of them invoked their body as their tool. The East Village itself was located on the other side of the city, far from the bucolic setting of Yuanmingyuan. Its location on the east side of the capital merited a naming that also paid homage to its New York idol.

In 1993, it was home to a mix of hapless locals and migrant workers who were entirely without official employ, and who scraped a living from odd jobs, dealing in scrap metal, and collecting waste products for recycling. There was water on both sides of the "main" road, a small lake of sorts, its banks heaped with garbage, which infected the air with the odour of putrefaction. The people themselves seemed to live under the refuse. The village was "discovered" by several individuals independent of each other, whose pursuit of their dreams led them to converge on this septic isle. First were the musicians, then photographer Rong Rong, followed in late 1993 by the future leader of the clan, Zhang Huan.

Importantly, rents were cheaper than at Yuanmingyuan. The devastatingly supine androgyne Ma Liuming paid eighty yuan per month. "I told the landlord I was a university graduate seeking to better myself in Beijing. They couldn't understand why I didn't want to find a job and a proper place to live... but at least they left me alone." Not for long... when invoked as a tool of art, his waif-like, ethereal body was hugely perplexing for his neighbours: common people unprepared for cross-dressing in their midst. The existence of the East Village was diametrically opposed to that of Yuanmingyuan. The manifesto the East Villagers drew up was specifically intended to disassociate themselves with everything that Yuanmingyuan had come to present as new Chinese art. And oh, the spectacle of the days that saw them go out to prove it...

In September 1993, Zhang Huan and Ma Liuming were present at the opening of the Gilbert & George exhibition in the China Art Gallery in Beijing. As journalists photographed the duo of showmen, Zhang and Ma sidled into the frame. "We were young; we thought it was funny," Ma claimed. Luckily Gilbert and George were amused, and titillated by these rather attractive young men, expressed interest in visiting the village. A time was arranged for the following day, and Ma Liuming decided to perform an impromptu piece. "When they arrived, I was standing, shirtless on a table in the middle of the room... I put my hand on the ceiling and appeared to cut myself. 'Blood' [red paint] began to flow down my arm, my chest." All this unfolded to the sound of Pink Floyd's *The Wall*, before the pale, wan artist was lifted down, signalling the end of the performance. Subsequently titled *Dialogue with Gilbert & George*, to the envy of all others, it went down in history as the first performance at the East Village.

The following June, Zhang Huan performed a now legendary piece called *Twelve Square Metres*. Naked, and covered in fish entrails and honey, he sat absolutely still in a village latrine for an hour. The baking heat extracted a huge volume of sweat, but the flies didn't seem to mind; they covered his body and had a feast. That piece was performed largely for an audience of

one: photographer Rong Rong, although a few passersby from the village raised more than a casual eyebrow to see Zhang finally walk into the local "swamp" to wash off the entrails. Immersing himself, no doubt, in a greater degree of contaminating substances than those brought to the performance. Despite the small attendance, the imagery of the piece became part of the iconography of contemporary Chinese art history,

This time could be called part of Zhang's practical training, as he prepared himself for bigger things, for which he put his body through all manner of tortuous experiences. This included lying naked beneath a circular saw, precisely positioned to catch the rainbow of sizzling sparks that arced out and down as the saw's teeth tackled a thick steel girder. These pieces were all building up to his major work, *Sixty Five kgs*, which also took place that summer in July. On this day, his backyard was choked with an unnatural hush. Neighbours stood, quizzical, in the blazing sun as members of the Beijing art community drifted towards his space. Inside it was hot like a sauna, especially for the Mongolian arts writer Kong Bu (whose pseudonym means 'terrifying'), who was masked like a doctor and swathed in a medical gown, his hands squeezed into the tight, smoothing skin of protective latex gloves.

In the barn-like roof, suspended above the crowd, Zhang waited to begin his piece, lying on a door used as a board until the appointed time. The artist was suspended by chains that cut deep into his body (weighing sixty five kgs, hence the title of the piece) as two hundred and fifty millilitres of blood was extracted from his arm and "cooked" on a tray beneath him. In contrast to the sturdy door that had been his support, the door to the artist's house was particularly flimsy, as was demonstrated a few hours later when local public security officers came for him, keen to elicit the details of his unhealthy, dangerous even, practices.

In spite of the swift arrest – and release – of their leader, Ma Liuming and Zhu Ming decided to go ahead with performances planned for the very next day. As expected, they too were arrested, but unlike Zhang they were held for two months on the charge of performing "pornographic acts" in public. On the quiet Sunday afternoon in question, Ma Liuming appeared naked before curious locals and an invited audience, which included a number of foreigners, in the courtyard which he shared with several other families. This "naked chef" then proceeded to cook a symbolic lunch of rocks and earth. Concerned at the nature of the bizarre spectacle unfolding before them, totally ignorant of how this related to art of any kind, these neighbours immediately alerted the village security bureau. Still naked, Ma Liuming was clumsily wrapped in a blanket and whisked away.

In their attempt to distinguish themselves from the broader new art scene, the image the East Village artists contrived was as radical as their chosen form of expression. In contrast to the long-haired Yuan-mingyuan painters, Zhang Huan shaved his head, alternating between a pigtail or a cropped Mohican, as the mood took him. His chiselled features and piercing gaze were as unnerving to the villagers as Ma Liuming's sexual ambiguity. Their appearance also made them stand out as they went about their

business in the city. Unfortunately for them, this was the moment when official concerns about the profusion of migrant communities in the capital intensified. This took on increased urgency as Beijing prepared to host the International Women's Conference in September 1995. In anticipation of the international attention that would be focused on China during this event, the authorities were keen to have their house in order. This prompted a campaign, launched in July 1995, to dissolve all communities of migrant workers, returning all who failed to register themselves as required by law to the rural provinces from where they came. They were deemed responsible for the thriving black market, illicit trading and gambling, organised prostitution and the documented rise in sexually transmitted diseases in the capital.

In November of the previous year, the government had announced a fee scale for people wishing to become legally resident in the capital; the rates so high as to be beyond the means of a humble worker's pocket. In response, the communities of illegal residents became more closed and furtive, and suspicious of anyone in their midst who was not from their ranks; especially of the new breed of self-styled artists who never seemed to work for a living, and the stream of curious visitors they attracted.

At the close of 1995, the registration campaign came to a climax with the liquidation of Zhejiang Village located in the south of the capital, and the expulsion of thousands of illegal migrants to their rural homes in Zhejiang Province – hence the name the settlement acquired. East Village artists were among the many who found themselves on trains heading home, although this didn't prevent them from returning to Beijing a few months later when the situation had eased.

The denouement of Yuanmingyuan was a more complicated affair, simply due to the number of residents involved. A documentary film titled *Farewell Yuanmingyuan*, produced by artist Zhao Liang, records the final days through the complex emotions of a handful of stalwart residents. One artist describes his arrest, and subsequent deportation on a train headed for a labour camp. Squashed into a cargo compartment with thirty other deportees, he caught the eye of a soldier guarding them. For thirty yuan the soldier turned a blind eye as he squeezed through the one tiny window and jumped from the moving train to freedom. When he returned to Yuanmingyuan, it was all over.

It was the end of an era during which, as Qi Zhilong asserts: "at least symbolically, every single artist who ever lived [in the Yuanmingyuan Artists' Village] helped to establish the identity of an artist as an independent entity in society."

In 1994, ahead of the turmoil surrounding the termination of these two landmark communities, a small group of established artists spearheaded the Songzhuang settlement in a small, laconic village on the fringe of the satellite town of Tongxian in the capital's eastern suburbs. The founding of this art village owed its origins to Fang Lijun, who brought with him five close associates. The basic model remained the same; renting land and courtyards from villagers delighted to extract

an income from homes they no longer required, and which would otherwise lie idle. Today, Songzhuang is conveniently linked to the capital by an express highway. In 1994, it could only be reached by byroads and dirt tracks. It offered ample plots of land and the local people were native to the village, which meant the artists were joining a community which, for once, did not have residence permit issues. In the early days it was a perfect place to make art away from all the distractions attached to being part of an infamous collective – although it would be only a matter of years before Songzhuang became as famous as Yuanmingyuan, enticing an ever-greater stream of visitors.

By comparison with other untamed suburban farming communities, the village was rather idyllic. It was well-kept, thick with trees, and surrounded by cornfields that were luminous green in spring, deep brassy gold in summer, and burnt black as bitumen through the autumn – a dramatic contrast to the brilliance of the harvested corn, which local farmers raked out to dry in neat patches across the village lanes. Through the changing seasons, the air carried the aromas of the fields, of manure, hay and harvest, blended with caustic odours from run-down factories a few miles further out, and the merest hint of the scent of oil paint.

The first wave of artists to move there secured long leases, most of which housed a rustic courtyard, some out-buildings, and enough open ground to erect a studio. The result was a simple home and an expansive area in which to paint. As individual fortunes improved, so did the proportions of the studios. And

as the artists matured in tandem with their careers, they treasured privacy almost more than community, keeping social interaction in line with their own needs and preferences. This produced a harmonious existence that the community preserved in the coming years, even as the concentration of artists greatly expanded. While those with means gravitated towards Songzhuang, many more relocated to the inexpensive apartment complexes in Tongxian proper. This, too, resulted in a significant concentration of artists.

Not everyone saw merit in living so far outside the city limits. A new generation was emerging, and with it a new set of ambitions. In August 1995, the Central Academy of Fine Arts finally relinquished its central location in Wangfujing, moving to a fast-developing suburban area called Huajiadi. Sichuanese artists like Zhang Xiaogang and Chen Wenbo moved here, although it was also home to native Beijingers like Lu Hao.

Realising the potential of defunct factory spaces, some leading artists were keen to find a large acreage of land that could accommodate a studio and living quarters as well as extensive exhibition spaces. One search led to the haphazard village of Caochangdi, just off the new airport expressway. This thriving community of galleries, studios, and residences has helped put contemporary art on the cultural map of Beijing. The measured pace of its development clearly worked in its favour.

By comparison, Dashanzi Art Zone, or 798 as it is more commonly known, exploded into life in 2002 with all

the panache of a shooting star, and for many reasons is in constant danger of fading away. As an expansive complex of cavernous defunct factory buildings, it represented a dream come true to artists, architects, and designers who harboured a newly-formed yearning for "loft-style" living.

The low rates offered in the early days were hard to ignore, even as rumours circulated about plans for demolition. Not given to long-term thinking, a force of creative individuals poured in, scoffing at other rumours concerning the levels of noxious substances permeating the air; a legacy, the government warned, of the factories' former manufacturing operations that it was not in a position to specify. Deemed as a ruse to curtail the community's growth, the volume of residents increased almost weekly. Inevitably, as the battle for legitimacy gained momentum, and triumphed over the opposition, the complex became increasingly desirable, encouraging a sharp increase in rental rates.

A district containing venues for recreational and artistic pursuits, this was the first community open to the public. Its cache was its concentration of culture, art, music, performances, film screenings, bookstores, cafes, and array of quirky trinket stores. While this made it a valuable asset for city life, for residents and visitors alike, it changed the daily existence of artists in its midst. The distracting volume of human traffic and the cost of spaces prompted many artists to relocate. Luckily there was no shortage of choices at this stage as the profit potential of this kind of settlement had attracted the attention of businessmen with access to tracts of land on the city fringes. New studio complexes

popped up in places like Feijiacun and Suojiafen, and the units were snapped up in no time at all.

Suojiafen, however, was to meet a sorry demise. In November 2004, more than a hundred residents were ordered to leave and make way for a fleet of bulldozers waiting at the gate. The community was given less than a day's notice to evacuate. The authorities claimed that the development was illegal, that the developer did not have the required paperwork, and that it would have to be demolished. Although the developer had been told this several months before, he had not informed the community of the problem. The first time the members of the community heard of it they were faced with a large force of police officers, bulldozers in the background, and an ambulance standing by.

Songzhuang is one of the few artistic communities that still stands. In recent years the local media have often commented on how the artists there have adapted to village life, integrating into the local community, even how they have adopted the gestures and vocalisms of the peasant vernacular. It seems the very model of harmonious existence. But here too, as with all previous artist communities, they face an uncertain future. Again, the prospect of redevelopment is looming large.

In 2007, a small number of farmer-landlords began approaching artists in an effort to reclaim the plots of land they had signed away. As the number escalated, legal advice was sought and law suits were filed. In a test case, the court sided with the landlord, on the understanding that compensation would be awarded to the artist-tenant commensurate with the number of

years they had left to run on the lease. This sent shock waves through the art community, many of whom suddenly realised how vulnerable their spaces were.

The local government's power to protect this local artists' community, and its own initiative, the Songzhuang Art Museum, has yet to be tested. And perhaps it never will, but certainly these will be interesting times for the last-remaining, history-making community of contemporary artists in Beijing; the likes of which progress has ensured will not be seen, or perhaps needed, again.

Touching the brass door knobs of the Forbidden City is believed to bring good luck

A shop window dummy lies in the rubble of the hutongs

Paul French has the unusual distinction of holding an MPhil in Socialist Theories and Movements from the University of Glasgow, a programme of study which led him to travel to China and the Soviet Union throughout the late eighties and early nineties. After a brief spell working for *Time Out* magazines and guidebooks in London, he began writing on consumer markets in Asia for various leading British publications in the field. In 1997, he co-founded Access Asia, a firm specialising in researching and reporting on trends in China's consumer markets. He is based in Shanghai.

An impassioned, and certainly eclectic researcher, Paul has published three books to date: *One Billion Shoppers* (co-written with Matthew Crabbe); *North Korea: The Paranoid Peninsula*; and *Carl Crow, a Tough Old China Hand: The Life, Times, and Adventures of an American in Shanghai.*

He has three new titles in the pipeline: *Fat China: How Expanding Waistlines will Change a Nation*; *Through the Looking Glass: The Foreign Press Corps in China from the Opium Wars to the Revolution*; and *A Peking Murder*, a book-length version of the following story.

If Paul's fields of interest seem diverse in the extreme, his approach to their study and exposition is consistent. Consuming himself utterly with a topic for a period of roughly two years at a time, Paul is regularly to be found buried in archives anywhere from Edinburgh to Missouri in search of leads and details, before abandoning each project in hot pursuit of his next obsession.

A Peking Murder

by Paul French

Truth (n.) - Conformity to fact or actuality. The actual state of things.

This is a true story. The events described actually happened in January 1937 and no names, dates or locations have been changed. The murder and horrific mutilation of Pamela Werner, a seventeen-year-old English woman on the eve of Chinese New Year in a dark deserted corner of Peking was to cause panic in a city about to be plunged into total war. As the fruitless hunt for the murderer proceeded, family feuds, triads, bizarre rituals, political intrigue, espionage, drugs and sexual scandal were all to raise their heads.

Theories included a deranged and aggrieved father murdering his daughter, a crime of passion committed by a debauched and mysterious lover, and a politically motivated assassination designed to instill fear into Peking's foreign community. It was a brief *cause célèbre*, irresistible fodder for the press, a conundrum for the police and a subject of obsessive and intense gossip for Peking's overworked rumour mill.

Ultimately Pamela and her murder were forgotten as China descended into world war, civil war and then revolution, by which time there seems to have been no one left to care. Pamela Werner was part of an old China nobody had the time or the inclination to revisit. All we are left with is the certain knowledge that a murder occurred, a young woman's body was horribly mutilated and a killer escaped justice amid the chaos of the times.

Locus Delicti - The place of the offence.

Peking - January 8, 1937

The Western New Year celebrations and a tense Christmas had just passed and few were sure what 1937 would bring for either China, Peking or the tight-knit remnants of the city's foreign community as Japanese aggression towards China heightened. Peking's Chinese residents were preparing for the lunar New Year festival apprehensively.

Pamela Werner was visiting her father in Peking during the holidays from her school in Tientsin from where she was soon to graduate. Sometime after dark she left her father's home on the quiet Armour Factory Alley and rode her bicycle along the road adjacent to the nearby Tartar Wall. Where she was going is unknown; if she planned to meet anyone then we do not know who or why. At 8am the following morning her lifeless body was discovered in a deep ditch near the Wall. She had been dragged from her bicycle and murdered. Most distressingly, her heart and lungs had been removed through a surgically neat circle cut in her diaphragm. There was evidence of recent sexual intercourse.

The murder naturally shocked both the police and the public. Murder may not have been that uncommon in the tense atmosphere of Peking in 1937 but mutilation and organ removal was gruesome even by the violent standards of the time. The British Legation was panicked and launched their own investigation with one overwhelming objective – to prove conclusively that it was not a European who had murdered and

butchered Pamela; to preserve Western 'face'. They were never able to achieve this. Professionals were needed and a Scotland Yard detective resident in Tientsin was despatched to Peking to lead the investigation. He too was unable to discover either why Pamela was murdered or who had committed the crime.

But there were theories and there were suspects.

Ritual Murder (n.) - The murder of a person as a human sacrifice to a deity. A murder committed in such a way as to resemble a sacrifice to a deity.

The English language press, the foreign community and especially the British Legation did not want to countenance that the murderer could be one of their own and so the first theory to surface was that Pamela's murder had been either part of some gruesome triad initiation rite – a ritualistic Chinese killing – or that the heart and lungs were wanted for some sort of medicinal purpose. This theory was popular with British officialdom – either way it seemed to pin the blame firmly on the Chinese.

Immediately the rumour mill swung into operation; but there were problems with the theory. The local police could not recall a murder involving the removal of a heart and lungs for medicinal purposes and their records recorded the last one being over two hundred years before and never involving a foreigner. There were no records of triad rituals involving the removal of a heart or lungs, and though there were some in Peking's foreign community who remembered 1900, the Boxers, the beheadings and the horror of the Siege of the

Legations, organ removal had not been one of their leitmotifs.

The theory ran aground on lack of evidence, motive or justification, despite the official British belief. It may have suited British sensibilities to write the murderer off as an unknown Chinese engaged in some bizarre criminal initiation or pagan rite but Scotland Yard continued to pursue other avenues after quickly dismissing ritual murder. They fell back on what they knew from a thousand murder investigations in the Yard's history – that people with a prior knowledge of, or close relationship to, the victim are most likely to have committed the murder. It was time to look closer to home and stop chasing triad ghosts and pagan shadows. In fact they started their investigation in Pamela's home itself, with Pamela's family.

Filicide (n.) - The act of murdering a son or daughter.

Pamela had grown up in a privileged if not altogether happy family. Her father was Edward Theodore Chalmers Werner, known as ETC, who, by 1938 had retired after many years of distinguished service in the British Chinese Consular Service. He lived alone as a virtual recluse in Peking serving as a member of the Chinese Government's Historiographical Bureau and working diligently on mammoth books about Chinese history and social customs that were read and understood by few, but highly praised by the small coterie of sinologists the world over. His major work to date had been a book called *Myths and Legends of China*, published in 1922, and he was generally regarded as the leading authority on the subject. He

had served in the British Legation in Peking during the Boxer Rebellion and the siege, and had crowned his long career with his appointment as British Consul in Foochow, or Fuzhou as it is now known.

Pamela's mother was Gladys Nina Ravenshaw, the daughter of the wealthy and well-connected Charles Withers Ravenshaw, who had been the British Resident of Nepal and came from a distinguished, landed and titled family based on the estate of Nether Priors in Essex. Gladys had died shortly after Pamela was born leaving ETC a widower. He had stayed in China and raised Pamela even though many in the stuffy British community found him odd – he had not retired to Bournemouth or somewhere equally suitable, he wore Chinese clothes, lived in a Chinese-style dwelling and was generally considered to have 'gone native' – a more harsh insult the more pompous Brits could not imagine. His home was not fit for a young girl like Pamela; his lifestyle completely unsuitable; he was a bad influence.

And there was scandal. At first Werner was seen as an elderly man (he was already seventy-four), a grieving father and, despite his slightly odd lifestyle and interests, a fellow member of the foreign community to be consoled.

However, soon the police and the rumour mill started to speculate that perhaps he was not such an innocent old gent. His reclusive nature did not win him much support from the cliquey and 'appearances before else' higher-ups in the British community. Rumours spread that he was not Pamela's biological father, that after

discovering this he had murdered his wife, that Pamela suspected and disliked him, that she was glad to escape to school in Tientsin and hated having to spend the holidays in a stuffy house in old Peking with an old man she neither loved nor cared for. It seems that ETC was not in fact Pamela's biological father while the rumour that he had killed his wife swirled around him for years unproven.

But ETC was seventy-four – surely too old to have murdered a young, healthy girl. And even if not her biological father he had been her guardian since birth, paid for her school, fed and clothed her – to have killed her and then cut her heart and lungs out with surgical precision? It seemed unthinkable and the police finally deemed it probably physically impossible. He remained a suspect – but not the prime suspect. Even the most hardhearted among Werner's doubters agreed that the old man appeared genuinely distraught at Pamela's death. Indeed Werner himself publicly named the man he believed had been Pamela's lover, her corrupter and finally her killer.

Crime of Passion (n.) - A defendant's excuse for committing a crime due to sudden anger or heartbreak.

Following Werner's accusations the spotlight of suspicion and accusation almost immediately fell upon the Peking dentist Dr Prentice, a man known in the foreign community for more than just his ability to extract teeth and fill cavities. Prentice, who quickly became Scotland Yard's prime suspect, was the best-known dentist in the Legation Quarter and he

was Pamela's dentist and, ETC alleged, her much older lover. She had supposedly had an appointment with him earlier on the day she was murdered.

But what caught the attention of the newspapers was that as well as pulling out rotten molars, Prentice was rumoured to be at the centre of what was politely termed a 'love cult'; what might now be termed a 'swingers' group. While Shanghai's foreign community had built themselves a reputation as a wide-open bunch in the 1930s where anything went, Peking was different. Governed by the diplomatic community, more close-knit than Shanghai, the Peking foreign community retained an almost Victorian tinge. As the Chinese capital had moved south, and commercial activity had centred on the Yangtze Delta, Peking was a virtual backwater by the mid-1930s – neither politically, commercially or militarily so important anymore.

Foreign love cults were not talked about openly but they did fulfill a need. Men could make use of local prostitutes but for the vast majority of European women contact with China and the Chinese around them was limited to servants, and even for those who may have found their surroundings interesting the barriers of language, culture, manners and sexuality were hard, if not impossible, to cross. However, many men in Peking were young, single and in an environment with a deficit of available women of marriageable qualities. Add to this that by 1937 foreigners were in what many considered a dangerous place at a dangerous time with an uncertain future. Perhaps a little added spice took the edge off?

That Prentice ran the cult was also not that surprising. His position as the leading dentist to the foreign community gave him access to a wide variety of people, both men and women, of all ages. As a dentist he could be fairly intimate with them. For many women in particular, Dr Prentice would have been one of the few males they saw alone in relative privacy. This was a position of trust that he could potentially abuse. And, as the papers pointed out at the time – he had ready access to large amounts of opiates and other narcotics. Given the uncertainty of the times – people far from the social norms and constraints of their home society, with money, drugs and a dose of the old High Victorian taste for a bit of perversity – who knows how far the love cult descended into a Bacchanalian orgy? Sadly, the participants were discreet enough not to leave us detailed descriptions. But still, generally, neither dentists nor organisers of orgies commit murder. But then perhaps there was more to Prentice?

At the time, Scotland Yard knew next to nothing about Prentice beyond the fact that he had a direct link to Pamela as her dentist. It was the press that revealed his role as love cult organiser. And the rumour mill, spurred by ETC's allegations, added in that he had probably been in a relationship with Pamela, had lured her into his cult and had provided drugs at his 'events'. None of these accusations were ever proved but the rumour mill asked itself: was this a crime of passion? Perhaps so, but if it was such a crime why were her heart and lungs cut from her chest? Surely this was the work not of a spurned lover but a monster. The rumours swelled and questions about Prentice remain even today.

It is believed that Prentice arrived in Peking around 1934 to set up his dental practice. Even after he emerged as the prime suspect in Pamela's murder most of the foreign community still at least believed him to be a trained dentist and accorded him a certain amount of respect as such. The truth appears to be somewhat different. Prentice first appears on the British Dental Register in 1922 having opened a practice in Wigan, Lancashire. The Register had just been introduced in Britain forcing dentists to officially record themselves. However, the Register did not mean that they were qualified and the law still allowed for untrained dentists to practice. Prentice registered as an unqualified dentist; twelve years later he surfaced in Peking as Dr Prentice, though no record of him ever having qualified at a British dental training college exists. Naturally the 'Dr' prefix did no harm to his standing, business, reputation and fees and it was unlikely that anyone would doubt his qualifications or look too closely at his past in Wigan.

At the time Scotland Yard was unaware of his lack of qualifications and so he was largely dropped from suspicion. Though aware of his flawed character and his social and sexual proclivities many in the close British, and wider European, community in Peking could not bring themselves to believe that a professional man, a doctor no less, could be capable of murder. The professional classes simply did not commit murder, certainly not murders as horrific as this. But then the professional classes and upright Europeans were also not supposed to engage in regular opium-fuelled orgies – but they did and Dr Prentice organised them. More than one upstanding European in Peking had

their reasons for Prentice to be cleared quickly and unequivocally before too much else came to light about his nocturnal activities.

Perhaps the spotlight should have focused on Prentice for longer. Perhaps, despite his unconventional leisure tastes, he was simply no more than Pamela's dentist and occasional lover. Perhaps looking too closely at Prentice and his lifestyle and contacts would have led to too much scandal in the Legation Quarter. Those worried about public embarrassment caught a lucky break – a woman came forward with another theory that largely allowed the press and Scotland Yard to forget Prentice and look in another direction; a direction almost as bizarre as dentists running love cults – one that involved espionage, terrorism and assassination.

Terrorism (n.) - The unlawful use of force or violence by a person or group against people or property with the intention of intimidation or coercion.

After several weeks the investigation had got nowhere. Scotland Yard, the Legation, the press and the Peking rumour mill had all got no further than speculation. Hard evidence and witnesses were conspicuously absent. Bizarre rites, ETC Werner's oddness and supposed grievances; Prentice's rumoured decadence; crimes of passion or diabolical monsters on the loose – all led to a dead end.

Then things changed. A new theory appeared that was alarming and frightening to both the diplomats and the public; the Chinese and the foreigners. It was political and reflected the heightened and frenzied

atmosphere of the city as war loomed and it involved one of the best known foreigners in the city – Helen Foster Snow. Helen, who was also known by her pen name Nym Wales, was the wife of the leftist American journalist Edgar Snow. In January 1937, Edgar was finishing the book that would win him international fame – *Red Star Over China* fame. The book was to feature glowing accounts of Mao's guerrillas and was eventually published in October 1937. It was widely known that Edgar was working on a sensational book that portrayed the Communists in a sympathetic light while also discrediting Chiang Kai-shek's government, and was overtly hostile to the Japanese. Helen was as readily identified with the left wing of Chinese politics and her dislike of Japanese aggression as her famous husband. Clearly they were potential targets for both the advancing Japanese and the fanatically right wing Blue Shirts of Chiang's Guomindang.

The Snows also happened to live two doors down from the Werners on Armour Factory Alley. Edgar and Helen had been at a party the night of the murder. They had arrived home by taxi around 10pm, approximately the time Pamela was killed. The next day Helen heard the news of Pamela's murder and realised that they must have been close to the killing. She read the rumours concerning ETC, Prentice and triads and found them all unbelievable. She thought differently – she thought the killing was perhaps a warning, an act of terrorism – one that had gone terribly wrong and led to the slaughter of the wrong person. The right person, Helen believed, was herself. She became convinced that it was a case of mistaken identity: it was dark; they were neighbours; they both regularly cycled by the Tartar Wall; both Helen and Pamela were roughly the same build; their hairstyles were similar and; though Helen was older than Pamela, in the dark they could have been mistaken for each other. Why kill a harmless teenage girl home for the holidays? It made no sense. Why kill a leftist journalist and the wife of the most notorious pro-communist foreign writer in China? That made a lot of sense in many ways. She declared that, "The Japanese and Chinese fascists had much to gain by frightening both Ed and me into leaving Peking."

The Scotland Yard detective came to see her at her home on Armour Factory Alley. She met a man whose, "...face was pale and green and he was shivering – not only from the cold." The detective was scared as well as getting nowhere. He thought the killer was still nearby and that if Helen was right then he would know he had made a mistake and possibly return to do the job right. Helen was also nervous but Edgar, though publicly laughing off the suggestions of attempted assassination, had still arranged for four bodyguards with swords to protect the house.

Pendente Lite - A case in progress; judgment is pending.

In real life stories don't end neatly. Pamela's story has never been concluded – it is *pendente lite*. A murderer, or possibly murderers, walked away from her mutilated and lifeless corpse and disappeared into the maelstrom of a China on the brink of total war. They may have hidden in plain sight. The inferno of the Second World War that swept across China, and then the world, saved them. Did her killer survive the war? We do not know.

ETC Werner lived until 1954 dying at ninety but never again spoke of the events; Dr Prentice disappeared into history and remains lost to us; Helen Foster Snow recounted the murder in her memoirs written in 1984 but finally decided she had not been the target of an assassination. She died in 1997.

Scotland Yard never came to a conclusion beyond their belief that the killer was clearly insane, obviously a maniac – perhaps one driven by a hatred of foreigners, perhaps one just chancing upon a weak victim on a dark night in a deserted place and taking advantage of the circumstances. That was as far as they ever got. There were too many questions they were not in a position to answer – records of Prentice's past were not readily accessible; forensic science could tell no more than that Pamela had had sexual intercourse recently but not with whom; too much was rumour and there were no witnesses.

Superstitious Beijingers believe that walls have spirits and that even though the vast majority of Beijing's old walls are long gone the spirits remain. But we cannot solve the murder, only recover it from history. And surely remembering Pamela is an important act in itself. Pamela would have been an old lady in her eighties now; perhaps a great-grandmother telling her children, grand-children and great-grandchildren stories of old Peking. But it was not to be – she was dragged from her bicycle, murdered and butchered in 1937 by someone who did perhaps go on to become a great-grandfather who told stories of old Peking – all except one.

Tour groups in Tiananmen Square

Tibetan, Western Mongolian and Eastern Turkish inscriptions order visiting officials to dismount their horses outside the main gate to the Confucian Temple in Beijing

Michael Aldrich studied traditional Chinese culture and Buddhist studies at Georgetown University. In 1984, he received a masters in history, specialising in Chinese-United States diplomatic relations, from the State University of New York. He graduated in law from Columbia University in 1990, and has since worked as an international commercial attorney in Asia for more than fifteen years. He is now a partner in the Beijing branch of the London-based law firm Lovells.

Michael's knowledge of the heritage and history of Beijing is formidable. He moved to the capital in 1993, and in what he describes as a "seminal moment", soon happened upon a copy of Arlington and Lewiston's *In Search of Old Peking*. Armed with that hallowed tome, a fabulous memory and a growing appreciation of Beijing's rich multicultural past, he spent the next decade exploring the city's hidden corners and rummaging through obscure antique markets and bookshops for research materials. His first book, *The Search For a Vanishing Beijing* was published in 2006.

Beijing's utterly cosmopolitan heritage has led Michael down various research paths. His fascination with the city's Mongolian connections, as illustrated here, is matched by his interest in Muslim culture in China. Michael's second book, *The Perfumed Palace: Islam's Journey from Arabia to Peking* is set for publication in 2008.

Batjargal's Secret History of the Mongols

by M.A. Aldrich

Batjargal pours salted milk tea into two flat silver bowls while he courteously cups his right elbow with his left hand. We are seated at a table adorned with starched, nearly brittle, white linen in the restaurant on the second floor of the Ulaan Baatar Hotel, a stern Soviet-style architectural relic. A small park in front of its main entrance hosts a statue of Lenin that is smeared with pigeon droppings. Through the floor-to-ceiling windows of the restaurant comes the sunlight of a late Mongolian afternoon, refracting colours into vibrant three dimensional phantasms. No one else is in the restaurant save a tall sleepy Mongolian waitress dressed in a red velvet uniform and knee-length boots. Bored, for a long while she leans against the wall and stares out into the middle distance. Later she paces up and down, her heels clacking on the pine floor like a metronome. I have just mentioned to Batjargal that Peking has become a cosmopolitan city. He leans forward in his chair.

"We look upon the city that you call Beijing as a Mongolian city. Did you know that?" Batjargal lifts the steaming cup with both his hands and takes a soft sip of tea, closely examining me for my reaction.

"Actually, I prefer to call it Peking. More of a classical resonance. But never mind that. From my reading of Chinese history I know that Kublai Khan built a capital city in what is now Beijing, but it was rebuilt by the Yongle Emperor as a Han capital for the Ming Dynasty."

Batjargal drops his chin on his chest and lets a few seconds hang silently in the air. "There is some truth in what Chinese historians write," he said, "but it is only half the story. It is like composing metaphysical philosophy with only the *yang* and not the *yin*, or any other elements of the cosmos for that matter. Or speaking of time by referring to the day while ignoring the night."

He gestures to the national emblem on a Mongolian flag in the corner beyond his left shoulder, with its assortment of shamanistic symbols representing the universe. "The Han Chinese and our ancestors have been locked in a struggle, sometimes fractious, sometimes not, for more than three thousand years. It is one of the longest running geopolitical Cold Wars, perhaps longer than the one between you Europeans and the Persians."

The waitress clacks by our table, this time more slowly; she is apparently listening in on our conversation. "Your King Leonidas must have had the blood of the Xiong Nu, our ancestors, in his veins," Batjargal says absent-mindedly, as one of my eyebrows shoots up like a question mark. "It is quite possible that there was a connection," he continues, "The steppe was never a barrier to us but an ocean to be traversed, so my supposition about our cultural influences in Europe is not as far-fetched as your myopic history books suggest."

He shakes his head suddenly and returns to the topic of bias in historical records. "Our side of the story always seems to slip past the attention of you China-obsessed Westerners. You study so much from their sources that you pick up all the biases of the Han Chinese."

He lets the comment sink in before continuing, as I shift uncomfortably in my chair. "Our claim to Peking, these days, is simply a moral one that asks for recognition. It is not a political one, and, of course, it is not one to be resolved in violence." Batjargal refills our bowls from a pure white cylindrical porcelain tea pot. "Beijing was called Khanbalik when first built by Kublai. If you favour the classical resonance of older names, then perhaps you should use our name for that city from time to time as well. And our claims to the city are of a more recent vintage than Kublai, by the way."

"How is the Mongolian moral claim on Khanbalik more recent?" I ask, somewhat defensively, as Batjargal has exposed my own bias in a few artfully fired sentences. Batjargal raises both his palms to me in a gesture of acquiescence and nods his head slightly. "Please don't get me wrong, Michael. I have the utmost respect for Chinese civilisation. But there is a secret story about the ties between Peking and Mongolia. We Mongolians tire of never having our story aired."

"The floor is yours, Batjargal," I say, "What is the Mongol side of the story about Peking, nee Khanbalik?" The waitress stops behind my back and pretends to look beyond the scaffolded construction sites to the green felt-covered mountains to the south of the Tuul River Valley.

"There are the official accounts of what goes on in China, and then there are the unofficial stories, the ones that fall out of the official histories, gazettes and newspapers. These days, no one ever takes the official reports of events in China seriously as they are sanitised to keep away... unpleasantness. We Mongols fear the loss of truth, but the Chinese fear the loss of face. The ring of truth is heard only in unofficial reports in China. And so too it was in the past.

"As we approach the Olympics, the Peking government will undoubtedly sing the praises of Zhu Di, the third ruler of the House of the Ming and the man who allegedly transformed the city into a capital. Actually, he was one of ours."

I set the bowl down on the table and ask, "How do you mean he was one of yours?"

"As you know, Zhu Yuanzhang, the illiterate monk-turned-brigand-turned-emperor captured Khanbalik and established the very last Han ruling house in China in 1368. He is known to us by the name Prince Juhe."

"Prince Juhe?"

"We never recognised the Ming government as legitimate so I am reluctant to use his reign name. It may sound like a bit of diplomatic pedantry, but in the early years of the Ming we were no more accepting of our loss of Khanbalik than the current government in Peking is willing to let the island of Taiwan slip away." Batjargal makes a clawing motion with his right hand.

"Zhu Yuanzhang was not a lettered man but he learned of the succession struggles that plagued the Tang and Song from storytellers and classical opera performers in the markets of his native Anhui. Once in power,

he adopted the principle of primogeniture to avoid internecine struggles among his four sons by his main wife, the Empress Ma. He made it crystal clear in the Ming Code that only the eldest son born by the Empress could inherit the throne. In turn, only the oldest scion of that son could become emperor. When Zhu Yuanzhang's eldest son died before he did, his grandson became the next in line to the throne, leaving Zhu Di out in the cold.

"There is another fascinating element to this drama. The Ming official records claim that Zhu Di's mother was Empress Ma. In truth, Zhu Di's real mother was a Mongolian concubine. That is why I assert that he is one of ours."

"Is there only an oral tradition to support this?" I ask.

"Aside from our oral history, there is historical proof," Batjargal says. "Zhu Di built the famed Porcelain Pagoda outside Nanjing as an exercise of filial piety for his mother, whom everyone assumed to be the Empress. It was a splendid structure covered in white porcelain tiles with a circular staircase that wound its way up nine stories and opened onto a balcony at each floor. In the evenings, hundreds of lit oil lamps hung from its eaves. Father Matteo Ricci once commented on the stunning effect of the Pagoda as it shimmered in the evening darkness. When the Taipings pillaged Nanjing in 1856 they broke into the pagoda and found a separate hidden shrine dedicated to the memory of Zhu Di's real mother, the "Consort Kong", which is the Chinese transliteration of the name of a Mongolian woman. Sadly, the Porcelain Pagoda was one of the casualties of the civil war between the Taipings and the Manchu government. It no longer exists, but even the English-language newspapers in Shanghai and Canton at that time carried reports about the secret shrine set up as a filial display of reverence to Zhu Di's real mother."

The waitress returns with another teapot of salted milk tea, which she pours into our bowls cupping her right elbow. She is evidently pleased with Batjargal's discourse and my reaction to it.

"Such a tragedy that a gorgeous monument to a kind Mongolian woman fell to China's domestic disturbances in the nineteenth century," Batjargal adds, as the waitress walks away.

He calls the waitress back and orders two large glasses of *arkhi* and a plate of hardened goat cheese.

"Let me continue. There is circumstantial evidence that also points to Zhu Di's Mongolian roots. He grew to maturity in Peking. There, he was constantly surrounded by reminders of his mother's culture. He lived in renovated palaces that had once served as the grand homes of the Khans, within the walls of what became the Forbidden City. He was nourished on a northern cuisine consisting of milk, yoghurt, cheese, wheat and barley, rather than rice and that dreadful bean curd." Batjargal briefly shudders before continuing. "Zhu Di hunted and ate the game that was felled by his own arrows. No doubt he savoured the four seasons of northern Asia rather than the unspeakable climate of middle China, which is either unpleasantly

humid or brutally hot, or both. He spoke Chinese, the version that you call Mandarin, with the inflections and changes in sound that were accrued on account of five hundred years of northern 'barbarian' dominance." Batjargal gives me a wry wintry smile at the word "barbarian". "And there on the dry plains of Peking he learned to fight on horseback, always an elusive skill for the Chinese until they began to study our tactics, but perhaps one that is not so difficult for a native son.

"Zhu Yuanzhang found it difficult to trust his fourth son, and he was frequently plagued by a nightmare that featured a black serpent coiled around a column in his palace. The royal soothsayers said that it meant that within the royal household lurked a danger against the emperor's succession plans.

"Later, while watching his children play in the Great Within of the Nanjing imperial palace, the emperor saw Zhu Di with his arms wrapped around a column just like the serpent in his dream. Our shamans say that a dream about a black snake signifies betrayal. As you know, after Zhu Yuanzhang died, Zhu Di overthrew his nephew in the course of an usurpation that led to a brief civil war among the Ming.

"We helped Zhu Di with that usurpation. He was crafty. Prior to rebelling against his nephew he cut a deal with us, his half-brothers and half-sisters. If we did not attack his exposed northern frontier during his invasion of central China, he would return Khanbalik to us and, more importantly, allow us to continue to have the fruits of the labour of artisans, which we sorely missed once we had lost Khanbalik. So the deal

was made, and since his mother was one of us, we trusted him. We could have cut his northern flank to ribbons, but we were allies. His nephew's Han army tried to apply Mongolian cavalry tactics, but the vast majority of Zhu Di's troops were Mongols who struck by way of fearsome lightning raids that decimated the soft southerners, who were more suited to riding cows than horses. How else could he have won the war so conclusively within three years? It took our cousins the Manchus four decades to bring all of China under Qing rule."

The waitress arrives with brandy glasses full of *arkhi* and a bowl of hardened goat cheese.

"One should be cautious in mixing one's blood for fear that the worst aspects of each parent's culture will emerge in the offspring. This was true of Zhu Di. He was not filial to his father's choice as successor. And once he gained the dragon throne of the Ming, he reneged on his promise to restore Khanbalik to his mother's people. Do you not realise how much that city had come to mean to us? After the last Yuan emperor Toghon Temur was compelled to evacuate the city, he wrote a lament that is famous among Mongols:

The pride of forty thousand Mongols
The four-gated city of Khanbalik
The blessed country created by the divine Khan
Lose I did to Prince Juhe
What a terrible shame befell me.

I see an opening for a provocative question. "So it seems that the Chinese were not always so incapable

at warfare? You did lose your capital city to them. Without missing a beat, Batjargal replies. "Khanbalik fell to Zhu Yuanzhang because his army for the northern expedition consisted of Chinese Muslims, the descendants of mercenaries that had settled in China during the Tang reign. The Chinese have always depended upon their native-born Muslims to get them out of tight corner."

Letting out a deep sigh, he continues: "We expressed our disappointment at Zhu Di's duplicity in our customary way. We raided north China to recover what had been promised to us. Zhu Di had the temerity to lead an army of Han farmers into his mother's homelands but, in a show of punishment from the Eternal Sky, he died from a fall from his horse whilst in Eastern Mongolia. It was a fitting end for an oily half-Han *politico*.

"Even after Zhu Di's death, we never forgot that broken promise. We nearly toppled the city in 1450 thanks to that lunkhead descendant of Zhu Di, Zhu Qizhen, the so-called Yingzhong Emperor." Batjargal almost spat out the name. "In that year, our herds had suffered on account of an unusually bitter winter. We needed to purchase food and other products from the markets in China but the Ming court refused us. So we raided northern China for our own survival. At the advice of some insipid eunuch, Zhu Qizhen and his army sallied out without the slightest knowledge of combat to 'teach us a lesson.' Of course, his army was decimated. We even managed to kidnap this 'Son of Heaven' but it did us no good. We discovered that there were capable men, like the Minister of War, Yu Qian, who rallied

the forces around Peking and set up a new emperor to maintain continuity of rule." Batjargal shrugs. "We were worn out by the famine, so we were in no position to raise a long siege, and we had that useless imperial hostage on our hands, with the Ming court expressing no interest in taking him back. Once we realised he was not worth a brass farthing, we sent him back, cap in hand, to Peking. Of course, upon his return to Peking he conspired to retake the throne and kill all the competent ministers, like Yu Qiang, who saved the city from us. For perfidy, Zhu Qizhen was certainly cut from the same cloth as Zhu Di."

Batjargal looks off into the distant sunset. "I hear that after maintaining Yu Qian's home as a shrine for six hundred years the Chinese government has torn it down to build a Hong Kong-style skyscraper. Such a worthy adversary. I wonder if he had Mongol blood in his veins."

I try to change the focus of our conversation as the sense of unappreciated recognition hangs too heavy in the air. "Tell me, Batjargal, contemporary Chinese historians spill much ink about the utility of the Great Wall in preventing depredations by their northern neighbours. Wasn't the Great Wall an obstacle to your raids?"

Batjargal is lost in thought, appraising the figure of the red velvet waitress, but he snaps out of his blissful reverie.

"The Great Wall? You mean the Grand Mud Hillock? On this point, Chinese historians know not their own

history, or else they ignore it. From its inception under Qin Shihuang, the Great Wall was only a hard-packed mud wall. And you know the Chinese are not capable of maintenance; in most places we could ride our horses over the eroded walls. Our servant Marco Polo did not even notice it on his trip to Khanbalik. Who notices a muddy embankment? No, it was only when we once again were hit with another brutal winter in 1550 that we again laid siege to Peking in search of produce for our survival.

"We also were at a loss because the Ming government sent in armies that slaughtered Mongols, men, women and children. After those battles the Ming government decided to bolster its defences by paving the wall, no doubt at the advice of some official who had the concession to operate the brick kilns. Even then, it did little to stop any of us northern peoples from launching a successful attack, as the Manchus soon proved."

Batjargal let out a deep sigh. "But we were losing our power by then. Two things changed everything for us; first, we could not cope with the arrival of Western firearms. You have seen that Japanese film *Yojimbo*, yes? Then you understand the unfair advantage presented by gunpowder technology. The firearms blunt the advantages of our skills in horsemanship.

"And second, the *dharma* of Lamaist Buddhism softened our ways of life, which was probably all for the best. From the karma point of view, it explains why we have been on the *yin* side of things for five hundred years, following one hundred and fifty years of expansion.

"Nevertheless," Batjargal says as he points his right index finger into the air, "the loss of Peking still rankles."

I look out the window at the growing storm of traffic jams on Ulaan Baatar's streets. Black SUVs and BMW limousines are in the majority, competing for road space with the occasional bruised and battered Volga or Lada. The eastern sky turns to a deep blue while the sun sets and the moon rises in the east. A few Mongols with ill-fitting grey suits and bad haircuts enter the restaurant and several blue-labelled bottles of *arkhi* are set on their tables. Then, a couple wearing Italian designer labels stroll in and order Campari and soda. My impressions of Mongolia are changing by the minute.

"But, Batjargal, why are the Mongols so obsessed with Peking? After all, your empire included so many fabulous cities: Damascus, Moscow, Kaesong Isfahan, Canton, Krakow, Hanoi, Samarqand. What is the special significance of Peking?" The waitress plays some Chinese techno-pop, drawing a harsh glance from Batjargal. She quickly switches to Bach Cello Suites and receives a warm smile, which she returns to him.

"Peking is different for us because we do not remember it as a city of conquest. We *built* that city." Batjargal crosses his arms and concentrates on his glass of *arkhi* in front of him. "Perhaps I should take you a step back further in time.

"Before our rise to power, Peking was an outpost, a settlement of little significance except for trade. You

know the type; cowrie shells in exchange for beaver skins, a crossroads for people going to more important places. Our cousins, the Khitan Mongols, took that settlement from the Tang in the tenth century and developed it into something more significant. Their traces can still be found in Peking. Do you know the Pagoda of the Temple of Heavenly Tranquility?"

"Outside the West Second Ring Road?" I ask.

"Precisely. It dates from around 1150, the time that our Khitan cousins made the city into one of five administrative capitals for the Liao Dynasty. They also built the Marco Polo Bridge across the Settled Water River to the southwest of the city, which still graces the landscape there.

"And then there is the Pagoda of the Old Man of the Ten Thousand Pines at the Xi Si intersection. I have heard that the Chinese were using it to sell women's lingerie some years back. Imagine! A funerary pagoda for a Buddhist monk who died a thousand years ago being used as a second-rate shop to sell brassieres to undersized Chinese women." Batjargal shakes his head and returns his gaze to the waitress, who evidently would not find anything to fit her at the pagoda's lingerie outlet. He drains the glass and calls for another.

"The greatest transformation of the settlement needed to wait until 1269, when the Great Kublai Khan chose the city to be the capital of the most cosmopolitan dynasty in East Asian history. Kublai's own expansive viewpoints were reflected in the cosmopolitan nature of his upbringing. His mother was a Nestorian Christian, and one of his daughters became a devoted Buddhist nun who took her vows in the Temple of the Clear Pools and Mulberries in the Western Hills. During his education he learned of the cultural variety of our people's empire. He realised the need to establish a sedentary capital from which he could direct his campaign against the Southern Song, and also to impress the Chinese with the fact that his regime had absorbed the more prestigious elements of their culture.

"So he built Khanbalik from scratch in accordance with the Chinese principles of a *wangcheng*, or kingly city, a magic square that would fit perfectly into the cosmological scheme of the universe as his Chinese subjects saw it. His urban designer was a Central Asian Muslim named Ikhtiyar who fashioned a triple-walled city with perfectly geometric concentric boundaries as demanded by the *Zhou Li*, an early Han treatise about governmental order and architectural propriety.

"The heart of the city, then as now, was set out in a perfect chess-board manner. If you mounted the wall at one gate, you would see straight through to the gate on the other side. The street Nanchizi, set one block from the Khan's main palace, was the site for warehouses full of wheat and other provisions, a magistrate's chamber, residences of palace workers and academics, as well as a sheep pen. Other quintessentially Peking streets, like Wangfujing and Bei Changzi, were surveyed and paved at this time. To the north of the back lakes district, the Old Drum Tower Avenue takes its name from a point of reference to Kublai's tower, long a memory

only preserved in a street name. In the western part of the city, our Prince To To built a courtyard home that became the Temple of the Protection of the Country, a major market site until Chairman Mao and his cronies took over the mainland. The Gate of Excellent Scholarship, or Chongwenmen, in the southeast corner of the Tartar City was still called the Gate of Hata well into the last century, in honour of a Mongolian prince named Hata who lived in that vicinity during the Yuan Dynasty.

"You say Peking is becoming a cosmopolitan city? If it is, it follows in the footsteps of Kublai. In his time, Peking was alive with the sounds of cathedral bells and the calls to prayer of the muezzins, Lamaist chants and Armenian plainsong, Persians and Arabs worshipped at mosques within the city, while a diplomatic mission from Ethiopia arrived seeking the famed Central Asian king Prester John to create an alliance against threats from the Mamluks in Egypt; Sumatrans brought their nutmeg and Sri Lankans their cinnamon.

"Whenever Kublai posted a decree, it was written in all the languages of the empire. Kublai even commissioned a Tibetan monk to invent the first universal phonetic alphabet so that our records about things as disparate as rivers in Hungary, mountains in Georgia, priests in India and temples in China could be accurately recorded. *Pinyin*? Psshaw! Even the Koreans borrowed our script for their 'blessed' *hangul*, but please do not ever say that to them. Or if you do, do not stick me with attribution." Batjargal swirls the *arkhi* in his glass and drinks. "While these changes went on, Kublai did not neglect his heritage. Within the confines of the Forbidden City he set up *gers* and decorated them with furs from the hunt and partook of roasted lamb during the celebrations calculated by the lunar calendar." Batjargal leans forward for dramatic effect. "*Our* lunar calendar." I blink. "From the outside, the palace conformed to Chinese propriety. Within, we preserved our ways."

Batjargal continues. "I have always held a warm spot in my heart for the Marco Polo Bridge. You know our progenitor Genghis as a scourge of God, do you not? However, I am certain that you do not know about the journey of Qiu Changji, a Taoist alchemist who lived beyond our empire in Jurchen-controlled Shandong." I admit my ignorance.

In 1222, Genghis summoned the sage from Shandong to visit him at his encampment outside today's Kabul. Qiu dutifully fulfilled his obligation and went to see the Khan, treading over the Marco Polo Bridge on his way through Peking to Central Asia. He later returned and was given highest respect by our ancestors, who first let him stay on the shores of Beihai Park and then later built a monastery for him. You know the White Cloud Temple? It was built by the fiat of Genghis Khan. The Confucian Temple? Likewise, built in the early thirteen hundreds by Mongol emperors of China who appreciated the need for proper administrators versed in Confucian virtues. Even the word 'hutong' comes from our language."

Batjargal's intricate knowledge of the city stuns me. I interrupt him with the question, "How do you know the city so well?" He smiles coldly and answers simply,

"It is my business to know it." I suddenly realise that the Chinese ought not to be too complacent about their northern neighbours.

"The *arkhi* makes me passionate," he continued. "The crowning piece of Khanbalik is the White Pagoda Temple. It angers me that you foreign tourists never visit it." He frowns. "But it is comforting to know how important it is to the Chinese who live in the hutongs, they feel deep affection for this lone sentinel. It is a magnificent white stupa, about fifty metres high, designed in a Tibetan style by a Nepalese architect named Arginer, under the direction of the Muslim urban designer Ikhtiyar for Kublai, the Mongolian Emperor of China in 1271."

Batjargal calls the waitress over and hands her several thousand *tughriks* to pay for our drinks.

"Here in Ulaan Baatar, on the southeast corner of Ghandan Khiid, is a remnant of a Buddhist flagpole, the type that you will find in temples all over Asia. However, this one is different. Our shamans and lamas all tell us that it is a magical conduit between the spirits of the earth and sky. We venerate this pole as it is our way to talk to our ancestors and the spiritual forces around us. It represents the pure essence of Central Asia and is visited by supplicants, night or day, in good weather or foul." Batjargal stands up to put on his coat. The streetlights reflect a slight dusting of snow out in the streets.

"As the Qing Dynasty tumbled towards its destruction, the Chinese *amban* here ordered his guards to saw off the pole at its base as a mean-spirited effort to make us lose our culture. In the first attempt, as the teeth of the saw pierced the bark, the pole gushed blood, frightening the guards away. The *amban* personally supervised the second attempt. About a metre above ground the men tried to cut the pole, only to hear a deafening bellow from its inner core. It carries on as a site of Mongolian spiritual strength, despite Chinese attempts to alienate and destroy it. Somewhat like our moral claim to Khanbalik. Would you like to visit it?"

I nod my head. We drain our glasses of *arkhi* and then together Batjargal and I go out into the night.

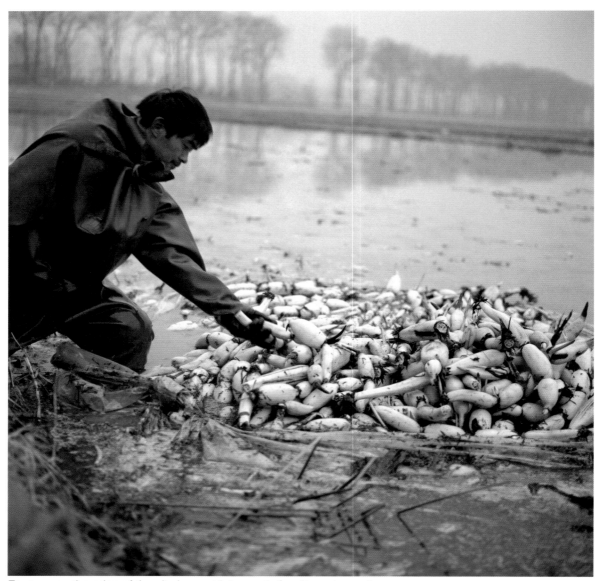

Farmers on the edge of the city harvest lotus roots for city restaurants

If you build it, they will come

Hong Ying was born in Chongqing in 1962, towards the end of the Great Leap Forward. She began to write at eighteen, leaving home shortly afterwards to spend the next ten years moving around China, exploring her voice as a writer via poems and short stories. After brief periods of study in Beijing and Shanghai, Hong Ying moved to London in 1991 where she wrote her first novel. She returned to Beijing in 2000.

Best known in English for the novels *K: The Art of Love; Summer of Betrayal; Peacock Cries*; and her autobiography *Daughter of the River*, Hong Ying has been published in twenty-five languages and has appeared on the bestseller lists of numerous countries. Many of her works have been adapted for television and the big screen.

Hong Ying has long been interested in the stories of homosexuals living in China, a theme explored here and in her short story collection *A Lipstick Called Red Pepper: Fiction About Gay and Lesbian Love in China 1993-1998*. In her work, she likes to focus on human stories, hardship and history. Her responsibility as a writer, she believes, is in part to explore the lives of marginalised groups struggling for visibility – and for compassion – in contemporary China.

北京：中国同性恋之都
Gay Capital

虹影 Hong Ying

餐馆和拉拉

拉拉们近些年喜欢到餐馆，胜过到通常去的北京紫竹院公园聚首。拉拉比男同志喜欢外表装束，流行寸头，以前倒是不能从头发上看出来。她们大都从熟悉或半熟悉的人堆中找自己喜欢的人。东城好几家连锁的台湾餐馆，可见女人们手拉手进去，坐下来，一边吃一边聊。总有好些人用异样的目光盯着她们。

仍在北京东城，有个王府改的餐馆，拉拉们爱去那儿。一进门，那些女服务员打扮成清朝高贵的格格们，高髻插花，热情地招待。这儿像是女儿国，包间里，拉拉们酒足饭饱后亲热地在烟榻上依靠在一起，仿佛从前宫女们为了度过没有男人寂寞日子，彼此以厮磨或抚摸对方身体得到性满足。有时她们在腰间套上一个工具，做爱。

到这儿来的女人，有种心照不宣的感觉。离这儿不远的是后海胡同，一些由小资或外地艺术家开的小餐馆兼酒吧，拉拉面前放着一台笔记本电脑、两盏可口小菜加上啤酒，与一个看上去中意的女子攀谈。相比男同志，女同性恋们几乎没有马上进行性行动，起码表面上不是这样，她们讲究感情世界胜过感观世界。当然并不排斥她们喜欢集体裸舞，或开同性之爱Party。

所以，凡是拉拉的读者，都认为我是拉拉。有时在餐馆里遇到我，哪怕有我朋友在场，也会走过来，介绍自己。有的拉拉介绍完自己后不会离去，若是我和朋友会转场到酒吧，她也会跟着去。一旦认识，马上就有占有欲，机警别的女人对我的态度。有一次我在西单图书城签名售书，一个女同性恋来签名，她要请我去吃上海菜。我客气地拒绝了。我与出版社在人大有活动，她就一直跟着。出版社请她离开。第二天我们去上海，在机场遇到

她，她打扮得非常漂亮，她一直跟到上海。在上海三天，她每天通过旅馆前台给我转来一封长长的信，说她如何喜欢我，信里谈到小时父亲如何抛弃她和母亲，她与不停自杀的母亲相依为命等等。她说她恨男人，也不是对每一个女人会动心，而我，让她丢魂落魄，夜夜难眠。"能不能再见我一次？哪怕一次也好。"她的信似一团火，可是点不燃我。虽然我不想见她，她还是写信来。这种狂追，最后到我回伦敦才停止。

坐在宵云路一家舒适的小餐馆里，面对美食、女人一颗柔软的心，说实话谁能不受到诱惑？C在这儿的一家椰子柠檬东南亚风味的餐馆认识了小凤，两人一见倾心。半个月后，租了一间胡同里的房子开始共同生活。小凤的母亲听到这消息如同雷击，劝女儿回家，但是小凤不听。C在音乐学院毕业，没工作，晚上到五星级的饭店拉大提琴。我见过小凤，她看上去很年轻，短发漂染了几缕黄色，穿牛仔裤，上面套了一件唐装，一说一个笑，非常可爱。一年后我和朋友坐在她俩经常去的这家餐馆，我说起小凤，问她和C怎么样？

朋友说，难道你不知道小凤死了？

我大吃了一惊，摇摇头。

朋友说C在旅馆认识了一个加拿大男人，两人的关系进展快速，到了结婚论嫁时候。小凤伤心之极，采用各种方式拉不回C，最后对C说，她同意C离开，但是要与C告别。一个晚上她与C做完爱后，用水果刀捅死了C，她自己报了警。朋友说，小凤绝望之极，她不能没有C，C比她的母亲更理解她，也比母亲对她好，C对她发誓要一辈子和她在一起。生是同鸟飞，死了做鬼也要在一起。

小凤交代时态度恶劣，故意对抗，被判了死刑。据说行刑那天小凤打扮得漂亮，让母亲送来口红和一件黄色的

连衣裙，高高兴兴地装束好，面带幸福的微笑面对开枪的人。她如愿以偿！朋友连连感叹。而我早已泪流满面。

一对学者女同性恋一个四十岁，一个四十四岁，两人各有住所，各有事业，周末聚在一起，大都爱问我京城有哪家新开张的餐馆，有时是她俩去，有时我们三人在那餐馆见。不过因为她们住在三里屯附近，我们就常去那儿的三个贵州人。水果拼盘来了，一人一手一支香烟，当我们谈到同性之爱时，年长的从皮夹子抽出一张照片来，是一张自拍的婚纱照，两人看上去最多三十岁。照片背后写着一行娟秀的字："我们相爱，我们也想和心爱的人白头偕老。"

她们走在时代前列，那好看的婚纱不过是自我安慰而已，父母反对，亲友蔑视，同事看不起，自然没有祝贺者，更不合法。

公共厕所和男同志

第一次来北京，那还是上个世纪八十年代初，我去路边公共厕所，经过男厕所时，朋友拉着我的衣袖神秘地说，"嘿，那个地方，知道吗，同性恋去那儿相自己中意的人。"

一个穿中山装的中年男子不时探头探脑朝厕所门口瞧，头上摸了油，皮鞋也刷得锃亮，像在等人，等得很耐心，我和朋友上完厕所，那男子还在那里。厕所管理员是个六十岁左右的老太太，她凑近我们跟前说，那人哪，一天都要来好几趟。这种人大都上午就会来，在门口转悠时，碰到有熟悉的，就会跟上去。遇上老太太在里面打扫，就给老太太一毛钱。他们哪，好几个小时才出来。

在北京坊间都知道到东宫西宫去找同志。从上个上个世纪80年代初中期，男同性恋者活动最集中的场所是天安门城楼东西两侧的劳动人民文化宫和中山公园内的公厕。当时同志们就叫这两个公厕为东宫西宫。

这两个地方现在更是成为北京同志们人人皆知的地方，不过也因此，在北京东城一些不错的公共厕所里，尤其在后海三里屯酒吧区一带，同志们在那儿找同路人，而且醒目地用各种笔迹在厕所的墙上，写着"我是你所需要的人，给你小费50元，电话1390577XXXXX。或直接写："同性恋，乘106路电车到XX商场厕所，电话1337411XXXX。"更多只是留了电话号码。公厕管理员即使头天清洗了这些内容，第二天又会被涂上。

小时候，我的邻居胖大叔有一天被公安局带走，说他是"鸡奸犯"，后来看见他挂着这三个字的重重的大木牌被示威游行，听人说，他是那种跟男人乱搞的比流氓还坏的人。那时我十二岁不到，不太明白。只觉得他敦厚，老实，从未和邻居红过脸，在街上遇见人有难处，他一声不响地帮助人。

据说胖大叔经常去江边靠悬崖的隐蔽处，那儿是当地男人方便之处。停留在长江沿岸的水手也上来歇脚。男人爱上那儿，在那儿抽长烟，消磨时间。那个地方很神秘，而且去那儿的人焦急地去，满意地归。后来才知那个露天大厕所就是当地同性恋找性对象的地点。

同性恋在我国最早出现，始于黄帝时代，几乎每个汉代皇帝都有同性恋对象。汉文帝宠幸邓通，赐给他开采铜山自铸钱币的权力，邓通因此而富比王侯，成为中国历史上因"色"而获益最多的男人。唐朝五代，男色之风渐衰，宋朝重新兴盛，元代又衰，明代又复盛，从正德皇帝到下面的大小官员儒生，喜男色，尤其宠男戏子。清代情势并不见逊色，不少小说，如《品花宝鉴》，都

是对同性恋的仔细描写。1949年共产党统治中国之前，中国是全世界同性恋的最后一个乐园，欧洲的王尔德们来到中国，如鱼得水。

我曾在小说《K》里写到哈罗德·阿克顿爵士(Sir Harold Acton)，与我的男主人公朱利安·贝尔有过一段交往。阿克顿生前曾是英女王伊丽莎白二世的好友，三十年代在北京大学教书，他和学生，也是很好的诗人陈世镶在一起，将有才华的中国诗人的作品译为英文，收入《现代诗选》在伦敦出版。华北沦陷日军手中后，阿克顿在北京留了两年，1939年回到英国。他和陈合译中国爱情名著《桃花扇》。陈后来去了美国加州伯克利大学。阿克顿闻讯，追到加州。可是人虽在，乐园已失，面对现实，两人只得分离。

东西方男同性恋都喜欢到厕所去找性对象，是因为方便，因为禁忌，因为秘密。但公共厕所在中国是特殊国情，五十年代对同性恋处罚是二十年以上重刑。总数超过四千万的中国同性恋在这个国家受到禁止，处于地下隐蔽状态，戴着假面具生活。

青岛大学医学院教授、中国同性恋问题研究专家张北川，他的另一个身份是中国最有影响力的同性恋刊物《朋友》的创办者和主要负责人。据他说，中国同性恋的人数在逐步扩大，他作了统计，目前中国同性恋者约有3000万，其中2000万是男同性恋者。目前北京1500万人，同性恋就有30多万。这个共产党的红色心脏，近年更是成为同性恋们争取身份认同和亮相，寻求社会理解他们的同性恋之都。

首次中国同性恋文化节在北京艺术村落798工厂举行时，遭遇北京警方强力干预，被迫停止。1997年北京99575同志寻呼热线开通，1998年8月，北京西山大觉寺同性恋聚会内部举行，1998年10月，全国女同性恋者在北京召开内部会议，2001年和2004年间，北京的民间也组织了两次地下同性恋的电影节，女同性恋者内部交流资料《天空》创刊。

"中国第一同志"－北京电影学院副教授、作家崔子恩，他在课上放映了大量当时还属于禁片的欧洲同性恋电影。因为同性恋事件，学生告发他，他被学校当局惩罚不能教书，调离大学。

如果北京举行同性恋大游行，我愿意走入其中，别人如何看我，我不在意。我会与他们手挽手，同唱一首歌。我们有足够的耐心信心和足够的勇气去争取作为人的权利和自由。希望不久的将来有一天，现在同性恋们的秘密生活不再存在，北京的餐馆只是餐馆，公共厕所只是公共厕所而已。

'Lala' and 'Comrade' are Chinese euphemisms for female and male homosexuals, respectively.

Restaurants and Lalas

In recent years lalas have started meeting in restaurants more often than their customary gathering place of Beijing's Purple Bamboo Park. Lalas are more particular about their appearance than comrades. Crew cuts are popular these days; it used to be you couldn't tell just from the hair. In the Dongcheng district you can often see girls entering fashionable Taiwanese restaurants hand-in-hand. As they eat and chat, people stare.

There's one restaurant in Dongcheng, a former prince's residence, where lalas particularly like to go. As you enter you're greeted enthusiastically by waitresses dressed as Qing Dynasty princesses, with flowers in their high-coiled hair. It's like a kingdom of women. In the private rooms the lalas, sated with food and drink, cuddle together on low couches and, like the palace girls of old who led lonely lives without men, rub and stroke each others bodies for sexual satisfaction.

Compared to comrades, female homosexuals in Beijing generally don't initiate sex immediately, or at least they're less obvious about it; they are more concerned with the world of emotion than with the world of the senses. They tend to choose lovers from among friends or acquaintances. Of course this doesn't prevent group dances in the nude, or holding gay love parties.

I've written quite a bit of fiction about lesbians – about their breakups, their jealousies, their lives as 'kept' women and the spiritual wounds they suffered as children – and I'm often referred to as the spokeswoman of Chinese feminism by the local press. One of my stories has even been the focus of several graduate theses. In it, a group of lesbians form a homosexual club, pass judgment on immoral men, attack their self-respect and social status, and finally use a big pair of iron scissors to shear off their reproductive organs. The story was originally set in the capital Beijing, but the magazine editors got scared and switched the location to Shanghai.

My lala readers all assume I too am a lala. When they see me in a restaurant, regardless of whether I'm with someone, they'll often come over and introduce themselves. Some lalas sit down to join the table, even if they haven't been invited. The more intrusive ones will follow my friends and I after we leave the restaurant. Once acquainted, there's often an immediate desire to possess. When I was signing books once at the Xidan Bookstore, a lesbian invited me to dinner. I politely declined. I went with my publisher to an event at the People's University, and the lesbian came along. The publisher had to ask her to leave.

The next day, on our way to Shanghai, she found us in the airport. She had made herself up beautifully and she followed us all the way to Shanghai. I was in Shanghai for three days, and every day she left a long letter for me at the front desk telling me how much she liked me. The letters described how her father had abandoned her and her mother when she was a child,

and how she and her suicidal mother had depended on each other for survival. The stalking continued until I left for London.

•••

Sitting in a comfortable little restaurant on Xiaoyun Road, faced with delicious food and the tenderness of a woman's heart – honestly, who wouldn't give in to temptation? In a coconut-and-lemon South-East Asian restaurant C met Feng, and the two immediately hit it off. Two weeks later they had rented a house in a hutong and started a life together. Feng's mother received this news like a physical blow and begged her daughter to come home, but Feng wouldn't listen. C had graduated from the music academy and had no work, so she played the cello at five-star hotels in the evenings. I met Feng once; she looked very young, clad in jeans and a traditional man's shirt, her hair streaked with yellow. She had a winning smile. A year later a friend and I were sitting in the restaurant Feng and C frequented, and I asked how they were getting on. "You mean you haven't heard?" my friend asked. I shook my head.

My friend told me C had met a Canadian man and they fell in love, quickly getting to the point of talking about marriage. Feng was heartbroken, but no matter what she tried she couldn't get C back. Finally she told C that she'd let her go, but she wanted a chance to say a proper farewell. C agreed, so one night they met and made love. Afterwards Feng stabbed C to death with a fruit knife, then turned herself in to the police. Feng was in despair and couldn't live without C – she understood her better than her own mother, and treated her better too. C had promised to stay with her forever. They were one of a kind, and if they had to die their spirits would still be together. Feng was given the death sentence. They say that on the day her sentence was carried out she asked her mother to bring her lipstick and a yellow dress, and she made herself up very beautifully. She smiled happily as she faced the person who pulled the trigger. Her wish had been fulfilled. My friend sighed over the tragedy; my face was already wet with tears.

•••

One lala couple I know are both academics, one forty years old and the other forty-four. They each have their own home, their own career – they meet at weekends. They love to dine out and always want to know about new restaurants in Beijing. As they both live near Sanlitun we often eat at the Three Guizhou Men restaurant. Very often, by the time the fruit plate has arrived and cigarettes have been lit, the conversation has turned to homosexual love. This night in the Three Guizhou Men was no different. The elder one pulled a photograph from her leather purse, an amateur image of their wedding. They looked about thirty years old, at most. Handwritten on the back was: "We love each other, and we want to grow old with the one we love."

They were far ahead of their time – the beautiful gowns they wore on their wedding day were a small consolation. Their parents disapproved of them, acquaintances despised them, their co-workers belittled them. They had no well-wishers, much less legal recognition.

Comrades and Public Toilets

I remember the first time I came to Beijing, it was in the early eighties. I went to a public toilet at the side of the road, and as I passed the men's side a friend tugged my sleeve and said in a mysterious voice, "Hey, you know what? That's a place where gays go to meet their lovers."

A middle-aged man in a Mao suit was glancing occasionally at the door of the toilet. His hair was oiled and his leather shoes buffed bright, he seemed to be waiting for someone, waiting very patiently. He was still waiting there as my friend and I left the toilet.

The toilet supervisor, an old lady about sixty years old, sidled over to us: "That man, he comes here several times a day," she said. "Those people mostly come here in the morning and hang around the door. When they see someone they know, they'll follow him in." If they find the old lady sweeping up inside they give her one mao. They don't come out for several hours.

Everyone in Beijing knows that the 'West Palace' and 'East Palace' are the places to go to find gays. From the early eighties the most lively venues for comrade activity were the public toilets of the People's Culture Palace and Sun Yatsen Park, to the east and west of Tiananmen Gate, respectively. Gays call these two toilets the East and the West Palace.

These places are still very popular with the comrades of Beijing, but they've also begun to seek out their own kind in the nicer public toilets of Dongcheng district, particularly in the Houhai and Sanlitun bar areas. They write in eye-catching letters on the toilet walls, "I'm the one you need, I'll give you fifty yuan, my phone number is ...". Or they'll write: "Gays, take the 106 bus to the mall and go to the toilets there, call me on...". Most just leave a phone number. Though the toilet supervisors scrub these messages away, they're always back again the next day.

When I was a child my neighbour Uncle Fatty was carried off by the police. Later I saw him paraded around the streets, carrying a heavy wooden sign with the word 'buggery' printed on it. They said he was one of those guys who fooled around with men, worse than a criminal. That year I hadn't yet turned thirteen and I didn't understand. All I knew was that he was a sincere, honest man who never made trouble for his neighbours; when he saw someone in difficulty, he would lend a hand without a word.

They said that Uncle Fatty often visited a secluded spot by the bank of the river, a convenient spot for local men. The sailors on Yangtze riverboats would also go there to rest. Men loved it there; they could smoke a lazy cigarette and pass the time. It was a mysterious place, where people went in a hurry and returned satisfied. Only later did I learn that the big open-air toilet there was a place homosexuals went to look for sex.

The earliest records of homosexuality in China are from the time of the Yellow Emperor, when nearly every Han Dynasty emperor had a male sexual companion. The Hanwen Emperor doted on Xing Dengtong and

bestowed upon him the authority to mine copper and mint coins. Dengtong thus became richer than a prince, and profited more from sex than any other man in Chinese history.

The acceptability of gay relations waned under the five emperors of the Tang Dynasty, waxed under the Song, waned again during the Yuan, and once again came into fashion during the Ming. From the Zhengde Emperor down to the lowliest officials and Confucian scholars – they all loved men, and were particularly fond of male actors. The Qing Dynasty, not to be outdone, produced plenty of novels like *Pinhua Baojian,* which included detailed descriptions of homosexuality.

Before the Communist Party took control of China in 1949, China was the world's last remaining paradise for gays. The Oscar Wildes of Europe slipped into China like fish into water. In my novel *K: The Art of Love,* I wrote of Sir Harold Acton, who had a relationship with the book's protagonist, Julian Bell. He was a good friend of Queen Elizabeth II, and taught at Peking University in the thirties. He lived with the Chinese scholar and poet Chen Xiang, and translated the works of talented Chinese poets into English, publishing them in London in *Selected Modern Poetry.* After northern China fell to the Japanese, he stayed in Beijing for two years before returning to England in 1939. With Chen he co-translated the famous Chinese love story *The Peach Blossom Fan.* Chen later went to study at Berkeley University in America. Acton followed him to California, but though he found his man, their paradise was already lost – the two of them decided to face reality and part ways.

Gay men in the East and West go to public toilets to find sexual partners because it's convenient, because it's secret, because it's taboo. But the public toilets in China are different – during the 1950s homosexuals were given jail sentences of twenty years or more. So many were outlawed in this country and lived in secrecy, wearing masks.

Zhang Beichuan, a professor at Qingdao University's department of medicine, has another identity: he's an academic authority on homosexuality and the founder of China's most influential publication on homosexuality, *Friend.* He says that the number of homosexuals in China is steadily growing: he estimates there are thirty million nationwide, twenty million of whom are male. Of Beijing's fifteen million people, more than three hundred thousand are homosexual, he says. Beijing is the red heart of the Communist Party, but in recent years it has also become the capital of the gay struggle for acknowledgment, openness and social acceptance.

Some landmark events plot the struggle: In 1997, Beijing's 99575 gay hotline opened; in August 1998, a private gay gathering was held in Dajue Temple in the Western Hills of Beijing; in October 1998, a private national conference of lesbians took place in Beijing; between 2001 and 2004 two underground gay film festivals were held, and the lesbian interior circular *Sky* began publication; when China's first gay culture festival was held in the 798 Factory art centre in 2005 it met with forceful resistance from the police and was shut down. Cui Zi'en, known as "China's Number One Gay", an author and assistant professor at the Beijing

Film Academy, showed his classes many gay films from Europe, illegal in China at the time. He was reported by students for his homosexuality, barred from teaching by school authorities, and dismissed from the university.

If a gay pride parade were held in Beijing I would join in and not care what others thought of me. I would go hand-in-hand with them and sing their songs. We have all the patience, confidence, and courage we need to fight for the right – and the freedom – to be human beings. I hope there will be a day, not long in the future, when homosexuals will no longer have to lead secret lives; when Beijing's restaurants will once again just be restaurants, and the public toilets only public toilets.

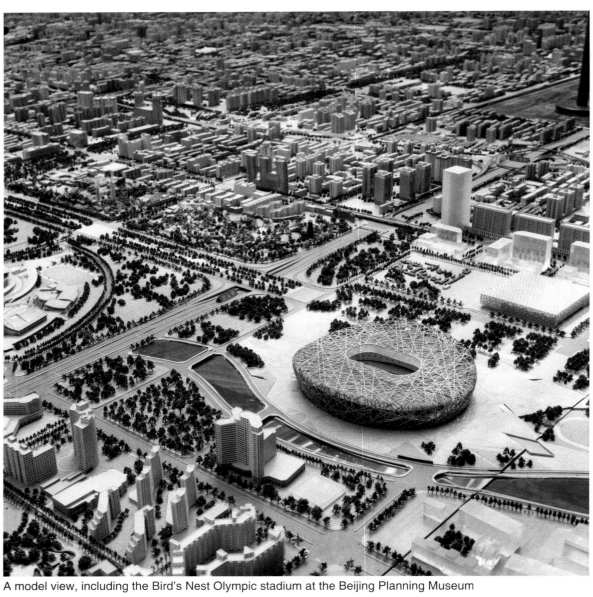

A model view, including the Bird's Nest Olympic stadium at the Beijing Planning Museum

A young worker admires a developing Beijing

Rob Gifford developed a taste for Asia as a child, when he lived in Manila and Singapore. He first set foot in China in 1987 to study Mandarin as part of a Chinese degree at Durham University. He also holds an MA in East Asian Studies from Harvard.

A former BBC producer, Rob has travelled widely throughout China and Asia over the last twenty years, reporting for the BBC and for US National Public Radio. From 1999 to 2005 he was based in Beijing as NPR's China correspondent. Two days after the terrorist attacks on the United States in September 2001, he flew to Pakistan for the first of many reporting trips to the Muslim world.

Although he has always been interested in the bigger picture, he used to say he would never write a book on China. That changed after he made a radio series for NPR about travelling China's equivalent of Route 66. The resulting work, *China Road: A Journey into the Future of a Rising Power,* was published in 2007. The book documents his 5000km road trip along Route 312 from Shanghai to the Kazakh border, exploring the country's social, economic and political contradictions along the way.

Rob is now NPR's London bureau chief.

Return To Centre

by Rob Gifford

The essence of Beijing as a city has always been its buildings. There is no major river here, there is no coast. There are some hills to the west and north, with the Great Wall stretched across them, but there is none of the geographical razzle-dazzle that has created cities like Hong Kong and San Francisco and Istanbul. As the historian Arnold Toynbee noted when he visited Beijing in the 1930s, Beijing as a city owes little to nature and everything to art.

The art of which Toynbee wrote was contained within the ancient walls of the Forbidden City, where the emperor resided at the geographical heart of old Beijing. But the art was also the buildings themselves: beautiful, angular, Chinese buildings, whose presence seeped imperial significance down into the dusty soil, sanctifying an otherwise unremarkable spot on the North China Plain.

The man responsible for much of the old city was the Yongle Emperor of the Ming Dynasty. On his orders, between 1405 and 1421, thousands of workmen constructed a new capital, on the foundations of the Mongol city built by Kublai Khan more than a century before. The city would not just be capital of China, but capital of the world, and indeed the cosmic centre of the universe.

Europe had yet to rise, and China at that time, though a little past its heyday, was still the world's economic superpower. With no competitors, the emperor was confident of his and his culture's moral and economic superiority, and the capital that Yongle built was fit for the throne of the Son of Heaven. Constructed according to ancient rules of geomancy, and surrounded by suffocating layers of inner and outer walls, its symmetry reflected the cosmic symmetry which the emperor sought to keep in balance through his just and harmonious rule. In traditional Chinese thinking, all under heaven belonged to Yongle, the world revolved around his domain, and so the word for China in the Chinese language was *Zhong Guo* – the Middle Kingdom.

But such cosmic (and terrestrial) equilibrium was hard to maintain indefinitely. After a final, fatal flowering under the Qing Dynasty in the eighteenth century, China, and Beijing, went into a death spiral of humiliation and semi-colonisation. By the nineteenth century, Western incursions had transformed it from Alpha Male Middle Kingdom to Sick Man of Asia, struggling on the periphery of the modern world.

Now, though, the wheel is turning once again.

You can still visit the heart of Yongle's spectacular Forbidden City, its yellow roof tiles, heavy with history, weighing upon the maze of rich red walls. But when China's current emperor, President Hu Jintao, declares the Games of the XXIX Olympiad open in August 2008, he will be looking out on a city, and on a country, that has torn down many of its walls – both actual and metaphorical.

Hu will also be standing in one of the most talked-about buildings in Asia. Designed by Swiss architects Herzog and de Meuron, the Beijing Olympic Stadium

has been dubbed the Bird's Nest by its designers, on account of the strands of silver steel that weave their way around the outside of the stadium itself. In fact it looks as though a shiny silver spaceship has landed amid the smudged browns and the dull greys of northern Beijing. Certainly its design is alien to any Chinese architectural tradition. But that's the point. Large parts of Beijing are being rebuilt along Western lines, not laden with the heavy symbolism of Chinese tradition, but exploding with the sparks of Western post-modernism. The Bird's Nest is seeping its own twenty-first century significance down into the still dusty soil of the North China Plain.

Beside the Olympic Stadium stands another huge blob of Western post-modernism. Known as the Water Cube, and designed by Australian architects PTW, this is where all the Olympic swimming and diving events will be staged. Its angular, rectangular exterior is made up of a honeycomb of blue bubbles – a design probably not considered by Yongle's architects in the Ming Dynasty.

Further south, near the heart of the city, stands another monument to the changed Chinese psyche: the new headquarters of China Central Television. Designed by Dutch maestro Rem Koolhaas, and budgeted to cost a cool US$600 million, its toppling twin towers emerge from the confused Chinese earth to embrace each other in mid air.

Just along the Avenue of Eternal Peace stands the titanium egg that is the new National Theatre. Its smooth curves clang with the Ancient-Greece-meets-Soviet-Union angles and pillars of its neighbours in Tiananmen Square. There, eyed warily by the portrait of Chairman Mao, a huge clock counts down the minutes and seconds to the opening ceremony of the Beijing Olympics.

These new architectural masterpieces are monuments to the rule-breaking individualism that is breaking out in China's cities. They are daring experiments that stand out like candles on a celebratory coming-of-age cake, symbolising the psychological break that China has made with its past, as it has emerged into the brave new post-Mao world. They speak of the psychological transformation of the urban Chinese mind, wanting to jump into the post-modern, while in many parts of the country, there is barely a modernity to be post.

The rest of New Beijing cannot claim such a thoroughbred architectural pedigree, but there is no doubt that it too has been transformed. The city has perhaps changed more in fifteen years than it did in the previous five hundred. Beijing is finding a character of its own, more important than simply what it represents. Walls have become windows. The old enclosed courtyard houses have been replaced by bright, airy apartment buildings and office blocks. The walls in Chinese minds have become windows too, as Chinese people step out boldly into the world, redefining themselves just as they are redefining their capital.

The changes have come at a price. The government has bulldozed whole neighbourhoods to create the new vertical city from the carcass of the old horizontal one. The Forbidden City and other tourist crowd-pleasers

aside, developers have not been kind to Beijing's history, as capitalism outdoes even communism in its frenzy of iconoclasm.

The heart has been ripped out of the old city. Old Beijing has been destroyed. The hutongs, some of which date back to the time of Mongol rule before the Yongle Emperor, have been demolished to make way for the symbols of the new Beijing. The traditional sounds of the hutongs are being drowned out by the wrecking ball sent to destroy them. The smells of old Beijing have evaporated into the dust. Many do not lament their passing and relish the thought of a new well-heated apartment with indoor plumbing. There have been complaints, but they run up against one of China's few remaining walls: the wall of Communist Party power.

Who knows if that wall too will crumble? Who knows whether the smashing of the symmetry, the disregard for cosmic balance, heralds something more than just an architectural transformation?

For now, those questions – and many others – have been put on hold. For now, the dazzling ziggurats of Beijing herald a Chinese Renaissance – flawed, costly, but real nonetheless. The glass and metal, the curved edges and the winking windows declare that China is open, like it never has been before. They declare that China is looking forward and outward, like it never has before. And they declare that Beijing – the imperial city, the capital city and now the Olympic city – has once again become the centre of the world.

Acknowledgements

Alex and Lucy would like to thank: Tim Clissold and James Kynge for their early support and encouragement throughout; the contributing authors for their generosity and enthusiasm; Peter Goff for his painstaking and clear-sighted editing; Jenny Niven for her revealing and personal insights into each author; Magnus Bartlett for running with the idea; Li Suk Woon, Jack Zhang and Max Zhu for printing and design.

Thanks also go to: Andrew and Joyce Pearson, David Cantalupo, Fu Jia, Karin Finkelston, James Lindsay, Stephanie Hallford, Matthew Durnin, Jim Harkness, Dan Brody, Aoife O'Loughlin, Liu Rui, Flora Drew, Rebecca Trigger, Bridget Rooth, Liu Xudong, Xia Zhongxing and Dragon Du at 798 Photo Gallery.

For beautiful cameras, and knowing how to use them, Lucy would also like to thank David Cavender, Martin Cavender, Ignatius Woolf and Jane Bown.

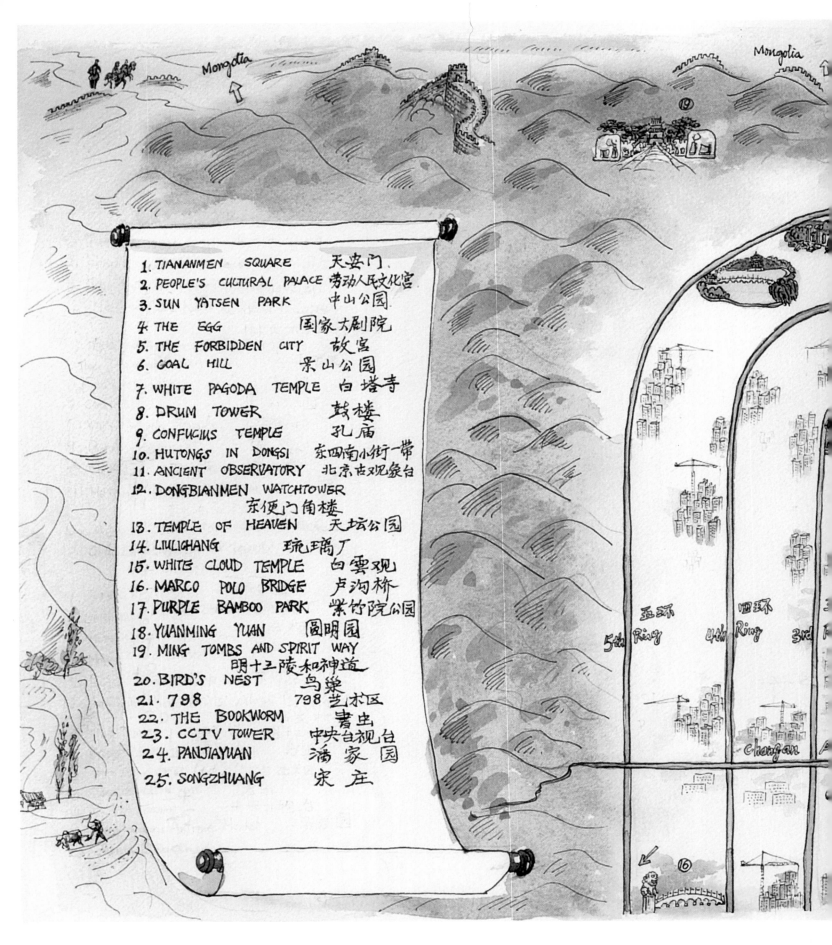

1. TIANANMEN SQUARE 天安门
2. PEOPLE'S CULTURAL PALACE 劳动人民文化宫
3. SUN YATSEN PARK 中山公园
4. THE EGG 国家大剧院
5. THE FORBIDDEN CITY 故宫
6. COAL HILL 景山公园
7. WHITE PAGODA TEMPLE 白塔寺
8. DRUM TOWER 鼓楼
9. CONFUCIUS TEMPLE 孔庙
10. HUTONGS IN DONGSI 东四南小街一带
11. ANCIENT OBSERVATORY 北京古观象台
12. DONGBIANMEN WATCHTOWER 东便门角楼
13. TEMPLE OF HEAVEN 天坛公园
14. LIULICHANG 琉璃厂
15. WHITE CLOUD TEMPLE 白云观
16. MARCO POLO BRIDGE 卢沟桥
17. PURPLE BAMBOO PARK 紫竹院公园
18. YUANMING YUAN 圆明园
19. MING TOMBS AND SPIRIT WAY 明十三陵和神道
20. BIRD'S NEST 鸟巢
21. 798 798艺术区
22. THE BOOKWORM 书虫
23. CCTV TOWER 中央电视台
24. PANJIAYUAN 潘家园
25. SONGZHUANG 宋庄

Mongolia

Mongolia

5th Ring 五环
4th Ring 四环
3rd R

Chaoyang

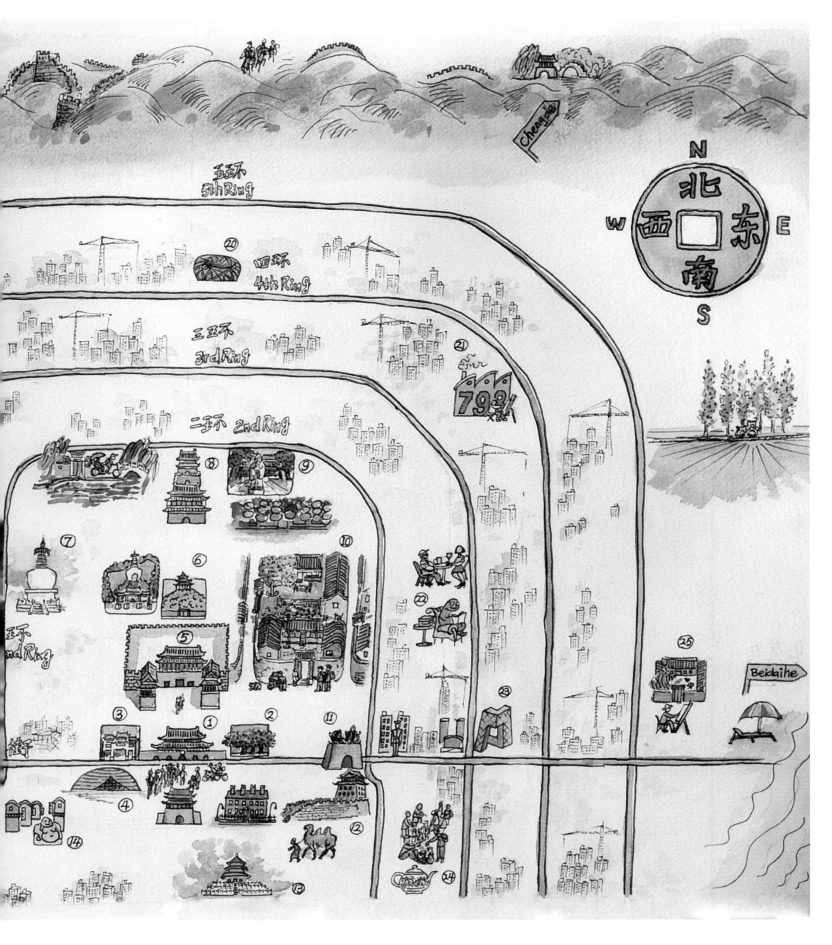